Karen Armstrong
satinalia

WISDOM OF WILDLY CREATIVE WOMEN

"There is an alchemist within each of us and an abundance of artistic prowess in these pages. A deeply inspirational writer, Angela LoMenzo's storytelling provokes a love and reverence for the lives of each of these creative women. Out of our life obstacles, adversity, and loss can come wisdom, greater integrity, immense power, and creative freedom. The fearless life stories and spirit within each of these magnificent women shows us to trust in divinity and follow our passions and our artistic reveries. From rockstars, designers, songwriters, actors, photographers, speakers, artists, and creators across the gamut, we see we are connected and empowered by our artistic visions. This exquisite book honors all aspects of living a wildly creative life and, as the author herself writes: 'Look to the harmony in nature's chaos: when the storm hits, the rain is our tears—the wind our resistance—the destruction our pain. Once it passes, there is the opportunity for new growth: the air is cleansed, the soil is nourished, and the brightness of the sun restored.' "

—NINA MORGAN-JONES, designer and owner of the award-winning clothing line ROMP

"I can so relate to these very courageous, strong women. I became a band's manager in the '80s and dared to step into a 'Man's World.' How dare I? I was told so many times, 'You can't manage a band, only men can do this job,' but Sharon Osbourne and I proved them all wrong and opened the door. This is a book of truly beautiful, uplifting words and photographs. I thoroughly enjoyed reading these incredible women's stories and highly recommend it."

—WENDY DIO, president and owner of Niji Entertainment Group, producer, coauthor of *Rainbow in the Dark: The Autobiography,* and president and founder of the Ronnie James Dio Stand Up and Shout Cancer Fund

"This beautiful book rightly reminds me that any ability to love, to see, to create endlessly, was given to me by my mother and grandmother. It is a joy to see so many women I admire making such a beautiful contribution to healing and helping the world."

—KRISTIAN NAIRN, actor (*Game of Thrones, Our Flag Means Death*), musician, DJ, and creative artist

"From the furthest depths of the ocean and widest expanses of artistry imaginable, to aerialists soaring to the absolute pinnacle of creativity, the boundary-breaking visionaries contained in this book will inspire you to take up your own pen, brush, and instrument (maybe even tattoo gun) and explore your own genius. Every single woman in the book is a badass and an exemplar of fearlessness, courage, resilience, and, above all, feminine power. Angela LoMenzo's book is itself a work of art, filled with stunning photographs and clearly crafted with heart and marvelous storytelling. *Wisdom of Wildly Creative Women* is just brilliant. Get one for yourself and every woman you love."

—BECCA ANDERSON, author of the bestselling book *Badass Affirmations*

"In a world that can sometimes feel parched—thirsty for creativity and joy—this book by Angela LoMenzo is a fountain of juicy stories about inspiring women. The author introduces us to more than two dozen courageous and trailblazing artists, teachers, and entrepreneurs from all walks of life who live with generous hearts and spirits that we can all learn from. If you want to feel that a little more zest is possible for you, read this book! If you need an extra boost of bravery, read this book! If you want to simply feel more positive about the world, read this book!"

—SHERRY RICHERT BELUL, founder of Simply Celebrate and author of *Say It Now*

"Having played and recorded with artists such as Lady Gaga, Melissa Etheridge, Stevie Nicks, Celine Dion, Loretta Lynn, Reba McEntire, Alanis Morissette, and Dolly Parton, I know firsthand there is no greater force than the power of a creative woman. The transformational journeys of the women featured in this book will deeply inspire the creative power in you! Read it, feel it, then set the world on fire."

—KENNY ARONOFF, world-renowned drummer, author, and speaker

"This book is a rallying cry to all creatives who need an inspiring pep talk from a sisterhood of badass (successful) women. Creativity, grit, resilience, and motivation—THE book that every girl needs in moments of turmoil and in celebration of her triumphs!"

—JENEDA BENALLY, award-winning bassist and singer, actor, traditional Dine' Navajo dancer, activist, and radio host

"Wisdom of Wildly Creative Women is a beautifully written, inspiring tribute to incredible women who dared to trust their creative spark—and find their authentic voice—despite facing hardship and adversity. If you're looking for a book that will inspire you to use your creative power, this is it."

—KIERSTEN HATHCOCK, author of *Little Voices* and founder/CEO of Mod Mom Furniture

"This unique look into the personal lives of such supremely strong, creative women is wonderfully inspiring and truly insightful! Each of these women is a powerful example of courage, strength, and the exuberant perseverance of their creative nature. *Wisdom of Wildly Creative Women* holds and highlights the beautiful humanity behind the grit and innovation it takes to collaborate with life and allow creativity's wisdom to guide the way!"

—BRANDI MILNE, painter, artist, and author of *So Good for Little Bunnies* and *Frölich*

"Angela LoMenzo's delightful and thought-provoking book will galvanize your feminine and creative energies in ways that lead to clarity, excitement, and empowerment. The insightful stories of the visionary trailblazers included in *Wisdom of Wildly Creative Women* will move you; they will connect you with your own innovative self, inspiring you to become a powerful force in the world."

—M.J. FIEVRE, coauthor of *The Book of Awesome Black Women* and *Female, Gifted, and Black*

"*Wisdom of Wildly Creative Women* is an AWE-inspiring read. I went from crying to laughing with everything in-between. There is something magical about how Angela LoMenzo weaves the stories of these women into one cohesive message about the beauty that comes with following one's passions. I definitely felt amped and ready to take action after reading their heartfelt stories."

—RACHAEL WOLFF, podcaster, speaker, and author of *Letters from a Better Me*

"Life is about building yourself and turning moments into memories and experiences as you navigate through the good, bad, and the unfortunate ugly in the world. To connect the 'dots' on your life's journey is key—you eventually gravitate towards those that resonate on the highest level with you. Being a Badass Warrior Princess is work: all these magical women have taken risks and show how we all fall and get back up again—constantly. Do the work and surround yourself with women that support you and want to see you shine."

—YAEL RALLIS, drummer, Desert Dome Studio CEO, documentary film director, and moto traveler

"In *Wisdom of Wildly Creative Women*, Angela LoMenzo shares the breathtaking journeys, harrowing turning points, and triumphs of courageous and creative women. Their lives spark a passion that will entice readers to start their own novels, businesses, sculptures, or bands. The inspirational stories are revealed in an intimate and engaging way that connects the reader on a deeply personal level. A truly captivating read!"

—KATHERINE TURMAN, journalist and coauthor of *Louder Than Hell: The Definitive Oral History of Metal*

WISDOM OF WILDLY CREATIVE WOMEN

WISDOM OF WILDLY CREATIVE WOMEN

REAL STORIES FROM INSPIRATIONAL, ARTISTIC, AND EMPOWERED WOMEN

ANGELA LOMENZO

PRINCIPAL PHOTOGRAPHY BY JAMES LOMENZO

Be aware that Chapters One and Eight contain passages describing violence against women.

mango
PUBLISHING GROUP

CORAL GABLES, FL

Copyright © 2023 by Angela LoMenzo.
Published by Mango Publishing, a division of Mango Publishing Group, Inc.

Cover Design: Megan Werner
Cover Photo: James LoMenzo
Layout & Design: Megan Werner

For permission requests, please contact the publisher at:
Mango Publishing Group
2850 S Douglas Road, 4th Floor
Coral Gables, FL 33134 USA
info@mango.bz

For special orders, quantity sales, course adoptions and corporate sales, please email the publisher at sales@mango. bz. For trade and wholesale sales, please contact Ingram Publisher Services at customer.service@ingramcontent.com or +1.800.509.4887.

Wisdom of Wildly Creative Women: Real Stories from Inspirational, Artistic, and Empowered Women

Library of Congress Cataloging-in-Publication number: 2022948265
ISBN: (p) 978-1-68481-152-6 (e) 978-1-68481-153-3
BISAC category code: BUS109000, BUSINESS & ECONOMICS / Women in Business

Printed in USA

For the three generations of women
eternally etched in my heart.

My daughter Zoe Rose, the greatest gift
of love and joy in my life. Your beauty,
talent, and compassion inspire me
every day.

My mother, Marci, whose creativity and
free spirit have enriched my soul and
empowered my freedom of expression.

My grandmother, Maureen Rose, who
showed me how to stand up for myself
with integrity and be a badass with grace.

"I WANT TO SING LIKE THE BIRDS SING, NOT WORRYING ABOUT WHO HEARS OR WHAT THEY THINK."

—RUMI—

CONTENTS

FOREWORD

BY KATHY ROSE

When Angela and I first met, it felt as though I had known her for a hundred lifetimes; talking with her always feels like a safe and sacred space. She is an artist who has a spiritual directive to heal the heart of humanity and works incessantly to transform the imbalances of this world into love. Through compassion and a profound artistic talent, she encourages women to bring forth a revolutionary vision to empower their passions. It is a great honor to be included in this work of art which Angela has created as a gift to us all. She is an ambassador of peace and advanced consciousness who embodies the divine feminine principles.

The way this book shines a light on the importance of nurturing creativity from childhood on resonates deeply with me. We all have it within us from the moment we are born, and it is so important to be allowed the freedom to discover where that creativity lies. I was fortunate to be raised by two extremely beautiful human beings who are directly responsible for cultivating mine.

When I was a child living in Tehran, my parents invited friends from all around the world to visit us, among them professors, artists, singers, musicians, and poets. I was surrounded by the arts and creative minds. My mother painted the den walls with murals of various trees, and I looked upon it as an enchanted forest. I have carried on the tradition of my mother's painted trees in my own house. My children, Saffron Valentine and Quinn Argyle, have a chalkboard wall, and there's another one in our living room that is meant for expressing ourselves. Right now, it's all glitter—rainbow glitter! I want my children to feel free to be artistic and believe in themselves and their creativity with absolute trust. I also want them to experience the magic and miracle of nature. Most of all, to know that art is everything!

Angela has cultivated these exquisite women for their uniqueness and their willingness to forge new pathways of thought and emotional intelligence. Every artist in this book has expressed an authentic, passionate, and courageous life path, while transcending the limits of what was previously thought possible. It is in the presentation of female leadership that wisdom is uncovered as a force to be revered—in every facet of our lives.

When women celebrate each other and nurture their beauty within, it transforms into collaboration. In my eyes, beauty stems from

self-worth and grace—you can't compete with grace. I explain this to my kids by saying, "Whoever is around you is your mirror." Seeing my kids grow into such beautiful human beings and positive mirrors keeps me focused on staying in a positive light right there with them. You get what you are, and you get what you think about most of the time. How you show up to people, and where your vibration is, is how you will be treated. It's all about the journey and who you're walking with in this lifetime. I've learned so much about intention as I've grown older—with relationships, discernment, and in what I create. How we are serving and giving back to each other and the world…that's what matters the most.

When we honor every living being on this earth, we harmoniously thread together this tapestry of life. My words are written in loving gratitude for Angela and all the women in this book, as well as every sister who is striving to expand herself into a higher state of self-discovery and grace. When Angela asked me where the courage to choose a creative career came from, my mind became oddly silent. Honestly, I had never thought about that before. I never questioned the action of being driven by what called to my heart; it's non-negotiable for me. It all starts with being authentically who you are. Once you know that, there are no limits to what you can do. It becomes a labor of love without fear. After turning the pages of this beautiful book, you can't help feeling the fortitude to bravely march into a world where anything is possible.

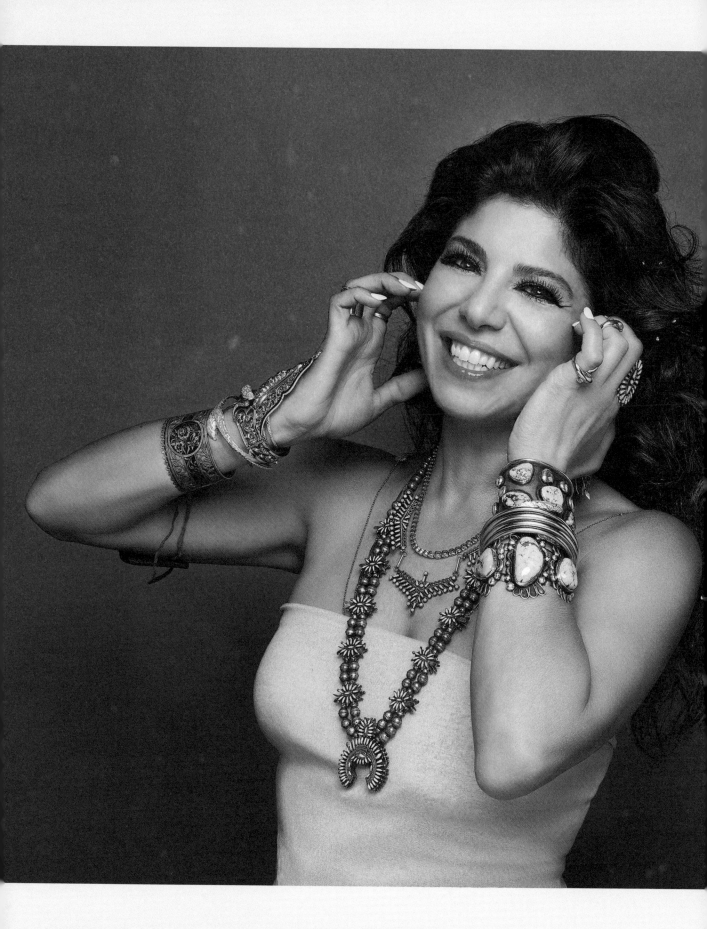

ABOUT
KATHY ROSE

JEWELRY DESIGNER

The rose is a symbol of love at first sight, which is precisely what happens when you meet Kathy Rose for the first time. She is the magic of the desert and the serenity of the sea. Being in her presence is immediately grounding. Her beauty and style are striking: a bohemian warrior interlaced with polished elegance. Her tranquil nature is pure love and humility. She exemplifies the essence of this book perfectly, and I am so fortunate to have the book's foreword written by such a beautiful soul. Because of her humble nature, I felt compelled to sing the praises of this accomplished creative.

Kathy, whose birth name is Katayoun, was born in Tehran, Iran. When she was seven, her family relocated to the beaches of San Diego, California; both places nourished her love of nature.

Kathy started officially designing jewelry in 1999 and opened Roseark in 2000, with then-husband Rick Rose. Roseark is a luxury goods store and gallery in Los Angeles featuring trend-setting collections of jewelry from cutting-edge artists around the world. Roseark is her kingdom of creativity; it electrifies your mind with inspiration and imagination. Her Earth Mother energy influences the designs of her jeweled creations, which include exquisite creatures and elements from land, sea, and sky, as well as pieces honoring Native American cultures. Just as the beauty of nature has no limits, neither does her creative vision.

Her first design piece was created with the intention of replacing a childhood fear of snakes with honor. The snake cuff elegantly wraps a diamond-encrusted snake around your wrist—

a dainty yet strong interpretation of this symbol of transformation, wisdom, and healing. Celebrities who have embraced this design include Rihanna, Penelope Cruz, and Meryl Streep, who wore it on the cover of *W* magazine. It has since become one of her classic designs and is always in high demand. Kathy's next design, the icicle earring, was worn by Cameron Diaz in the film *Vanilla Sky*, Courtney Cox on the cover of *People Magazine*, and Demi Moore at the *Charlie's Angels* premiere, and was purchased for Madonna—all in one month! After that, Kathy Rose designs were everywhere, and her career exploded.

Another cult classic of hers is the eagle cuff—in single and double-tailed versions. When asked what animal she connects with most, she emphatically replied, "The eagle. I am completely drawn to their energy, but I am not exactly sure why." I can see why; the eagle symbolizes a connection to the divine because it flies higher than any other bird and looks at things from a higher perspective. Kathy is always seeking higher ground in everything she does.

On my last visit to Roseark, I looked out the window, admiring the beautiful Zen garden in the courtyard. Birds were joyfully singing while perched in the trees. Entranced by the space's blissful energy, I left there that day seeing colors a little brighter and taking things a little slower, making sure to stop and smell the roses.

INTRODUCTION

Everyone wants a friend who gets them, someone who can see you—the real you. I found that person after a series of life-altering events left me feeling broken, defeated, and withdrawn. I had blown out the candle on my passions and fallen into a place of darkness. Our like-minded connection instantly lifted the veil of loneliness I had been experiencing. Then, just as quickly as she came into my life, she left—this beautiful, talented, and brilliant woman was taken from this world in an instant. Though our time together was brief, the impact her vivacious spirit had on me was everlasting. She became my light, my angel, and the spark that started me on the path to writing this book. It didn't happen overnight, but as soon as I took my first step in that direction, a shift occurred. The impossible suddenly felt possible, and I moved forward with conviction and clarity.

Her most profound message to me came after her memorial service, when friends and family gathered at her home. This talented artist's last project was the intricate undertaking of covering her floor-to-ceiling fireplace with gorgeous glass mosaics, all different shades of blue and green. I wandered into the living room to admire her work and was taken aback—it had never been completed. The unfinished fireplace stood there half-naked, with no fire inside. In that moment, she spoke to me about how precious life is, how important every minute is, and how I shouldn't spend another day without my dreams on the horizon. I listened, I woke up, and I began to live again, this time guided by the longings in my heart and the voice of my soul.

It didn't take long to uncover the inspiration that would be the key to unlocking my creativity: the exceptional and talented women who've been around me all along. When I reached out to them, their response was one of support and sincerity. In doing so, I discovered they too had visited those dark and empty places. I saw how connected we were as women, in our struggles as well as our aspirations. The power of this vibrant female energy touched me so deeply, I wanted to channel those feelings and emotions I was experiencing to other women.

Wisdom of Wildly Creative Women is the birth of that desire, featuring the stories of twenty-five accomplished and free-spirited women who have an uncompromising drive to pursue their passions. Collectively, these visionaries have faced tremendous adversities and overcome them with strength and resilience. They have courageously shared their stories for the sole purpose of helping other women rise. I am in awe of their generous and compassionate hearts and grateful to have the privilege of bringing their life-changing experiences to light.

My hundred-plus hours of conversations with these extraordinary women revealed several common traits

among them. One was seizing opportunities as they present themselves; even in unfamiliar territory, their mantra is *jump first and learn later*. Another prevalent characteristic was the ability to trailblaze careers for their unique talents; if there wasn't a position available, they created one, proving the secret is to believe—in yourself and your intuition. Quiet the voices that can hold you back and instill self-doubt or shame, and listen to the call of your innermost self; trust it, and you will be directed to where you need to go. These women have all silenced the sounds of disapproval and found a way to burst out of the box of discontent and into a world of wonder and fulfillment.

Who are the most successful people in the world? The ones who dare to be different and fearlessly stand out in the crowd. Those who embrace their adversities and perceived imperfections, recognizing these are the very gifts that give them the edge and advantages in their lives. Honor your battle scars and celebrate them; after all, that's what transforms us into warriors.

Interviewing these badass creatives has had an enduring effect on me, and I am so excited for readers to be moved by their stories just as I have been. My hope is that whoever picks up this book will find themselves somewhere, if not everywhere. My heart breaks to think of anyone feeling alone, in pain, or like an outcast. We are all unified by the human experience, and should never have to feel alone in our time of need. Let the warmth and positivity captured in these pages illuminate for you the possibilities and beauty in your life, and never forget to color your world with creativity.

Now go out and find your magic, that which ignites your flame. Finish your fireplace and keep the fire burning, no matter who or what may try to extinguish it. This is your life to decorate with all that fills your mind, body, and spirit with absolute joy!

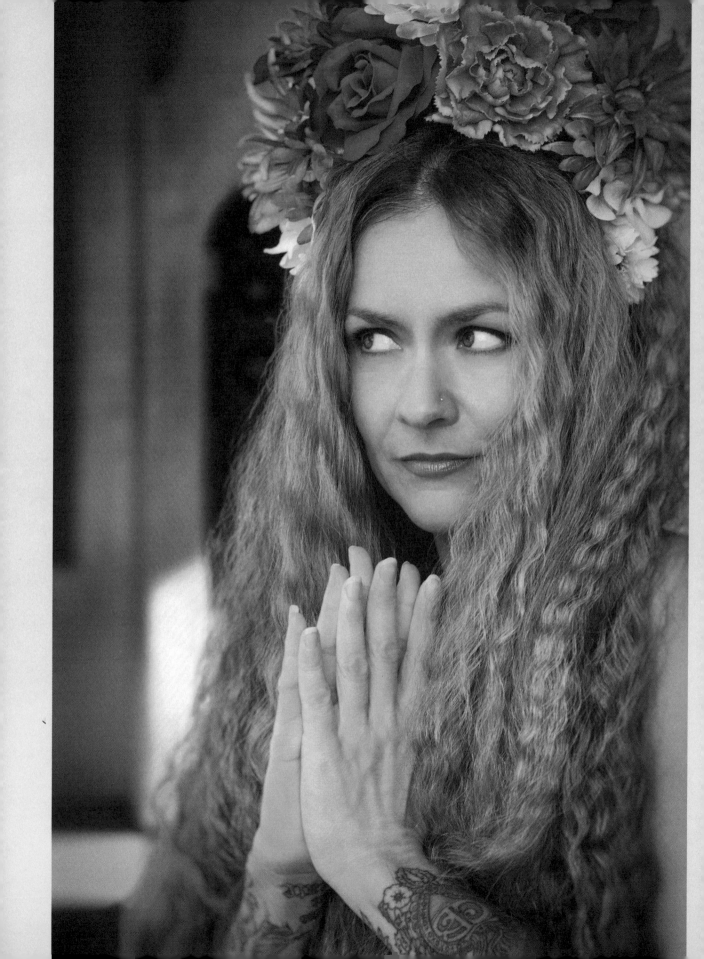

OUT-OF-THIS-WORLD ARTIST CHLOE TRUJILLO

ARTIST | DESIGNER | MUSICIAN

"HOW DID THE ROSE EVER OPEN ITS HEART AND GIVE TO THIS WORLD ALL ITS BEAUTY? IT FELT THE ENCOURAGEMENT OF LIGHT AGAINST ITS BEING, OTHERWISE, WE ALL REMAIN TOO FRIGHTENED."

—HAFIZ

What do you do when you're going to Chloe Trujillo's house, high atop the Santa Monica Mountains, and your GPS goes out? You follow the color! I did just that when I saw a vibrant pop of yellow peeking through the other houses, and yes, when you follow the yellow brick road, you do find Oz—Chloe's Oz—and it's a magical place to be. This sublime sanctuary, built into a cascading mountain of rocks, is filled with artistic energy that arouses your creative spirit the minute you walk through the door. The atmosphere for each room's color and mood is centered around her mystical paintings that grace the walls throughout the home. There are so many magnificent details that you could go back a hundred times and still discover something new. Chloe and her husband Robert designed this house together and filled it with furnishings from their world travels. The mosaic work alone will leave you awestruck.

HER HOME DIRECTLY REFLECTS HER PERSONAL STYLE. SHE IS A LIVING AND BREATHING WORK OF ART THAT TRANSFORMS DAILY. CHLOE'S FLOOR-LENGTH HAIR, WHICH HAS NEVER BEEN CUT SINCE THE DAY SHE WAS BORN, IS AN EVER-CHANGING SCULPTURE THAT CREATES THE IMAGERY OF A MODERN-DAY MYTHICAL FIGURE.

She is in a constant state of limitless forward motion with her art—adorning guitars, surfboards, skateboards, shoes, guitar straps, scarves, handbags, swimwear, and dresses. Chloe has single-handedly built an international fashion and art empire that is growing by the minute. You can also add musician and author to her list of accomplishments. She is currently working on new music and an illustrated children's book. How does someone incite this kind of prolific artistry? Chloe takes us on her journey, a healing journey, that led her to where she is today.

Chloe was born and raised in Paris, by fashion designer parents, and is the eldest of three daughters. Though it's hard to believe now, she

was an introverted young girl and used art as her predominant form of communication: "I talked, but I was shy, and art was definitely my way of expressing feelings that I had a hard time expressing with words. I was always drawing, drawing, drawing, and it helped me release all the stuff I wanted to say." The fact that she lived in a nontraditional family of artists and musicians made Chloe's life quite divergent from those of her school peers. "My parents being artistic, and my grandfather being an opera singer, I always felt that we were different, and wondered, 'How can I make friends who understand me when they can't even relate to how I live?'"

That all changed for Chloe with the discovery of the punk movement. It was the catalyst to finding her voice and providing an environment to develop her freedom of expression. "Actually, that was where I found my own people. That's when I felt less shy and more able to express myself with ease. It gave me the freedom to be myself. I gained confidence when nobody was judging me, and I could leave my house dressed however I wanted—feeling better in my own skin. I felt like…finally! Instead of trying to fit into something that didn't really fit me, I found something that was more connected to who I was, what I was feeling, and how I wanted to live."

Even though her parents had artistic careers, Chloe's father strongly encouraged her to focus on math and science, because he knew firsthand how hard it can be to pursue a career in the arts. You always hear about people excelling at either art or mathematics, but not Chloe. She is incredibly adept at both. She studied the structure of matter and quantum

mechanics at Pierre et Marie Curie University in Paris and earned a degree in mathematics and physics. Soon after, she got the courage to tell her father she had decided art was her calling, and she was going back to college for an art degree.

After graduating, she moved from job to job until a violent brush with death awakened an inner storm that steered her toward a transformative life path. It happened at a time when doubts, questions, and insecurities were consuming her thoughts. She was working a nine-to-five retail job, still active in the arts, but holding back and floating in stagnant waters. "I ended up doing little jobs I didn't care about. I had given up on everything I really loved and was passionate about, leaving me depressed, with no taste for life. I loved painting, I loved singing, I loved music, and I loved dancing, but my insecurities were coming to the surface. Giving up on all of that made life meaningless to me."

Then one fateful afternoon, as Chloe walked up the stairwell to her apartment, a man viciously attacked her. "I remember the exact moment when I switched my energy, and it saved my life. Even though I try to forget every other moment, I remember the fighting. I know the guy grabbed my hand and head-butted me. I fell, and he pulled the back of my hair and was banging my head along the stairs. He told me, 'If you make any sounds, I will kill you.' I didn't know if he had a weapon, so I stayed silent. I lived in one of those Parisian apartments that have the staircases with windows built in halfway through—this is where it was happening. He ripped my pants and then I turned my head trying to resist the beating while I looked up at the sky through the window. That's when I made the decision: 'I do care about my life.' A switch went off, and I got so much adrenaline and power. 'I am not going to be raped, I am not going to be killed!'

> "All of that energy work brought me back to the awareness of how energy affects everything around us. I started doing energy work more and more after that."

I knew that's what he wanted to do. So, with new strength, I was determined to fight.

"It is ridiculous to think of now, but when I was fighting back, I was worried about hurting him! It's not in me to hurt somebody. I was fighting, fighting, fighting, and suddenly he got up and started running. I think because it was the middle of the afternoon, he probably started thinking somebody would show up soon. I got up and started running after him. I got out the main door of my apartment building and realized my pants were hanging down and I was bloody all over. There were two girls out front. One took me in her arms and called the authorities, while the other one ran after him. Then, he disappeared into the subway.

"I was called into the police station to describe him for a portrait sketch, and to look at suspects in a

lineup behind the mirror a few times. It was always frightening, because I didn't want to see his face again; I just wanted to forget about him, yet I didn't want this to happen to anybody else."

Now it was time for Chloe to find her way back to herself after escaping death. The brutal assault caused her a tremendous amount of pain, physically and emotionally. Despite this, she feels it sent her in the direction she needed to go. "The attack made me realize that I care about living, I care about my life, I care about it all. There was so much inside of me that I wanted to bring out, but a bit of fear always held me back. Now I felt, 'What's the point of holding back, what do I risk? Nothing!' If people don't like it, so be it. You can't please everybody." Despite these renewed feelings of empowerment, she was still traumatized. She was able to find comfort expressing herself through singing. "I was at the point where I couldn't walk the streets because I would freeze from loud sounds. I didn't show it on the outside, but I couldn't breathe. Singing was so healing for me. The breath and the sound helped me so much."

She continued to explain how profoundly her life became unblocked after the attack. "That attack made me more courageous and made me not care about what other people think. I did an audition, I got a free place to stay in NY, and a bunch of other things after that. The fact that I accepted going there opened up all of this positive energy. I think the depressive state I was in had closed me up, and once I came to think 'What have I got to lose?' that all changed. That's also the time I reconnected with my spiritual side. I was always feeling and seeing things as

a young girl but had shut it down. Once I got out of that state, I found my way back to that part of me." Chloe worked to overcome the effects of the attack with various healers and holistic practitioners. "All of that energy work brought me back to the awareness of how energy affects everything around us. I started doing energy work more and more after that."

Chloe has a signature style that is definitively Chloe Trujillo—something artists spend a lifetime trying to achieve. She broke through all obstacles to find artistic self-discovery in its purest form. "Obviously it doesn't happen overnight, and it takes something from your gut. First, I went to regular art school and learned all the techniques on how to paint correctly using oils, acrylics, watercolors, Chinese ink, and engraving. It's almost like you learn the techniques so you can put them aside and integrate them into your own style. At that point, you can be yourself and feel free having your own way of doing things or seeing things. Finding your own voice and your own self takes a long time. It's all connected to your experiences in life—it's you and who you are. I did a lot of introspective searching and exploration, then it slowly evolved. It's also not being afraid of judgment. It's not censoring yourself because you're worried about people liking or connecting with it. It's about being okay with being yourself, and that's not always easy."

She also has an innate ability to balance both sides: the organized mathematician who makes lists and calculations, as well as the free-flowing creative artist and musician who works through visions and intuition. Chloe will feel the urge to paint a vision,

"FINDING YOUR OWN VOICE AND YOUR OWN SELF TAKES A LONG TIME. IT'S ALL CONNECTED TO YOUR EXPERIENCES IN LIFE—IT'S YOU AND WHO YOU ARE. I DID A LOT OF INTROSPECTIVE SEARCHING AND EXPLORATION, THEN IT SLOWLY EVOLVED. IT'S ALSO NOT BEING AFRAID OF JUDGMENT. IT'S NOT CENSORING YOURSELF BECAUSE YOU'RE WORRIED ABOUT PEOPLE LIKING OR CONNECTING WITH IT. IT'S ABOUT BEING OKAY WITH BEING YOURSELF, AND THAT'S NOT ALWAYS EASY."

and it stays with her as she is guided on an ethereal and spiritual level; then the message unfolds onto the canvas with an open intention for her work. Even when she does commissioned projects, she sets aside any pressure to please others, or her flow of creativity will become blocked. She proceeds with total confidence and trusts in her choices, feeling the client's wishes on a different plane: an intuitive one.

She works the same way with her music. Art and music are completely intertwined within her. Her art inspires her music, her music inspires her art. Sometimes, while painting, she will have the beat of a song come to her through the rhythm of the strokes, or lyrics may suddenly appear before her eyes. She will bounce back and forth throughout her day, from one creative outlet to another, like a hummingbird feeding off the nectar of many beautiful blossoms.

Chloe explained when this behavior originated. "Since I was fourteen, I would get depressed every birthday because I felt like I had done nothing. To me, it was this race against time. I also had this fascination of what's beyond life, and the meaning of life. When I was a kid, I would get up in the middle of the night to read the encyclopedia, seeking out all the information I could. I had this same fascination with math, and that's why I was so good at it. It felt like it held the secrets of the universe."

Chloe grew up in a house that always had some form of music playing, from her parents listening to Black Sabbath, Jimi Hendrix, or Iron Maiden to her grandfather singing opera, accompanied on the piano by her grandmother. She started playing piano at six, then added guitar a few years later. Chloe didn't start performing publicly until she was hanging out with the punks as a teenager, which catapulted her into years of performing in underground death metal and punk bands, cabaret acts, rock operas, and off-Broadway musicals. One of her bands, 66 Steps, had a song placed in the film *Stasis*, and in 2015, her acoustic duo, Descend, opened for Missing Persons on their summer tour. A few years ago, she did a solo album, *Ivresse*, with a producer who had a massive collection of instruments from around the world. Out of this smorgasbord of sounds, Chloe created a mesmerizing album that is a melodic blend of tribal, punk, metal, blues, and rock.

Currently, her music career has been in high gear. "In 2021 I released a new solo album, *Mothers of a New Nation*. I recorded an EP with my band 66 Steps and another EP, *Chloe Trujillo's Mystery Ride*. I have also collaborated with Rav Medic on a deal with Golden Robot Records, and we have already put out two singles, with a full album to be released at the end of 2022." Chloe has also filmed eleven visually stunning music videos of her songs with director Anne Pruvost. Don't think this means painting and design have taken a back seat to music. "Design-wise, I created an activewear collection including leggings, hoodies, and sports bras. I am still doing custom handbags and jackets, as well as merchandise for my music. Of course, I created a bunch of new paintings, and I did a few art exhibitions at Tracy Park Gallery in Malibu, whom I am now represented by."

When asked to name three of her favorite musicians, she first thought of Frank Zappa. I could immediately see why she chose this iconic musician, since the way he looked at music was contrary to the popular musicians of his time. Chloe also doesn't take the conventional route on anything relating to the creation of her art and music. What I didn't know of was her personal connection with the Zappas: "The Zappas have been like family to me and my family since I was thirteen. I got to witness Frank working many, many times—he even gave me a guitar lesson! I have always admired not only his work, but his process—quite inspiring!"

Who were the other two musicians? "Of course, I have to say my son Tye, who is completely self-taught, writes amazing riffs and melodies, and plays every day on his own for about three hours—any style from jazz to metal—just amazing! I have to include my husband Robert as well!"

Chloe's husband is bass guitar giant Robert Trujillo of Metallica. In 1990, she met Robert in Paris through a mutual friend while he was playing in the band Suicidal Tendencies. They didn't start dating until many years later, when Chloe moved to Los Angeles in her late twenties. "Everything happened so naturally. I don't even want to call it dating. We started hanging out, and it evolved into a serious relationship pretty fast. It felt so natural, which may be because we were friends before. Communication is very important, and I think a foundation of friendship makes it so much easier to communicate if there is a problem—or for anything. I also think history together and friends in common creates a strong bond."

Not long after they were married, Tye came into this world while Robert was on a rigorous touring schedule with Metallica. "It was not easy at first because I was very alone. I was lucky that he was able to be home for the birth, but then he had to leave right after. All of a sudden, I was alone with a newborn, learning how to do everything. I am sure this is what all new mothers go through. For me, one difficult thing was having to let go of a few career

> "Since I was fourteen, I would get depressed every birthday because I felt like I had done nothing. To me, it was this race against time. I also had this fascination of what's beyond life, and the meaning of life. When I was a kid, I would get up in the middle of the night to read the encyclopedia, seeking out all the information I could. I had this same fascination with math, and that's why I was so good at it. It felt like it held the secrets of the universe."

opportunities, so it was a big mental adjustment. It's not easy saying goodbye to a major opportunity, but I accepted that things would come later on. In the end, none of this mattered, because nothing replaces being with your baby. Of course, you quickly forget the difficult stuff like all the sleepless nights, and you're left with only the pleasant memories and how it felt so good."

Chloe soon became pregnant again, with daughter Lullah. "She was a surprise, but a pleasant one! I had Lullah before Tye turned two. Robert was home for her birth in June—but just like with Tye, he had to leave shortly after. But this time he was only playing some festivals over the summer, and it was a bit easier because he was off for a little while after that.

"When he got back into touring, I decided to bring our kids along, so we could all be together. They traveled a bunch when they were babies. That is why they have been exposed to a lot of different countries and cultures. When I travel, I like to see the sights and especially anywhere with art—whether it's art shows, museums, or whatever history I can talk about to my children. It's about letting them experience the world and, of course, being around the music and the shows. That's what I see in Tye today, with him being so into playing music and Lullah so into art. They love traveling and discovering places and are very interested in the world."

"That's when I felt less shy and more able to express myself with ease. It gave me the freedom to be myself. I gained confidence when nobody was judging me, and I could leave my house dressed however I wanted— feeling better in my own skin. I felt like...finally! Instead of trying to fit into something that didn't really fit me, I found something that was more connected to who I was, what I was feeling, and how I wanted to live."

One of the things that stands out in the Trujillo household is the fact that watching television is almost nonexistent. You can see the direct effect it has had on the children in developing their creativity. In this age of the tech child who barely looks up from their smart phone or video game, it's incredibly refreshing to see. Chloe said she didn't force this on them, and there was no rule regarding TV viewing. "I think it's because they have their passions and aren't attracted to TV. Every day when Tye comes home from school, he'll play his bass or guitar for hours until we call him for dinner—then he goes right back to it! Lullah will draw and paint. Right now, she is painting portraits on mini canvases.

I think that's why they're not in front of the TV; plus, they don't see us watching it.

"For example, last week I dealt with paperwork and emails all day in my little office with no windows, which can get very intense. If I could paint all day, I would! At around 7:00 p.m., I sat on the couch and decided to relax and see if there were any television shows or movies on. Then I heard my son playing his bass guitar and I thought, *Wait a minute!* I realized that I hadn't painted yet that day, so I should do my thing too! He inspired me in that moment. I turned off the television, got out some brushes, and started to paint. It's great because I think we all inspire each other."

Chloe recently revisited her science background when an old colleague invited her to be part of an experiment to project one of her paintings on the surface of the moon—proving there are no limits to where this artist can go! While in her presence, it is impossible not to be inspired by her enchanting spirit. The day after speaking to Chloe for the first time, I looked up at the sky and saw a huge flock of pigeons in a diamond formation. The birds were all different shades of gray, except for the one directly in the center. That one was a brilliant white, brightly glowing from the sun. I realized that's the essence of Chloe Trujillo: she is the illuminated presence that stands out from the flock. One of the most important messages to be taken from her story is to break free from the fears and restrictions within ourselves. Stay true to your unique self and unveil to the world your inner radiance that is just waiting to light up the sky.

THE CHILDREN'S SONGBIRD CHUDNEY ROSS

AUTHOR | ENTREPRENEUR

"BY DOING WHAT YOU LOVE, YOU INSPIRE AND AWAKEN THE HEARTS OF OTHERS."

—SATSUKI SHIBUYA

Chudney Ross's smile could light up the world! She shares that light by bringing the sunshine in her eyes, the sparkle in her smile, and the love in her heart to children everywhere. This children's book author and mother of two found a way to utilize her talents and love of children to formulate the perfect career. She is the owner of Books and Cookies, an enchanting mobile business offering literature, learning activities, music, and sweet treats. Her literary fun zone can be found at birthday parties, carnivals, and all types of kid venues everywhere. She is from a large family of creatives who were all encouraged to develop their individuality and passions. Her mother, the legendary Diana Ross, set the tone for this artistically abundant family, with love, devotion, and the infinite support of her children's aspirations.

THE DIRECTION OF CHUDNEY'S CAREER WASN'T AS CLEAR TO HER AS IT WAS FOR THE OTHER WOMEN IN HER FAMILY. SISTERS RHONDA AND TRACEE ARE BOTH SINGERS AND ACTORS. AFTER GRADUATING FROM GEORGETOWN UNIVERSITY IN DC, CHUDNEY STARTED ON THE ROAD TO FINDING HER OWN IDENTITY. THERE WAS ONLY ONE THING SHE WAS CERTAIN ABOUT: SHE HAD A CALLING TO SERVE THE CHILDREN'S COMMUNITY IN SOME WAY.

"I loved working with children, so when I heard of an AmeriCorps program called *Teach for America*, taking recent college grads and giving them onsite training to become teachers in the neediest of areas, I signed up. I was placed in Washington, DC, teaching fifth grade. It was the hardest year of my life. I was twenty-one and had no idea what I was getting myself into: one of my fifth-graders threw a brick through my windshield! After I finished that year, I taught for two more years here in LA, until I made the big decision to stop teaching altogether and began to explore what I really wanted to do with my life.

"I found myself wondering what was out there for me. What other things could I do? At the time, I was finally coming into my own voice. I had always been introverted, and some might say a nerd. I was uncomfortable in my skin, and it was a challenge to try and move through life not being confident. My sisters were both dynamic personalities, my mom is obviously one, so it was strange to think of myself as being so unassured. I am also a dynamic woman, but at the time, I was trying to figure out who I was in a household of strong women. Growing up, I was very sheltered, so going into the inner-city schools helped set the course on the road to finding myself. You must learn really fast how to be an authoritarian to manage a class of twenty-five ten-year-olds. I was this young girl pretending to be older by wearing frumpy clothes and glasses hiding behind the role of a schoolteacher. I eventually realized I was actually kind of pretty under those frumpy clothes and glasses."

This newfound self-awareness resulted in Chudney making a decision that would open her up to the limitless opportunities just waiting to be uncovered. "During this time in my life, I decided to say *yes* to everything. I know Shonda Rhimes wrote a book, *The Year of Yes*, about

doing this, and when I saw it, I literally said out loud, 'I did this! I don't need to read this book, I lived it.' I said yes to every opportunity that came to me that felt good or challenging. I was really feeling myself. I went to parties; I danced on tables—all of the stuff that much younger people do. I explored what made me happy and who I was as a person. I gained confidence in myself, my personality, and my voice."

Now the stage was set for Chudney to act on her innermost desires. "I was interested in the entertainment business, but I wasn't sure in what capacity. As always, I came back to the fact that I loved working with children. I was trying to figure out how to mesh those two worlds. Someone's advice was to write. Then, at a dinner party one night, I sat next to someone who asked me what I was planning to do next. I told them I was going to write a children's book and maybe children's television. She told me her sister was a children's book agent and suggested I talk to her about my ideas. I did, since I was saying yes to everything, and it all sort of fell into place from there. I got a book deal with HarperCollins. I know things don't usually happen that way, but I think because I was so open to whatever came my way and started putting my dreams out into the world, opportunities began presenting themselves. I'm a positive force, and once I put my energy behind something, things happen. Then, of course, the book industry changed. This was a long time ago when everyone was buying Kindles. HarperCollins informed me they

were only putting money into people that they knew would make them money. So, my book got shelved for about ten years! Instead of getting upset about it, I moved on to the next adventure."

That next adventure was opening a Books and Cookies store for kids. "I literally started by googling, *how to start a business*! I had a lot of fear and trepidation about it. My mom encouraged me, saying, 'Just go for it! You have nothing to lose.' Well, I did; I lost a ton of money! I went all in, signed a lease, and was in construction on my first Books and Cookies when HarperCollins contacted me and said they were ready to release my book. They needed me to do a rewrite. There I was, writing my book, *Lone Bean*, at the Coffee Bean while checking in on the construction of my business—life went haywire all at once. I've never worked so hard as when I started this business. I opened Books and Cookies big. I thought, if I'm opening a store, I should go for it! Many people start a business small and then grow it bigger. I definitely went the other way!"

This experience was an invaluable education in entrepreneurship for Chudney. "I opened the store in 2011 in a very large space on Main Street in Santa Monica. Unfortunately, it was just too big for what it was. I think the idea is still a solid one. It was beautiful, but I spent too much money on the beauty of the store instead of the part where you can make a profit. It was a huge learning process. I closed the space in

"I KNOW FOR ME PERSONALLY, GROWING UP IN A MUSICAL HOUSEHOLD, WITH CREATIVITY CONSIDERED IMPORTANT, OPENED ME UP TO ALLOW MY CREATIVITY TO FLOW. WE OBVIOUSLY READ A TON OF BOOKS, DID A LOT OF SINGING, AND BELIEVED IN ALL THINGS CREATIVE. IT'S ALSO IMPORTANT TO KNOW CREATIVITY DOESN'T HAVE TO BE PERFECT. THE IMPORTANT THING IS TO LEAD KIDS TO A LIFE OF EMBRACING ART AND SELF-EXPRESSION."

2014. Instead, we found places in other people's businesses; they would host us for pop-up events. We were still doing birthday parties and other events as well. Then I relocated the business to a smaller space in 2015, directly across the street from my original store, and that did very well. I signed a short-term lease because I learned my lesson the first time. We were making money, but I decided not to renew the lease. Our profits were just paying off the debt from the first space, and I felt like we could do things differently. Birthday parties at people's homes and parks were picking up, and the influencer market was starting to take off. We were getting called by all sorts of big brands to do events that paid much more than I was making in the store. We became a mobile business, and I even got a special Books and Cookies truck. I have a wonderful relationship with kid's venues, play spaces, and places that hold classes. When COVID happened, we did virtual story times from my backyard. I did them only three times a week because it's just too hard with the baby and homeschooling. It was a lot of fun to connect with a wider community online, everywhere from New York to Spain!"

Watching Chudney do virtual story time on her Instagram live feed, you quickly see that she is in her *happy place*. She is captivating, vibrant, and entirely in the moment with the kids. "People always ask me, 'Do you read in voices? Do you use puppets?' I don't, but I think because I'm enjoying it so much the kids do as well. I'm not putting on a show, I'm asking them to engage and have fun, and I'm having fun. Kids get it! You don't have to read with voices; just be enthusiastic and connect. The Instagram live spots are so funny because there aren't any kids physically there, but I talk to the screen as if I see them clapping and singing along with me. Before the quarantine happened, I was already looking at ways to bring what we do online or to a television platform. The documentary about Mr. Rogers, *Won't You Be My Neighbor?*, inspired me. The kids felt as if he could see them through the screen. I realized I don't have to wait for a big studio to film something beautiful—I just have to do it."

She has been a longtime advocate for children's literacy and discussed the benefits of exposing children to books early. "The first stage of literacy is when they're tiny babies licking and biting the books and listening to your voice. Research shows that exposing small children to books opens their minds to learning, and it's the same with the arts and music, even in utero. I know for me personally, growing up in a musical household, with creativity considered important, opened me up to allow my creativity to flow. We obviously read a ton of books, did a lot of singing, and believed in all things creative. It's also important to know creativity doesn't have to be perfect. The important thing is to lead kids to a life of embracing art and self-expression."

Her children's book, *Lone Bean,* finally came out to mixed reviews when she was late in her first pregnancy. "Some of the big review sites didn't give it great reviews, but the kids seemed to like it. I always remind myself that I didn't write it to make millions of dollars, or for the review sites: I wrote it for the kids. I also wrote it before I was a mom. I tell my daughter she can't say *shut up* or *hate,* but in the first chapter of *Lone Bean*, the main character says both of those words and all kinds of mean things! I think that's why it connects with kids, because their mom didn't write it. I read a few reviews on Amazon that said some parents didn't like that the little girl in my book dealt with bullies and real-life issues. It's not preachy, and it does have a positive message and lesson at the end. Lone Bean tries out some different hats that don't fit her and makes some poor decisions along the way. In the end, she makes a good one."

After hearing this, I went on Amazon and found mostly glowing reviews for *Lone Bean.* In fact, reviewers overwhelmingly cried out for Chudney to write another book. Their kids loved it, and they wanted more. The children have spoken! I think now parents are looking for more books that address the actual issues children contend with in their young lives and not just fairy tales.

When Chudney and I first spoke, it was during the 2020 quarantine, which had the country adhering to being safe and at home. She has two daughters: Callaway, who is seven, and Everlee, seven months, with her husband Josh Faulkner. "I was able to get back little by little into my life outside of caring for an infant, and then the COVID quarantine happened. I took a few steps back and shifted the focus 100 percent on these two beautiful little girls. The high emotions of what is happening in the world left me with no mental capacity to do anything else. Callaway is doing home school, and not having to drive her to school and after-school programs has helped me to slow down a bit and cherish this time with my family. The other stuff will eventually come. I know my career will come back, I know I'll get fit again, I know that I will write another book

> "People always ask me, 'Do you read in voices? Do you use puppets?' I don't, but I think because I'm enjoying it so much the kids do as well. I'm not putting on a show, I'm asking them to engage and have fun, and I'm having fun. Kids get it! You don't have to read with voices; just be enthusiastic and connect."

or do something else I am passionate about. It's just on hold for a while."

For as long as she could remember, Chudney had wanted to be a mother. Her first child was so easy to conceive that she never considered that there might be a time limit regarding getting pregnant. She waited six years after Callaway was born to start trying to have her second child. The decision to wait resulted in a lot of confusion, heartbreak, and questions. "Time passes so fast, and I didn't mean to wait that long to have another baby. Around the time I thought I would be having a second child, I was dealing with a failing business. I felt like if I had another child, my head would explode. Then, suddenly, I was almost in my mid-forties. I knew that if we were going to have a second child, the time was now. Since it had been so easy to get pregnant the first time, it was surprising that it didn't happen the same way the second time. I felt as healthy and young as I did when I had Callaway. I had two miscarriages in two years, and the toll it took on my heart was too much. I had to consider if I wanted to explore adoption or see if science had another way for me to conceive. Looking back, I wish I had known to freeze my eggs when I was younger, but I was fortunate enough to try one round of IVF using my forty-something eggs and we successfully had a healthy fertilized embryo, and now here she is!"

She has brought much of what she learned from her mother's example to the parenting of her two daughters. "My parents were divorced when I was very young, so I have no recollection of them as a couple. They were together before my memories began. My mom toured a lot when we were young, but I never remember the feeling of being without her. She was always there when I needed her, even if it was over the phone. She was there any time something important happened. She traveled back and forth so she could be with us as much as possible—sometimes to tuck us in at night and make breakfast in the morning. We always knew that we were her biggest priority and the most important thing in her life. I think she had an amazing way of putting us first. Even now, as adults, we know that we are everything to her, as well as her grandchildren.

"I saw a very strong, independent, creative, loving, and passionate woman in my mother. My sisters and I carried that on, and we got those values from her. I was taught that beauty comes from within. Happiness, joy, and confidence make you beautiful. The most important thing is raising strong and good human beings. Those are the big lessons from my mom that I have taken into my parenting and the way I approach the world. This is what I want to send my daughters off into the world with."

Having a childhood ensconced in music enriched her soul. "I always remember a lot of singing in our home. We toured with my mom in the summers, so live music was a regular part

of my life. I got to see how music could bring joy to so many people, and how it could not only move them to dance but move them to tears—evoking true emotions. For me, it was getting sung to sleep, so I know how that can bring relaxation and tranquility. I was always very aware of how music felt in my body."

Chudney became a different kind of songbird, one whose voice brings merriment to children and enlivens their imaginations, love of books, and thirst for knowledge. "People tend to label me as the one in my family who didn't get into the entertainment business, but I think what I do is entertainment and definitely creative. My audience is a bit different, and my stage is a little smaller, but for all intents and purposes it's a stage. It's entertainment, it's creative, and it's musical. It's artistic in my way."

Not only has Chudney found her voice, she also knows how she wants to use it. She is keenly aware of her emotional boundaries, as well as her strengths. She has strong convictions and knows how she can best serve her community and the causes she champions. "I avoid politics because I find it has a lot of negativity. I like to focus on joy and uplifting topics. The issues I try to get behind are ones that align with the work I do and relate to protecting children and children's rights. There's so much to fight for that it can be overwhelming and all-consuming. I try to keep a more positive outlook. I do educate myself on what's going on in the world, but I can't get consumed by it because I'm a sensitive person and can quickly get into a negative headspace. I'm clear that my power and voice is in love and kindness. My strength is in compassion and empathy. My activism is in my service to others; my commitment is in sharing diverse books with little ones who in the future will change the world. My activism is raising strong, smart, independent, empowered girls, and building

> "I saw a very strong, independent, creative, loving, and passionate woman in my mother. My sisters and I carried that on, and we got those values from her. I was taught that beauty comes from within. Happiness, joy, and confidence make you beautiful. The most important thing is raising strong and good human beings. Those are the big lessons from my mom that I have taken into my parenting and the way I approach the world."

their bookshelves with diverse characters and ones that address race, racism, and activism."

A quote that Chudney has referenced by Nelson Mandela, "Education is the most powerful weapon which you can use to change the world," expresses the principles that drive her. When you meet her, you trust her. There is no facade. She is genuinely the joyful, unpretentious, and loving woman you see.

She said, "I know I'm not doing brain surgery, but I really love what I do, and I think I bring passion and excitement to it; this can be my contribution to the world." She is exactly what the world needs right now: a champion for a positive future for our children. It's not just children who benefit from her energy; we all need to be reminded of how to find the bright spot in the sky even on the cloudiest of days.

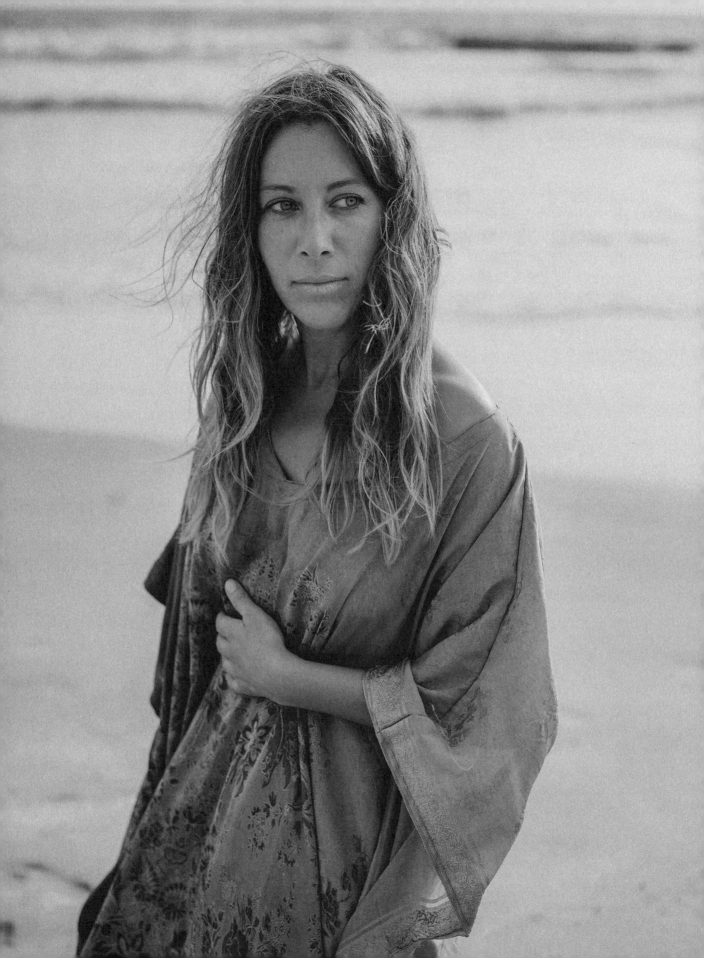

HERE COMES THE SUN
ELISSA KRAVETZ

DESIGNER | ENTREPRENEUR

"YOU KNOW THERE'S A THING ABOUT THE WOMAN ACROSS THE ROOM. YOU SEE THE WOMAN ACROSS THE ROOM. YOU THINK, SHE'S SO POISED; SHE'S SO TOGETHER. BUT SHE LOOKS AT YOU AND YOU ARE THE WOMAN ACROSS THE ROOM FOR HER."

—DIANE VON FURSTENBERG

Elissa Kravetz is guided by instinct and intuition, so much so that life-changing words will burst out before her mind has a chance to connect with the thought. Her career with shoe mogul Steve Madden and the inception of her Sun Child clothing line were both sparked by this insight, one she has come to trust wholeheartedly. Elissa looks at life with a child's wide-eyed curiosity and excitement. Amazingly, that spirit was not broken when she was brutally bullied as a young girl. She has been at the center of the fashion industry in NY and the celebrity life in LA, but happiness eluded her. A near-death experience and a dance with fate that had her trapped in the jungles of India became the key to unearthing her heart.

SHE AND HER YOUNGER SISTER, JESSICA, WERE RAISED IN FRAMINGHAM, MASSACHUSETTS. ELISSA'S NORMAL AND PEACEFUL CHILDHOOD CHANGED ABRUPTLY UPON ENTERING THE SEVENTH GRADE.

Middle school ended up being a year-long prison sentence of persecution, torment, and misery for her. It all started one day when she heard that her best friend was upset with her and had no idea why.

She would never find out what triggered this appalling behavior. Day after day, the number of people who shunned her grew until it turned into a swarm of hatred so toxic that they passed a petition around the school, signed by hundreds of students. It was sent to her with four excruciating words: *Kill yourself or move.* She would eat lunch in the nurse's office or a stall in the bathroom; she was egged, roughed up, and had *DIE BITCH* painted on her locker. Her parents went to the school numerous times requesting an intervention with the other parents, but they refused to participate and continued to deny their children would ever do such things. Elissa's parents did discuss moving away, but she wouldn't let them. Instead, she courageously walked up those stairs to school, day after day, enduring this torturous existence. This reign of terror would come to an end when the school shut down and

the students were sent to different middle schools, but the effects would haunt her for years.

Elissa shared how she processed this experience while it was happening: "At the time, I absorbed it. When you are bullied or mistreated, you either take it or you stick up for yourself. I never stood up. I guess a version of standing up for myself was showing up at school every day, but I never verbally stood up for myself. What happened to me happens in every school, as well as in people's homes and in businesses—it's a universal issue." It would take her twenty years to properly release the pain from this trauma, but it didn't stifle her unbridled enthusiasm for life.

An example of one of her characteristic intuitive moments was when she met Steve Madden: "I was a business marketing major at the University of Maryland, and in October of 1998 in my junior year of college, I went to the mall with my best friend. Entering through the Nordstrom shoe section literally changed the course of my life. There was a huge crowd because Steve was signing autographs. We both happened to be wearing Steve Madden shoes, so we got in line. When it was my turn, I said, 'I am going to work for you.' He responded with 'All right.' I reiterated, 'No really, I am going to intern for you.' He said, 'Sweetheart, what's your name?' I said, 'Elissa Kravetz.' He offered to give me an autograph. I told him I didn't need one, and that I really believed I was going to work for him. His assistant grabbed the microphone to draw from a fishbowl of names for a free pair of shoes. We hadn't entered so we weren't in the raffle. After the winner was announced, Steve grabbed the mic and decided to pick another winner. He reached into the

bowl and said, 'Elissa Kravetz.' We chatted for a while, and that was it. We bumped into him an hour later at the Steve Madden store. That's when I asked how I would be able to get in touch with him, since I would be moving to New York next summer and was going to be his intern. He wrote his assistant's name on the back of his business card and told me to call on Monday."

That was the first time Elissa had a vision of what her future would look like; it would not be the last. After she left twelve messages over the course of three months, he returned her call, and she got the internship! Her inner voice put her exactly where she wanted to be.

Once again, those words that just pop out of her mouth would materialize: "I spent the first days of my internship at the photocopy machine like most interns do, and on my way to the bathroom I passed by Steve's office with a bunch of executives crowded inside. The door was open, so I looked in to see what was going on. He was holding up a shoe and asking everyone what they thought of it, and they were all telling him how much they loved it. He looked at me in the doorway and said, 'What do you think of this shoe, intern?' I said, 'I think that shoe is fucking ugly.' The words just came out, and my face turned red. I knew I was going to get fired. Everyone turned and stared at me, and there was complete silence until Steve threw the shoe across the room and said, 'This shoe *is* fucking ugly.'

"The next day, right as I walked into work, I heard Steve's voice over the intercom saying, 'Intern Elissa, come to my office.' I walked in, ready to be fired, and instead, he held up a shoe and asked me what I thought

of it! For the rest of my summer internship, I worked next to him every day. A limousine would pick me up, and we'd go to malls. He valued my opinion because I knew his demographic. I went back to college, finished my senior year, and they offered me a job after graduation."

She continued to be by Steve's side for a few years, and then he saw her potential to rise: "In the early 2000s, a *New York* magazine article came out titled 'Power Girls,' about these Manhattan publicists. Steve put it on my desk and said, 'I want you to read this, and let's talk about it tomorrow.' The next day when he asked me what I thought, I told him they seemed like mean girls. He asked me if I were to do that job, how would I do it differently. I told him I would do it without being an asshole! He picked up his phone and fired his PR firm, and when he hung up, he looked at me and said, 'All right, you're going to do that job now.' That's how I started doing PR!"

Elissa bravely moved into uncharted territory. "I started handling all of Steve's PR in-house. I had no idea what I was doing, but I just went for it! I started flying to LA to dress famous people. I would go backstage at the Teen Choice Awards and give out shoes, and had gifting suites at the Billboard Music Awards. I worked with magazine editors and advertising executives. Looking back, I realize it was a bit obnoxious. I kept getting raises, I was flying around on a private jet with people who were much older than me, but I wasn't humble, and I started getting caught up in it all."

Those trips to LA found Elissa becoming obsessed with moving there. It doesn't take long to realize that once she is set on something, it happens! She told Steve that she wanted to move to LA and start her own PR company, and have him be her first client. He agreed, but she would need to work at a PR firm for at least a year to learn the business from all sides. She started working at a firm called People's Revolution in LA, and then a year later she started her own firm, Spin Shoppe, with two partners. Just as she had envisioned, Steve was their first client. "We started it from my kitchen table in West Hollywood, on Croft Street, around the corner from the Ivy. He sent us his first retainer check, and we took that check and opened a bank account. Then we started representing Fred Segal and all these restaurants around town, like Memphis, Bella, and James House. We had so many clients. When my sister Jessica graduated from college, she ran our NY office. After three years, my partners and I split, and my sister and I opened Kravetz PR."

After years of living a wild and decadent LA lifestyle, Elissa sought out a more centered and spiritual path. That included revisiting an incredibly painful time in her life, seventh grade. She wanted her experience to have a greater purpose and to serve others, so she decided to educate kids in schools everywhere about the traumatic long-term effects of bullying. She started

a nonprofit, The Farley Project, which is dedicated to teaching kids kindness. She went to schools, doing assemblies and workshops all over the country. The day after these assemblies, the counselors told her they had students *lining up* to talk to them. It opened a dialogue usually kept silent. The Project's mission statement is, "To empower youth to be fully self-expressed, aware, and compassionate individuals." Elissa elaborated: "We wanted to empower kids with a new way of behaving. We were aiming to replace jealousy with kindness, hatred with compassion, and fear with love."

> "When you are bullied or mistreated, you either take it or you stick up for yourself. I never stood up. ... What happened to me happens in every school, as well as in people's homes and in businesses—it's a universal issue."

The Farley Project not only helped heal others, it helped Elissa to heal herself and seek a deeper meaning for her life. She started studying Kabbalah and got off her anxiety medicine. "I started this whole eat, pray, love journey, traveling to Bali and India for Kundalini yoga and meditation retreats." Her work with the nonprofit felt so fulfilling that she considered doing it full-time, but something else elicited one of her *crystal ball* moments that put into motion a major transformation in her life.

"I was in India on a yoga retreat, and I ended up going to a night market. I spotted this piece of fabric in a stall and I was drawn to it. I went in and was mesmerized by the magnificent and vibrant silks. They were made into dresses and caftans from recycled saris. I started talking

"I SLOWED DOWN. I COOKED. I LIT CANDLES. I BINGE-WATCHED NETFLIX AND CURLED UP BY A FIRE. I HELD LILLEE. I DIDN'T DATE. THIS INCREDIBLE FEMININE ENERGY SURROUNDED ME. PEOPLE KEPT ASKING IF I WAS LONELY AND TRIED TO GET ME TO GO OUT. I FELT LIKE I HAD GONE OUT ENOUGH TO LAST ME A LIFETIME. I'D BEEN DRUNK ENOUGH TIMES AND BEEN TO ENOUGH PARTIES. NOW I WANT TO MAKE DINNER AND BE CREATIVE. I DIDN'T FEEL LONELY—I FELT COZY IN MY HOME."

to this girl, and the same feeling I had when I first met Steve came over me. I put my hands on her shoulders, and said, 'I don't know when, I don't know how, but I'm going to help your family. We are going to work together.' I saw the next twenty years of my life in terms of career. I thought it meant I was going to do PR for her; I didn't realize we were going to start a clothing brand together. These feelings or intuition are a flash, and I don't always get everything."

When she came home, Elissa couldn't get the family or the silks out of her head, so she flew back to India six months later. She spent the first week sorting through the family's silks and out of this created a collection of 108 dresses. Each dress is one of a kind. That's how Sun Child was born. However, transitioning from PR to designer was not seamless: "Seven years ago, I was thirty-eight, single, living in a tiny bungalow in Venice Beach with a rolling rack of dresses and maybe three thousand dollars in the bank. I was always good at making money but not saving money. I was like, wait, hang on, we're going to shut our PR firm down, and I'm going to start a clothing line with this family? Then I got evicted. My landlords didn't want to rent my house anymore.

"As I looked for a place to live, every time I meditated, I heard 'Topanga.' I found this house in Topanga Canyon that I couldn't afford and had one month of rent in the bank. I briefly suffered with, 'How is this my life?' But I didn't stay there for too long. I went to 'All right, let's go.' I had no idea what I was doing. I'm not afraid of failing. I think that a lot of people's downfall is in their ego. If you're rooted in your confidence and

reverence, then it doesn't matter if people judge you; that's on them."

Elissa nestled into her new canyon home with her beloved King Charles Spaniel, Lillee, and focused on Sun Child. "I threw myself into the brand and launching my line. It was a huge leap of faith. I had a lot of trust. I created a showroom. I invited women over to look at the collection. I would travel to Goa twice a year. I slowed down. I cooked. I lit candles. I binge-watched Netflix and curled up by a fire. I held Lillee. I didn't date. This incredible feminine energy surrounded me. People kept asking if I was lonely and tried to get me to go out. I felt like I had gone out enough to last me a lifetime. I'd been drunk enough times and been to enough parties. Now I want to make dinner and be creative. I didn't feel lonely—I felt cozy in my home. But after two years, things started to change and in 2018, Lillee got sick—it was my worst fear. I never felt I was missing anything—she was enough for me. She wasn't just the dog; she took up a lot of my heart space. My world revolved around keeping her alive."

A year after Lillee became ill, Elissa did as well. "On February 4, 2019, on a FaceTime call with my best girlfriend, I said, 'If I died tomorrow, I wouldn't die happy.' I felt like I was on a hamster wheel. I was tired, stressed, and working all the time. I knew something in my life had to change. The next day, I almost died.

"I was waiting for a client, and I doubled over in pain. I went to the bathroom and couldn't stop throwing up. My best friend came over, and he couldn't move me—I was screaming. They rushed me to the hospital,

and a CT scan revealed a 17.5-centimeter tumor on my kidney that had ruptured. I was bleeding internally. While under anesthesia, I saw all my dead relatives: both my grandfathers, my great auntie, my childhood dog, my brother-in-law's father, and my grandmother's best friend, who was calling my name and motioning me over with her finger. I screamed, 'Get away from me! I'm not coming with you!' Then I woke up." Elissa had seven blood transfusions and two surgeries before they could remove the tumor. It was during this time that Lillee passed away.

I first met Elissa in Topanga Canyon when we celebrated Christmas with mutual friends, only six months after her final surgery. I was struck by her warm, loving, and unencumbered energy, but she was clearly at a crossroads in her life. This spirited and prophetic woman's pilgrimage would start on her next trip to Goa, India, which she did a few times a year for Sun Child. This time would be very different: "I stay in the same place and walk down the same road on every visit. I decided to mix it up and spend a few days in the jungle. Two days later, the COVID quarantine lockdown hit. My ten-day nature retreat turned into four weeks. I felt like I was on an episode of *Survivor* meets *Big Brother* in the Indian jungle. I learned that if I made it through this, I could go through anything!"

Once she could get out of the jungle and stay where she usually does in Goa, Elissa had to come to a new realization: she was going to be living in India for at least the rest of the year. The rest of the year has now turned into a few years. Her life pushes her to the edge week after week, empowering her in ways she never thought possible. "It's not necessarily easy here, but my senses are stimulated in a way that they've never been before. I'll go to bed at the end of the day and think about how I don't experience life like this at home. Everything that happens in a day feels like a week's worth of experiences. This is the jungle, and right now, I am looking outside at the monsoon rain. Sometimes I see monkeys. When I make food, I take the scraps and put everything in a bowl for the cows that pass by. I am even driving here. I was always too scared to do that before! Goa is a lawless town—there are no rules, and somehow it works. I have been dancing on the edge of my comfort zone, and I have so much confidence because of it. I drive like a badass! I get in the car, dab my lavender oil everywhere, and blast some Kings of Leon! I love it. I fucking love it here!"

Elissa has tapped into a rare and endangered place of balancing passion, tranquility, creativity, and beauty. She describes what that looks like to her: "Balance is guitars and Ganesha, tequila and puppies." She's also learned a lot about the benefits of taking off her emotional armor: "We have to let it out. Feeling and releasing emotions is so important: cry, journal, dance, punch a pillow, throw rocks in the woods, anything to safely move the energy of what you're feeling. Then, shoulders back, head up high, you just keep going! You are not alone. Take deep, conscious breaths as much as possible and when all else fails, get in the car, blast some rock 'n' roll, and scream!"

HIGH-FASHION
FLOWER CHILD
CHERYL COHEN

FOUNDER & PRESIDENT
OF WASTELAND STORES

"EVEN I DON'T WAKE UP LOOKING LIKE CINDY CRAWFORD."

—CINDY CRAWFORD

Cheryl Cohen's vintage designer fashion dynasty, Wasteland, was conceived in 1985. Cheryl and husband Joe Swinney created this four-store empire with hard work and dedication, built on a foundation of love—for each other and the work. Wasteland has been celebrated in the pages of *Vogue, Nylon, Rolling Stone, In Style, W* magazine, *Vanity Fair, Glamour, Seventeen,* and the *Los Angeles Times Magazine.* Whether you leave there with a high-end designer piece or a rare vintage rock t-shirt, you can be sure it will always be one of the most treasured additions to your wardrobe. That's the magic of Wasteland, and at the center of it all is Cheryl. With the soul of a flower child and a Zen approach to life, she is the perfect example of leading with strength, compassion, and generosity to establish a family work environment filled with positive energy.

CHERYL WAS RAISED IN THE SAN FERNANDO VALLEY, OREGON, AND NORTHERN CALIFORNIA, WITH TWO OLDER SIBLINGS, SISTER PATTI AND BROTHER MIKE. HER FATHER WORKED AT TELEDYNE TECHNOLOGIES AS A NEGOTIATOR. HER MOTHER WAS IN SALES AT SAKS FIFTH AVENUE AND WAS THE STYLE AND FASHION ENTHUSIAST OF THE FAMILY. THEY WERE SUPPORTIVE AND LOVING PARENTS WHO PROVIDED A WARM AND SECURE ENVIRONMENT FOR CHERYL AND HER SIBLINGS.

Tragically, her brother lost his life in a car accident while Cheryl was in high school. "The experience of losing my brother would forever be a part of my life—it became an extension of myself, connected to me as if it was another arm on my body."

When it was time to go to college, Cheryl knew exactly where she wanted to go: UC Berkeley. She had yet to develop her fashion prowess, and instead took pleasure in a more laid-back existence. "When I went to Berkeley, I wore tie-dyed shirts and long skirts and continued to become even more bohemian. I wanted to have the full hippie experience in college. I did, and that included enjoying the Haight Street Fair, mushrooms, and a lot of live music—I did the whole thing."

After graduating from Berkeley, Cheryl started working at a clothing resale store called Buffalo Exchange. It appeared to be just another job, but that $5.50-an-hour sales position was the first step to launching her phenomenal career. "After I left the job, a coworker's friend, Joe, who had a lot of experience in the clothing resale business on the East Coast, asked if I wanted to start a store with him. I had just graduated from college and planned to move to New York for a month and pursue an acting career, so I didn't give him an answer. He was going back East to buy clothes, so we met up in Boston. That night, while we were hanging out, we came up with the name Wasteland for the store. I have always had a hard time making decisions because I can see both sides equally. I talked to my parents, and they said, 'Stop thinking about it, and the answer will come.' Three days later, it was clear as can be: I wasn't cut out to be an actress, and I didn't want to stay in NY. I came back to Berkeley and started Wasteland with Joe."

It wouldn't be long before the partnership took a different shape and tone. "Joe and I went out to lunch a lot and we would flirt a bit with each other, but nothing more than that. Joe was my ideal guy—a gorgeous bohemian boy who was so smart. He was a rhetoric and philosophy double major. He knew about music, art, and clothes. Now that he was my business partner, I tried to put any thoughts of my attraction to him out of my mind." Joe was the one who knew the inner workings of the resale clothing business. Cheryl had learned a lot at Buffalo Exchange, but now she was about to take off on a crash course in entrepreneurship.

"Joe and I started doing things together socially: we'd go to a movie or dinner. The first time we thought it felt like a date was when we went to an Italian restaurant down the street, and we saw the movie *The Unbearable Lightness of Being*, which is still one of my favorites. Actress Lena Olin was in it, who is smoking hot and gorgeous, and he said, 'You remind me of Lena Olin's character.' It wasn't my vision of myself at all, but he saw me in that light. We have been partners in every way ever since. Those early days of starting our first store were so much fun! We used to jump into his blue Chevy van and sit in those big captain's chairs and drive all over the Bay Area going to flea markets and yard sales buying clothes. He would always have my coffee waiting for me; that's when I knew I loved him. He would get McDonald's, and I would have coffee—nothing has changed!"

The very first Wasteland store on University Avenue was 1,200 square feet. They put the entire store together themselves. Cheryl even drywalled the dressing rooms. "I remember the first day we opened, Joe and I were upstairs in the office that had a big glass window overlooking the street. It was eleven o'clock, and Joe said, 'We've got to open the store.' I was up there smoking cigarettes and drinking coffee and said, 'Nobody cares if we're open. It's our first day.' We looked out the window and saw a line forming down the block." That glance out the window was a look into the future of Wasteland's success.

They opened with a modest inventory and staff: "We had one employee and sold biker jackets and rock T-shirts—Mod styles and rocker stuff. The first time I got into full entrepreneurial mode was when we bought ten biker jackets, and they sold immediately. It all started to click for me. When we first opened, we couldn't even

> "I have always been driven to help people because so many people need it. It doesn't hurt to be generous; it only makes you feel better inside. So many people have been generous to me, and I want to give that back."

53

afford petty cash. I had to borrow money from my roommate for it."

The store took off, and they were ready to open another Wasteland, a 5,000-square-foot space at 1660 Haight Street in San Francisco. "My friends all helped me open that store. We didn't have money for the opening, and I think I had this crazy confidence because my parents raised me to believe I could make anything happen. The San Francisco storefront is this beautiful and intricate old theater building; it has court jesters on each side and a lion on top with a framed egg under it. My friend Kent, an amazing artist, asked me what I wanted to put on the egg. I left it up to him, and he brought in all these picture books of fetuses." At the time, Cheryl was pregnant with their first child, daughter Kaye. "We decided to paint a fetus up there and used my daughter Kaye's ultrasound photo as the inspiration. So that's Kaye's claim to fame, and she loves telling people she is immortalized on the Haight Street store—it's very cool!

"We had this incredible window dresser who was getting the display ready for the opening, and she had built this mountain of broken glass and a goddess-like mannequin sitting on top of it. The day we were to open, the 1989 San Francisco earthquake hit." This sculpture resonated with Cheryl and is the perfect metaphor to express her feelings about dealing with adversity. "When there's a tragedy, there's broken glass everywhere. You have to be the goddess who sits on top of the mountain of broken glass."

She consistently rises above the struggles in her life with forward vision and walks through obstacles with action and integrity. She doesn't put one foot in front of the other—she jumps in wholeheartedly. These attributes are exactly what enabled them to get their next 7,500-square-foot space. "I still lived in the Bay Area, and when I would visit my parents in LA, I kept looking at this store on Melrose. I don't know why; I just wanted it so badly and couldn't imagine how we could afford it. Finally, we met with the owner, Jack Enyart, and he was so enthusiastic about us getting it that he sent over a cake with the store on it! He worked with us on the financials, but only gave us six weeks to open. Usually, you need three months. A bunch of our friends came down, and we got a tiny apartment. Then, as we were going through this rushed process of getting the store together in time, I found out that we needed a hearing to get a special variance from the city because we were a used clothing store; it would take two months. That same day I found out I was pregnant with my second daughter, Tessa. Then I found an expediter, Tom McCarty, who was able to speed up the variance process. He was one of my angels, just like Jack. I have been so fortunate to have these beautiful people who I call my angels appear in my life over the years."

"MY REVERENCE FOR FASHION DIDN'T START UNTIL AFTER WE HAD THE MELROSE STORE AND THE DESIGNER MERCHANDISE TOOK OFF. I LOVE THE CLASSIC DESIGNERS, AND ALMOST ALL OF THEM HAVE SHOPPED IN THE STORE AT ONE TIME OR ANOTHER, INCLUDING ANNA SUI, MARC JACOBS, AND JOHN PAUL GAULTIER. I FEEL EXCITED AND HONORED TO BE AMONG THOSE FASHION GIANTS IN MY OWN LITTLE WAY."

Cheryl has had to weather many storms during the learning curve of running her own business. "When people ask me about the secret of Wasteland's success, I always tell them, 'You learn more from adversity than from success.' When I am having success, it feels good, but when I made mistakes, especially early on, that's when I acquired the knowledge that benefitted me most in operating the business. For example, years ago, we went on a vacation to Seattle and fell in love with the city. We started looking at storefronts to open a Wasteland there. Of course, we found one, and it was a huge expensive space. We had also just opened an online store that had a lot of expenses. We almost went bankrupt. I was losing everything. I called my accountant, and he said, 'You have to file for bankruptcy—it's the only way out for you.' I got off the phone and thought, 'Like fuck we are!' I refinanced my house and figured a way out. That's why I am so careful now and tell people certain risks are worth taking and others are not."

After a few other mishaps, she developed a sure-fire system to which she diligently adheres. "When we first started, I didn't understand payroll tax or the scope of sales tax, and I got in trouble with those things. When you start owing people several hundred thousand dollars, you decide you better figure it out. I never wanted that to happen again. The advice I give every young person looking to start their own business is to have separate accounts for everything. I have a rent account and a sales tax account that money goes into every day. I also do that for my mortgage. That way, you don't have to worry. Mentally, I put things in different baskets: the kids basket, home basket, work basket, employee basket, financial basket.

> "Truth is the most important thing to me. I don't need thanks or appreciation; I need acknowledgment. I think that's why I acknowledge people, because that's what I need, to be valued."

When I figured out a way to keep us from filing for bankruptcy, I bought myself a used red Range Rover Discovery. I drove it home from the dealership and cranked up Dido's song, *Thank You*. What I want right now is that feeling of, 'Okay, I'm on the other side of things, and I feel blessed, I feel calm, I feel like myself.' I want that life, and I want that life for my kids."

Something else she learned on the job: a love and appreciation of fashion. "My reverence for fashion didn't start until after we had the Melrose store and the designer merchandise took off. I love the classic designers, and almost all of them have shopped in the store at one time or another, including Anna Sui, Marc

Jacobs, and John Paul Gaultier. I feel excited and honored to be among those fashion giants in my own little way."

What took Wasteland from a cool vintage resale shop to a world-renowned fashion empire? "I think it's the diversity of the people we have working for us, and their knowledge and unique sense of fashion so that customers find something they can't anywhere else. That's what happened with Gaultier. He saw something in the window he wanted while walking by the store. Anthony Kiedis from the Red Hot Chili Peppers wanted the clown costume in the window to wear on stage. At the San Francisco store, Steven Tyler and Joe Perry were walking by when we were closing and heard the employees blasting Aerosmith. They went inside and vacuumed the store! Sean Penn came into that same store during the Haight Street Fair and sat for five hours in our giant plastic hand chair. (He may or may not have been on mushrooms.) It's that kind of creative and positive energy that attracts people to the store.

"We get a lot of celebrity stylists and celebrities who sell to us, which gives us an incredible inventory. We're also one of the few places that sell designer resale on a grand scale. Our store took off when designer merchandise became popular. It sells itself. It's all one-of-a-kind items that only come across the counter once and sell quickly. My favorite is when people tell me, 'Oh my God, I got my first designer

bag at your store. I got my first pair of Prada shoes there.' I love those stories. I actually met Miuccia Prada while she was shopping at the San Francisco store looking for inspiration for her next collection. It connects me with people, and it's surreal. I love to be a part of that, even when people don't know who I am."

Cheryl treats her employees like family, and she thinks of the stores as her children. The inception of each Wasteland is considered a new life, the birth of a creation. "I always want my staff to feel that their opinions are respected and to make sure that they are paid well for their work. I never forgot how I felt in the past when I wasn't treated that way. My mom taught me, 'Kill them with kindness.' When I go into the store, people know exactly how I am going to be. I can't be around anyone who is passive-aggressive or has a hidden agenda. Truth is the most important thing to me. I don't need thanks or appreciation; I need acknowledgment. I think that's why I acknowledge people, because that's what I need, to be valued. We follow all the rules to protect our staff. People who work for you are giving you all of their time and deserve positive leadership. It's like folklore, one generation teaching the other. I have employees who have been with me ten to fifteen years, and they deserve that respect. I feel responsible for them, and I think with my heart for them. I get the greatest amount of joy from watching my employees grow over the years, get married, have children, and form friendships; it's a life-affirming atmosphere to be around."

Cheryl's inherent maternal nature made motherhood the core of her existence. "I would let go of all my worldly possessions for my kids to realize that money wasn't worth anything. I mean, obviously, we all like that we earn money and have things, but motherhood is everything because those beings are such beautiful gifts. I was so lucky to have two of the greatest kids. They're funny, smart, and so talented. Kaye's an artist, and Tessa is a musical artist. They have always been my priority. They bring me the most joy, as well as the most worry. I try not to be a helicopter mom, but honestly, I kind of am. I want them close, and that's partly because they're just the best people I know."

> "I have been so fortunate to have these beautiful people who I call my angels appear in my life over the years."

Recently, Cheryl went through a series of challenges that revealed how her ideology evolved from when she was a young business owner to the more mature and experienced one she is today. "I think when I was in my twenties, I took everything incredibly hard. Through all the adversity I've been through, I look at everything a little differently now. For instance, when the Melrose store was looted and destroyed during the George Floyd murder protests in May 2020, my daughter's friend was live-streaming it on Instagram. The younger me would have been freaking out and probably would've driven down there. Instead, I just watched it and thought, 'Wow, that's really bad.

That's really, really bad.' I think I was able to separate the people who were obviously in it for the money. They went in and stole all the designer stuff and were taking advantage of the opportunity to fill their pockets, exploiting the people who were actually protesting. If you put bad energy on someone, it just comes back at you tenfold, so I don't. I don't want their energy in my life, so I don't feed any energy to them. Sometimes I do a silent prayer for people like that. They totally bashed my store, and it was in the middle of COVID when we had been closed for four months—we were just about to reopen. So, I began taking steps to make something whole again, just like when farmers burn the field to replant the seeds so they will grow better."

Cheryl's spirit was unshakable, even when it happened again the very next day. "The day after the Melrose store was looted, it happened to our store in Santa Monica in broad daylight. We had to close that store down because our lease was up in May, and the amount of damage was too great. We lost about $850,000 in inventory from both stores." These events only made her generosity grow brighter. "We have seventy-three employees and were able to hire everyone back. I have always been driven to help people because so many people need it. It doesn't hurt to be generous; it only makes you

feel better inside. So many people have been generous to me, and I want to give that back."

Cheryl can see the hidden gems in every moment. When she recounts her first job as a dishwasher in a local restaurant, it's the big, delicious muffins she remembers; when she lived in a little house with five roommates in Berkeley, she thinks back to the blooming rose bushes that lined the walkway. Her discerning eye for beauty found a career in fashion, but what will forever bring her happiness is finding life's precious details that are oftentimes missed. She says she doesn't understand how the angels in her life have found her. The answer is perfectly clear: Angels always recognize other angels.

WOMAN OF THE WORLD
STEFANIE MICHAELS

TRAVEL JOURNALIST | LIFESTYLE EXPERT

"TAKE A HORIZONTAL LINE AND PUT A VERTICAL ONE OVER IT, AND YOU GET A POSITIVE."

—D.P. (STEFANIE'S DAD)

From the time she was three, Stefanie Michaels didn't walk…she danced. She had one goal in mind: to travel the world with the ballet. At fifteen, her dreams were shattered at the hands of a tyrannical dance instructor who would change the course of her life.

AFTER TWELVE YEARS OF TRAINING FOR A CAREER IN THE BALLET, STEFANIE WAS ABOUT TO REALIZE HER DREAM BY GETTING A SCHOLARSHIP TO STUDY AT THE SCHOOL OF AMERICAN BALLET, A NYC BALLET COMPANY. BEFORE SHE EVEN HAD A CHANCE TO PACK A BAG, A VISITING BALLET TEACHER WHO WAS INSTRUCTING CLASSES AT STEFANIE'S STUDIO HERE IN LA CHANGED HER FUTURE WITH ONE DESTRUCTIVE ACTION.

"An overzealous Russian teacher who didn't speak English was teaching our class that day. The Russian ballerinas at the time were unbelievable. The American students weren't taught the same techniques they were, and the teachers expected us to be lazy. My extended leg, which was up over my ear, wasn't back far enough in her opinion. She violently forced my leg backward, tearing the muscle off my hip and breaking off a piece of my hip bone with it—that was the end of my dance career."

After this earth-shattering blow, she had to take time to heal—not just her body, but her mind. In an instant, her dreams came crashing down; now she had to build a different vision for her future. She moved forward optimistically and chose journalism school at UCLA. She decided to integrate that with her love of travel. Stefanie has always had a nomadic hunger to explore everywhere and everything—at least once! This was something that apparently started early on in her life: "My parents told me they knew traveling was in my DNA since I was a baby. I loved to fly, and every year I would count down the days until our next vacation with a special calendar. There isn't anything casual about my love of travel…it's a passion." She became "Adventure Girl," and the brand took off, landing her everywhere from television and radio shows to magazine features. Her insatiable love of technology led her to discover Twitter at its earliest stage and become one of the first people to reach one million followers!

Stefanie was the kind of girl who preferred staying in and playing video games with fellow tech nerds to going to the prom. That made her part of the perfect demographic for embracing the new frontier of what was then called the World Wide Web. She was off and running with a career solely created by utilizing three of her favorite things: travel, technology, and people. Her inner tech nerd would prove to be the best

marketing and PR agent she could ever have: "I was really deep into the very early days of the web. This was before Network Solutions and AOL Online. In 1994, I ended up launching my first website, travelpartners.com, which was technically one of the first fifteen hundred commercial websites online. It was a site where people could access information about traveling, recommendations, and advice. I incorporated my writing into what I was doing online, and that's when people started calling me Adventure Girl, and my brand was born."

She had successfully put herself right in the middle of the dot-com explosion and was one of the few women seated at an extremely male-dominated table. "I switched my site from travelpartners.com to adventuregirl.com and started incorporating the Adventure Girl moniker into my writings. I had online companies looking at me, like Sony Interactive and eToys. I had met with the eToys founder, who was around twenty-one at the time, at one of those extravagant tech parties. He wanted to make an e-Adventure Girl site. I had that contract on the table, as well as Sony's, and Yahoo!'s. I had started doing an Adventure Girl cartoon character that followed my real-life

"My parents told me they knew traveling was in my DNA since I was a baby. I loved to fly, and every year I would count down the days until our next vacation with a special calendar. There isn't anything casual about my love of travel…it's a passion."

adventures, and Yahoo! wanted to use it to help navigate people through their website; at the time, the web was so new that most people didn't know how to do anything."

Out of the three, she decided to focus on Sony Interactive's very lucrative offer. One of Stefanie's many strengths in business is her intuition: it has never let her down. "I took the Sony contract to my attorney. A couple of days later, my gut instinct was screaming, 'Do not sign this contract!' I didn't, and within a few days, the dot-com collapse happened. If I had signed with any of those three companies, I would have lost my Adventure Girl brand, because it would have been taken down with them. I firmly believe that if you listen to the messages the universe is sending you, you'll always be protected."

After that, people were afraid to do anything online and were running from the internet. Her entire business was built around her site and was sustained by sponsors, sponsor partnerships, and brand deals. This meant it was time for another career redirection. "I still knew the internet was the future, so I wasn't

"WOMEN WHO ARE WHIP-SMART, KIND, ALWAYS LEARNING, AND CONSTANTLY CHALLENGING THEMSELVES ARE THE ONES I LOOK UP TO. I'M SERIOUSLY A SUCKER FOR WOMEN IN TECHNOLOGY— TO HAVE THAT BRAIN IS AMAZING, AND SECRETLY I WANT TO BE ABLE TO CODE..."

going to give it up, but I had to get to work. I went back to freelancing for magazines and newspapers, keeping the Adventure Girl moniker going. Then, finally, I discovered this thing called Twitter. I learned about it from a friend who attended the SXSW Conference and had heard about it there. It was the perfect outlet for what I do. I immediately reached out to one of the founders, Biz Stone, and said, 'I noticed that my Adventure Girl moniker is on hold with you guys, so can you help me get it?' He said, 'Sure!' and I got to know all the founders through online interactions after that. They liked my brand and put it on top of their suggested user list. Then, when the CNN and Ashton Kutcher challenge happened, where they were competing to see who could get one million followers first, I was right behind them as one of the next people to reach one million. A lot of notoriety came with that for me. I have always been on the forefront of technology. I still am because I love it so much."

Twitter took her business to another level and opened her up to a much wider audience. Concurrently, *Vanity Fair* magazine did a feature on Stefanie, giving her the title "America's Tweetheart," which was a great publicity boost for her. She started writing and doing features for *E! Entertainment Online* and *E! Magazine*. *Access Hollywood* also made her

their on-air travel expert. She has continued to be on top of every new technological vehicle available for communication—always evolving.

She has been sent all over the world to write about resorts, hotels, spas, and restaurants, as well as new products and current events. Stefanie shared some of her favorite moments during the span of this exhilarating career: "Flying in zero gravity with Buzz Aldrin was the biggest highlight to date. Here I was tossing water balloons and M&M's as they floated around in 'space' to my favorite astronaut of all time. Pure magic!"

"I guess when you look death in the face, you choose life. Then you live it like it's your last days."

Which locations touched the woman who has been everywhere the most? "One of my favorite experiences was going to the Blackwater Region in Papua New Guinea. I got to meet the various tribes and learned about a fascinating and unique culture. Spending time there was extremely eye-opening and educational."

Though she enjoys a beautiful beachy island resort like anyone else, the type of island that really piqued her interest was one that was out of the ordinary. "I think my favorite place to go is Iceland. I've been there about six times now, and each time I discover something new. After all, this is a living and breathing island—the land

of fire and ice. It's stunning and raw, like nothing else I have ever seen. It is constantly moving; they average about 1,500 small tremors a day. The food is fresh and delicious, and the people are a lot of fun. I love the fact that some of the people there believe in the mystical: fairies and hidden people. If you love adventure, this is the place. You can even trek a mile into an underground snow cavity. I will never get tired of visiting this magical place."

She also had some special memories in Africa: "Traveling to South Africa may take a long time, even as much as two days, but the places I've gone to are gorgeous. Johannesburg and Cape Town are bustling cities, and from there it's easy to get to the bush, where safaris take place at many beautiful five-star camps. I loved the fact that the monkeys jump up and down on your roof to wake you up in the morning, so they can follow you to breakfast and steal from your plate—rascals! I loved Botswana and Namibia, where I floated on the Chobe River for a few days, watching hippos frolic in the water and hordes of elephant families emerging from the brush to bathe and drink at the river's edge. Victoria Falls in Zimbabwe was breathtaking, and staying in the tea fields of Rwanda serenaded my senses with the sweet and earthy smells of the local plants that fill the air."

"I firmly believe that if you listen to the messages the universe is sending you, you'll always be protected."

Stefanie slowed down from globetrotting long enough to find love. "Marrying Phil was the best decision I ever made. I was so afraid of getting married and took it slowly with him. He finally had to give me an ultimatum! We've had our hard times, as all couples do, and been through some very serious life-altering experiences, but we have always been there for each other. He continues to be my best friend and is such a beautiful human being." The two just celebrated their twentieth anniversary by renewing their vows in a Bermuda cave. They were surrounded by family and friends with stalactites descending around them like hundreds of icicles sparkling in the light.

Five years ago, her battle with breast cancer and a car accident almost took her life. Phil was by her side through this terrifying roller-coaster ride with her health. It all started while she was in Nashville scouting locations for a conference. "While Phil and I were looking at event spaces, I felt this fluttering on the right side of my breast. The fluttering turned out to be tumor tentacles pushing through my tissue and heading up toward my lymph nodes. I was actually able to feel it. The doctors said it was such an aggressive cancer that, had I not come in when I did, I would have been dead in a few months. Luckily, we caught it. I had a double mastectomy and, at the same time, had my

reconstructive surgery and implants put in. Little did I know that this ordeal was far from over."

Her next assignment was in Arkansas, interviewing one of the Little Rock Nine women: the first Black students ever to attend classes at Little Rock Central High School. Once she was cleared by her doctors to travel, she was off! Phil joined her, since it was her first trip after the surgery. Not more than five minutes after they left the airport in a tiny Kia rental car, a truck going fifty miles an hour blasted through an intersection and slammed into them. "We spun out, and our luggage flew everywhere on the street; the rental car was crushed; the seat belt did do its job but broke my implant in the process. I didn't realize this happened at the time, since I had what is called a "gummy bear" implant, which is what they put in breast cancer patients in case something like this happens, so it will stay in place. Unfortunately, the impact was so strong that it cracked."

She had the implant replaced, and two weeks later booked a press trip to the Florida Keys. She was cleared to fly, but noticed the draining tube hole from the surgery was still slightly open. "The doctor told me it was fine, but I needed to keep the hole covered, not to touch it, and keep it clean. The entire trip, I kept getting chills, but I thought I was getting a cold. By the time I got home, I was exhausted and slept for two days—I thought it was jet lag. Then, the breast I had surgery on got huge. After I sent a photo to my doctor, they rushed me to the hospital for emergency surgery. I had a staph infection in

the tissue around the implant, around my heart, and in my bloodstream. They had to put a line of medication directly to my heart because if they didn't stop it from spreading any further, I would die. From what they told me, if I hadn't gone in when I did, that's exactly what would have happened. I have angels surrounding me that wouldn't let me die—cancer, car accident, near-fatal staph infection, it must be angels."

Through it all, she has never veered from an enduring positive attitude. "I guess when you look death in the face, you choose life. Then you live it like it's your last days." She has tremendous gratitude for the angels who have looked over her, and in return works tirelessly to be an angel for others through philanthropic causes. This woman never stops living, loving, and giving with every ounce of her heart. Helping those in need is always on the forefront of Stefanie's mind. She picks a special cause every year to personally champion. One year it was to bring a girl who was going blind and deaf to Iceland, which was the one place she wanted to see before she lost her sight. Another year it was to organize a fundraiser to save the life of a woman who couldn't afford dialysis and would die without it. Stefanie is also a devoted animal advocate, with a revolving door of dog and cat rescues. After Hurricane Harvey hit Houston, she flew there to work with the Red Cross and Best Friends Animal Rescue getting food to the stray dogs and cats displaced by the disaster. Then she got Hertz to donate a big truck and took food to various shelters in cities outside of Houston that were

cut off from resources. By herself, this determined woman was driving a truck and making her way through the massive destruction of the hurricane to bring food to animal shelters. That's Stefanie Michaels—she never sees the rocks in the road, only ways to get around them.

The women she is inspired by have one thing in common: brilliance. "Women who are whip-smart, kind, always learning, and constantly challenging themselves are the ones I look up to. I'm seriously a sucker for women in technology—to have that brain is amazing, and secretly I want to be able to code; people like Susan Kare, who brought the Apple computer to life; actress Hedy Lamarr, not for her acting but because she invented spread technology and even remote-control technology for Navy torpedoes; Ada Lovelace, from the early 1800s, who was well before her time, developing an algorithm before computers even existed."

Stefanie is exactly like the women she admires—continually expanding her skill set. "During the COVID quarantine, with all travel being suspended, I finally had the opportunity to learn how to trade stocks, something I've always wanted to do. I love it! It challenges my brain and keeps me learning new things every day."

Even with all the places she has been, one will always remain at the top of her list—snuggling on the couch with her animals. One of my favorite pictures of Stefanie was taken by Phil while she was sleeping in her king-sized bed with four dogs and two cats surrounding her. She had but an inch of space to move around! "People think I live this wild Hollywood lifestyle, but in reality, I prefer home hands down. Otherwise, I am adventuring somewhere—absolutely anywhere!" In the end, Stefanie did end up dancing around the world and into the hearts of people everywhere.

FEARLESS PERFORMER BIANCA SAPETTO

AERIAL ARTIST | DANCER | CHOREOGRAPHER | DIRECTOR | TEACHER

(MOTHER, MAIDEN, CRONE)

"I HAVE HOPE IN PEOPLE, IN INDIVIDUALS. BECAUSE YOU DON'T KNOW WHAT'S GOING TO RISE FROM THE RUINS."

—JOAN BAEZ

Since she was a small child, Bianca Sapetto was obsessed with flying, jumping off everything she could, including the roofs of small buildings. Fearing she wouldn't make it to her sixth birthday, her parents enrolled her in competitive gymnastics, hoping it would be the outlet she needed. At age eight, she won the first of several national championships in rhythmic gymnastics, and in 1992, traveled to Barcelona as an alternate on the US Olympic Team. After high school, she left gymnastics and embarked on an academic life at Amherst College, studying comparative religion.

WHAT DO MOST YOUNG WOMEN DO AFTER THEIR FIRST YEAR AT A PRESTIGIOUS COLLEGE? THEY JOIN THE CIRCUS! AT LEAST THOSE WHO WERE BORN TO FLY DO. AT CIRQUE DU SOLEIL, SHE FOUND HER PEOPLE, THE LOVE OF HER LIFE, AND ARTISTIC FREEDOM.

Bianca was able to combine all aspects of her previous training and dance into a world of exciting new skills and techniques, making her the highly evolved artist she is today. You don't achieve powerful performances at this level without a strong sense of self and an acute awareness of your emotional depth. She has done the work, conquered her demons, and now shares her beauty and raw truth through her art.

She was raised in LA and lived in San Pedro for most of her childhood. "My parents didn't have a lot of money back then, but I never felt poor. I grew up in a large Latino family with three brothers. We are Argentines, Cubans, Chileans, and Mexicans, and our lively, passionate gatherings were all spoken in Spanish. Family was a huge part of my upbringing.

"Because of the gang violence in our neighborhood, my parents made a lot of sacrifices for us to go to a private Catholic school. San Pedro High School had metal detectors because so many kids were bringing guns to school. Even with so much discord where I grew up, we still played in the streets. All of this had a significant impact on how I see the world today."

Bianca's parents enrolled her in gymnastics at such an early age solely to keep her out of harm's way; not from the dangers of where they lived, but because of her obsession with flying. "My earliest memories were of jumping off lifeguard stations at the beach. I believed if I did it just right, I would fly. Even as a child, I felt the Universe was multidimensional, and we could pull different physics from those dimensions into this world. During my performances, I guide the audience to suspend their disbelief by creating an environment they can pull into their world. It's a spell. I think this early conviction had a big influence on why I became an artist."

Competing had Bianca traveling all through her childhood, which meant missing a lot of school. In high school, she did an independent educational program. "I started getting serious about gymnastics when I was five, training three hours a day, five days a week. By the time I was seven, I had moved from artistic gymnastics to rhythmic gymnastics. Once I got into a more elite space, I did home school and trained eight to ten hours a day."

She described the arena of competitive gymnastics through the eyes of a young girl abounding with

creativity. "The sport was different back then, with more opportunity for self-expression. Your choice of music and the drama of how you danced and performed your routines were all-powerful forms of creativity for me. That was juxtaposed against a hard, cold athletic sport, often run by a bunch of mean, misogynist people. Looking back at the way the sport treated little girls makes me so sad. I've watched it happen over and over in many different generations. It's not anything I would ever want for my own children." What kept her so devoted to the sport, no matter how harmful it became? "For me, it started with pure passion and the love of movement. I was mesmerized by picking up this ribbon and watching it form all this energy around me. I wanted to work really hard to be the best I could be because I felt that mastering the technique was the ticket to my freedom of self-expression. There is a price and a lot of sacrifices for mastering a highly disciplined practice like that."

The effects of mental and emotional abuse on her impressionable, innocent psyche would follow Bianca well into adulthood. "I had an earlier coach who taught me with a lot of beauty and focus on self-expression. Unfortunately, she also weighed us numerous times a day. We each had a measuring tape with our name on it. She made us all stand in front of the mirror and measure our bodies, then lined us up from the thinnest to the largest. We had to admire the thinnest girl and the beautiful lines of her body; it was horrendous, but a regular part of my training with that coach.

"My parents were very conflicted once they realized these atrocities were happening. They wanted to pull me out, but the sport meant so much to me. I won my first national championship when I was eight and traveled all over the country representing the United States Gymnastics Federation. I started traveling internationally when I was eleven and going to Bulgaria in the summers." Her parents could see how impassioned she was with the sport, so instead of pulling her out, they found a new coach. "Lydia Bree changed my whole experience. She was fair but tough, highly disciplined, and she didn't buy into the thin mentality. She recruited Mariela Spassova, a Bulgarian world champion, to our team. Once they joined forces as coaches, I went from fifth in the nation to first. Those two women did so much to heal my relationship with myself and the sport."

> **"For me, it started with pure passion and the love of movement. I was mesmerized by picking up this ribbon and watching it form all this energy around me. I wanted to work really hard to be the best I could be because I felt that mastering the technique was the ticket to my freedom of self-expression."**

Even though Bianca's new coaches didn't subscribe to her previous one's toxic methods, the pressure and negative messaging from the sport itself remained. "I can personally testify to how positive reinforcement changed me for the better as a gymnast and motivated me to want to work harder. That being said, I remember going to Bulgaria and, no matter how much positive reinforcement my coaches gave me, I was still within the system of the United States Gymnastics Federation and the International Women's Gymnastics Federation, where the pressure to be anorexic thin was so intense that I couldn't help but fall into it. While training in Bulgaria one summer, some of the other gymnasts taught me how to throw up my food. Between that and anorexia, I developed a severe eating disorder. There was no way for my body to be that thin without starving myself."

In the dysfunctional quest for the perfect athletic physique, Bianca also had to contend with puberty's inevitable progression: "I had my first period at eleven. I didn't get another one until I was nineteen because of the intense training and the eating disorder. I rationalized it as a sacrifice I had to make for the sake of my sport. In reality, it became an addiction that took control of my life for a long time. After I left the sport, it took two hospitalizations and a lot of work over many years to recreate my relationship with food. I sought many different types of therapy in order to heal."

Bianca was moving forward with a clean slate for her future and, for the first time, outside the realm of the performing arts. She moved to Massachusetts to attend Amherst College, one of the most prestigious and selective liberal arts colleges in the United States. Her love of religious studies attracted her to a major in comparative religion, which would open her eyes to many new ideas. "One of my first courses was Luther and the Reformation. I finally learned from the other side about the evils of the Catholic Church, from the Middle Ages to the present day. It sealed the deal for me in terms of not becoming a nun, something I had considered when I was younger. I got into Eastern religions, specifically Buddhism. I took a wonderful course with Professor Janet Gyatso, who is now associate Dean at Harvard Divinity School. Her Women in Buddhism class was one of my favorites. I'm doing an art piece right now based on the enlightenment of Ye-Shes Mtsho-Rgyal (Yeshe Tsogyal, a key figure of Tibetan Buddhism). Like every other religion, Buddhism doesn't have a lot of strong female figures, but she is one of them. The study of these powerful spiritual women has had an enormous impact on me."

Reveling in a sea of information and different perspectives, Bianca opened herself up to exploring new ideas and becoming enlightened by whatever spoke to her heart. This time was instrumental in developing her core belief system. Little did she know, a summer job would change her world in unimaginable ways. "Between my freshman and sophomore year, I performed at SeaWorld shows choreographed by the head of the UCLA gymnastic team, Valorie Kondos. After I had resumed my sophomore year at Amherst, I found a message on my answering machine from the casting director of Cirque du Soleil asking if I could come to Montreal

"MY EARLIEST MEMORIES WERE OF JUMPING OFF LIFEGUARD STATIONS AT THE BEACH. I BELIEVED IF I DID IT JUST RIGHT, I WOULD FLY. EVEN AS A CHILD, I FELT THE UNIVERSE WAS MULTIDIMENSIONAL, AND WE COULD PULL DIFFERENT PHYSICS FROM THOSE DIMENSIONS INTO THIS WORLD. DURING MY PERFORMANCES, I GUIDE THE AUDIENCE TO SUSPEND THEIR DISBELIEF BY CREATING AN ENVIRONMENT THEY CAN PULL INTO THEIR WORLD. IT'S A SPELL. I THINK THIS EARLY CONVICTION HAD A BIG INFLUENCE ON WHY I BECAME AN ARTIST."

and see if I was a good fit for a show. As it turned out, Valorie had recommended me. That was a huge tectonic shift in my thinking because performing was not on my radar at that time. I never considered being able to use the skills I had refined as a rhythmic gymnast for a career."

Cirque du Soleil clarified her path and awakened a world of possibilities. "When I returned from Montreal, I packed my stuff and never looked back. Interestingly enough, my years with the circus became my college education for what would later become my career. Back in those days, Cirque du Soleil really paid attention to the individual performer and the crafting of the artists. We were taught many different disciplines and art forms, as well as singing, percussion, French, and multiple apparatus. We learned clown or what they called *jeux*, which means games in French. I was learning it all from these masters *and* getting paid to do it!"

Under the tutelage of the circus, Bianca was able to spread her wings, breaking out of a cocoon of limitations, rules, and regulations. "I was so ripe to burst out of my box as an athlete and into the freedom of a performing artist. I got to understand the body, theater, and dance in their purest forms. It wasn't reduced to a series of movements to get a score, which never really spoke to me. If there had been a way for me as a child to do rhythmic gymnastics and not compete, I would have jumped on that in a heartbeat. Now, here I was doing just that!

"My work has been my journey, and as an artist it has been about unraveling that. In particular, competitive gymnastics is still horrific for girls. I've been mentoring a couple of rhythmic gymnasts over the years with their transition from athlete to artist. It's been a huge gift for me to do for them what my dear friend, Michelle Berube, did for me. She mentored me through the beginnings of that transition, and I'll forever be grateful to her. Mentoring is a way of keeping that healthy cycle alive. It has exposed me to many different gymnasts who have battled eating disorders, sexual abuse, and emotional trauma inflicted by their coaches or others in the federation; we all endured at least one, if not all three, while in the sport. That's why it is so important to tell our stories, because it's the only way to start breaking the cycle and effect change."

Bianca discovered artistic liberation, education, and the camaraderie of like-minded people at Cirque du Soleil, but she also found love. She met her husband, musician Robin Finck, when he took a detour from his band, Nine Inch Nails, to join the circus orchestra. The two had an instant otherworldly connection when they first laid eyes on each other, but bonded as friends before moving on to the next phase of their relationship. "Robin and I spent all our free time together. We were only friends, neither of us thinking in terms of romance. Apparently, we were pretty dense. It took a while to figure out what was happening between us, but finally we did!"

After Robin accepted Axl Rose's offer to play guitar in his newly formed version of Guns N' Roses, he moved to LA. Bianca stayed on the circus tour, and

she and Robin continued a long-distance relationship. Bianca's heart would be the guide for her next life decision. "When it became time to move on to Europe and renew my contract with Cirque du Soleil, the decision was clear: it was time to go back to LA and be with Robin. I was choosing love over career. I realized that I needed a break from performing. After a thousand and one shows, my body had suffered a lot of injuries. Doing ten shows a week as an aerial acrobat is brutal because I was on stage the majority of every two-hour show, pushing it hard. I wanted my body to heal."

When she left the circus, a dear friend, Isabelle Chasse, gave Bianca her aerial fabric as a parting gift. Bianca started to connect with this apparatus in ways she had never done before. "I had a huge oak tree in my front yard that I would climb up to rig my aerial fabric. I discovered a career niche in this art form, and my friend, Christine Van Loo, and I were getting hired for most of the jobs in this genre. It was the beginning of the circus infiltration into performing arts. The two of us were flown all over the world to perform. I started to get interested in the creation of new apparatus and got hired more and more to create for shows, companies, and productions. I got to work with a lot of incredible people during this time, doing everything from the American Music Awards and the Grammys to blockbuster films, nightclub shows, and low-budget theater. Deborah Lynn Brown, the choreographer of Cirque du Soleil, brought me in as an artist in her experimental dance company, Apogee. I broke a lot of the molds and ideas I had of myself, art, and performance with that company. It was another exciting time in my career."

"I have such respect for the wise ones, the elders, the power of that aspect of our lives. I embrace the crone, but the wise woman is treated much differently than the wise man. We see this hypocrisy imposed upon the non-white, non-binary community as well. We still tell white, straight, cis men as they age that they are vital and relevant, but we don't with others. Instead, we tend to be treated as if we disappear. The fortunate thing is, as you get further into your wise one, you step into a consciousness that recognizes the grand scheme of life's gifts and you gain access to a power that transcends the trivialities."

After Robin and I were married, I kept freelancing all over the world, and Robin went back to playing with Nine Inch Nails, so we returned to a long-distance lifestyle. I eventually got a job in San Francisco at

Teatro ZinZanni, which I did on and off for almost a decade. I started as a performer and then moved to choreographer and associate director for the shows. I collaborated with incredible musicians, opera singers, magicians, acrobats, dancers, comedians, and clowns. These experiences opened me up, not only as an artist but as a human being. I feel it's important to redefine myself, not be stagnant, and never put myself into a box. This is what has given me longevity as an artist."

The next chapter in Bianca's life was motherhood. "Having a child was a huge risk because I knew it would change my body, which is my instrument. It dramatically shifted my perspective on life, my understanding of myself, my place in the world, and my value to myself, others, and society. Parenthood is a love that cracks open your heart unlike anything else. It forever changed my career, my body, and my priorities, and it was all worth it in the most beautiful way.

"During my daughter's first nine months, I was on tour. Robin was able to come with me, and we raised her together through circus, theater, and opera productions. It was fantastic, but at the same time, I realized it wasn't sustainable. By the time I was ready to have our second child, my idea of what motherhood looked like had changed. This time, I wanted to take the time and focus on being a mother."

Bianca's desire to become pregnant again was met with heartache after a series of miscarriages. "My body was struggling, and I was having a hard time holding onto the babies. Miscarriages are so emotionally difficult—it's horrible. On multiple occasions, I felt like my body was a graveyard. I couldn't understand how it could give life and then take it away. For terrible reasons, this subject is laced with shame. We feel like somehow it's our fault, which of course it's not.

"We were about to go the route of a Western fertility specialist when a friend referred me to a fertility doctor of Chinese medicine, Dr. Pei Li Zhong-Fong. I'm so grateful for finding her, and once I started seeing her, my pregnancy stuck. Her advice to me was invaluable: 'If you want to hold onto your pregnancy, be lazy and stupid.' It sounds funny, but it made perfect sense. I was putting too much energy into other areas of my life and pulling the blood and energy away from the center of the womb, which is where creation is happening. To carry a pregnancy full term, I had to change my mentality, and that was one of my second daughter's greatest gifts to me: slowing down!"

Since our discussions centered around women and women's issues, we talked about the archetypes Maiden, Mother, and Crone—the triple Goddess that symbolizes the cyclical stages in the feminine archetype. We addressed her maiden period, and motherhood, and then we looked toward the future, where the crone (the wise one) awaits. Bianca has the most refreshing and positive outlook on this time of life, which usually elicits feelings of dread.

"You know, I'm starting to get glimpses of the Crone now, and I see her in my family and friends, people

I have day-to-day contact with, and people who have been strong influences on me. The closer I get to embodying her, the more empowered I feel. The things that felt important to you in the past start to wash away, especially regarding youth. So much of that is overrated, illusory even, and since we live in a culture that worships youth, there's a lot of rewiring to do if you want to think differently. There are things you have to dissolve in our culture and in the profession of the performing arts.

"I have such respect for the wise ones, the elders, the power of that aspect of our lives. I embrace the crone, but the wise woman is treated much differently than the wise man. We see this hypocrisy imposed upon the non-white, non-binary community as well. We still tell white, straight, cis men as they age that they are vital and relevant, but we don't with others. Instead, we tend to be treated as if we disappear. The fortunate thing is, as you get further into your wise one, you step into a consciousness that recognizes the grand scheme of life's gifts and you gain access to a power that transcends the trivialities. My current work as artist, teacher, and magical practitioner carries a lot of the same themes it always has—character, narrative, archetype, dynamic aesthetics, myth, magic, and often social justice—but I am more interested than ever in challenging the forms it takes and what an audience, or student, may derive from it. Rising out of the framework of societally imposed definitions of gender, age, spiritual practice, social issues, etc., consequently pushes out the edges of my artistic magical practices."

The philosophies that guide Bianca in her life are beautifully expressed in her own words: "On this tiny planet in an infinite universe, I cannot think of a better way to live than to be happy, and I have found there is nothing that makes me happier than to live in harmony and generosity with my planet and my fellow sentient beings. I wholeheartedly welcome the marriage of art and service in my life. Sometimes service is a message best portrayed and received through the visceral properties of the performing arts."

Bianca shows us a different reality through her craft—one created with art, beauty, inspiration, and enchantment. She did indeed learn to fly, and shares that gift with her audience by taking them on their own flight—a flight of imagination, magic, and the realization that all things are within the realm of possibility.

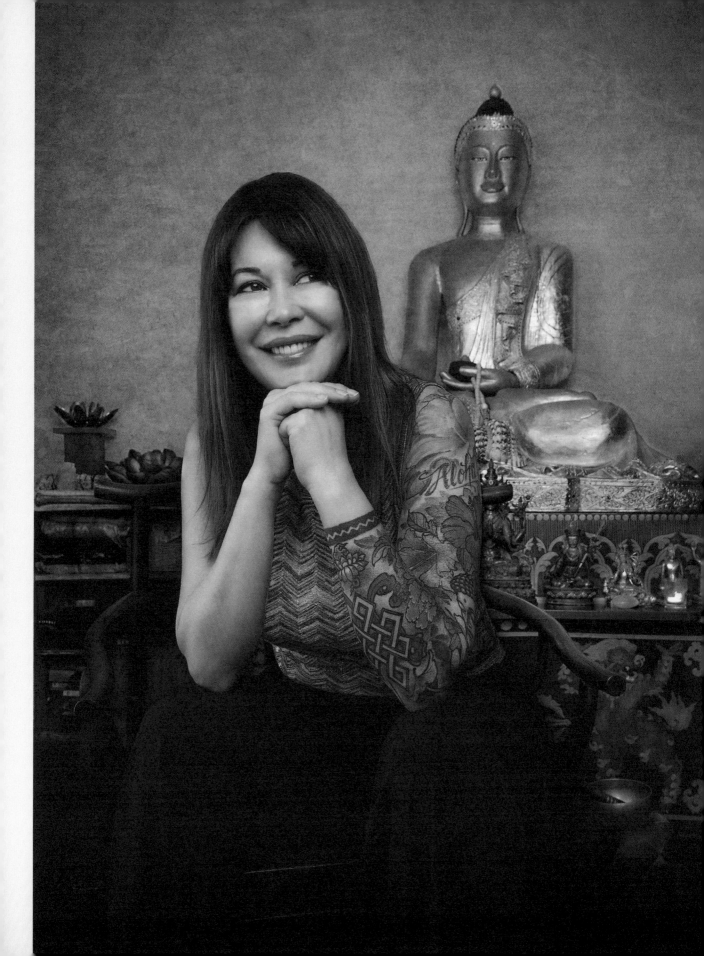

ZEN TECH VISIONARY
NANEA REEVES

CEO TRIPP | VIDEO GAME TECHNOLOGY EXECUTIVE

FOCUSED ON BRINGING AR/VR MEDITATION EXPERIENCES TO THE METAVERSE

"PLAY THE GAME. NEVER LET THE GAME PLAY YOU."

—TUPAC SHAKUR

Nanea Reeves started leadership training early in life. As a child, her innate thirst for knowledge and problem-solving provided the survival skills she needed to make it through a childhood imperiled by neglect, addiction, and insecurity. Later, these qualities proved to serve this future CEO in personal and professional success. "I started talking openly about my background once I could see that my experiences as a young person were much of the foundation for what I consider my strongest attributes. I was able to reframe my journey through an empowering lens, as opposed to looking at myself as damaged. For years, I did operate from a wounded place, but when I looked at being the daughter of a drug addict and how that gross negligence benefitted

me in some ways changed everything. I didn't get any hard-core programming on how I should behave or who I should be. In many ways, neglect allowed me to organically develop my curious mindset. Some of it was out of a real need to figure out how to do things like feed a baby when you are only six-and-a-half years old."

THAT BABY WAS HER HALF-SISTER, LAURA. WITH A MOTHER CONSUMED BY A HEROIN ADDICTION, AN ABSENTEE FATHER, AND ALREADY HAVING TO CARE FOR HER YOUNGER SISTER VICKI, NANEA COURAGEOUSLY TOOK ON THE ROLE OF CARETAKER FOR BOTH GIRLS. SHE FELT TOTALLY ALONE, BUT THERE WAS ONE PLACE SHE COULD ALWAYS FIND SANCTUARY: THE LIBRARY. SHE COULD LOSE HERSELF IN AN ABUNDANCE OF INFORMATION; EVERY FACT WAS LIKE CANDY TO THIS HYPERINTELLIGENT YOUNG MIND.

"I would spend hours and hours at the library, reading and figuring things out on my own. When the internet first appeared, way before the World Wide Web, I was drawn to it by my natural desire to be self-taught and access information. I put a lot of weight into being self-reliant. I didn't want to depend on anyone, and I wanted to do everything my way. That got me into trouble later, both personally and professionally. Wanting to do everything on my own kept me from appearing to have trust in others, where I am perceived as going rogue. I've recently been working with multiple coaches to open myself up to being more receptive to the diversity and inclusion of different points of view in the workplace and in all relationships in my life. Having a posture of accepting other people's feedback and input is a huge area of growth for me."

Alternatively, as a child, she had no choice but to listen to other people's ideas and decisions for her care when her extended family intervened. There was no consistency or security for Nanea while going from house to house, state to state, and country to country. "With our mother unable to care for us, we were bounced around all over the place. Vicki and I lived with my aunt in Toronto, who traveled back and forth to her apartment in New York, on and off for many years. Then sometimes we would live with my grandmother in Hawaii. My half-sister, Laura, lived with our maternal grandmother and her

husband. By the time I was eleven, my mother had moved to LA, so periodically, we would go there as well. My grandparents were wealthy and would give my mom an allowance. She would get more money when she had my sister Vicki and me, so we were like bargaining chips for her. She would get straight long enough to get us back, and then the destructive cycle would start all over again."

Feeling like she didn't belong went beyond Nanea's vagabond lifestyle: "There was a lot of pain inherent to being multiracial for me. I felt stuck between two worlds. I wasn't Hawaiian enough for my Hawaiian family, and I was too Hawaiian for my mom's WASP-y Grosse Pointe family. They refused to call me Nanea because they thought it sounded too ethnic; they called me 'Nan' instead. I'm only now realizing how, early on, that created a feeling of not being quite right for either faction from which I'm composed. That made me feel isolated and very much the *other* in any environment. That can define you as an outsider when your self-esteem is not fully

formed yet. Then add the secret of a drug addict mother who you couldn't talk to your friends about, unless, of course, they had a similar background. It becomes a cycle of seeking out people who have that in common with you, which creates this tribe of damaged children trying to make their way in the world. That doesn't always result in the best choices because we're not coming from the healthiest foundations."

Nanea came closest to feeling parental affection when she lived with her aunt Patric. "My aunt was very young and bohemian, and she raised my sister and me along with her own two kids. Outwardly my aunt wasn't the warmest person; she was very British in her demeanor and experienced a rough childhood of her own. She was orphaned very young when her mother died from tuberculosis. Abandoned by her father, she pretty much raised herself. She made sure that we had the best of everything, such as riding lessons, studies in Chinese painting, and an excellent

> "There was a lot of pain inherent to being multiracial for me. I felt stuck between two worlds. I wasn't Hawaiian enough for my Hawaiian family, and I was too Hawaiian for my mom's WASP-y Grosse Pointe family. They refused to call me Nanea because they thought it sounded too ethnic; they called me 'Nan' instead. I'm only now realizing how, early on, that created a feeling of not being quite right for either faction from which I'm composed. That made me feel isolated and very much the *other* in any environment."

"I HAD TAKEN THE CANVAS OF MY LIFE AND PAINTED A DARK, PAINFUL PICTURE, AND THEN A MIRACLE HAPPENED FOR ME WHEN I REALIZED I COULD REPRIME IT AND PAINT A NEW PICTURE. EARLIER EXPERIENCES MAY NOT DEFINE MY LIFE ANYMORE, BUT THEY ADD TEXTURE TO THE PAINTING I CREATE NOW."

education. The foundation she gave my sister Vicki and me shaped a lot of the good qualities of who we became."

Regardless of this, Nanea continued to feel like an outsider. "Even at my aunt's house, I still felt like the *other*. I know now how much she loved us, evidenced in her care and willingness to take us in; but at the time, I felt like we weren't her kids because we'd been thrust upon her. We weren't easy to deal with; we were more like feral children. When I was twelve, Patric told my grandmother, 'I've had enough—either I adopt them, or they have to stay with you.' She wanted to send me to boarding school. I was very much against it at the time, but now I can see the value that might have had. We were wild, but she is the one who worked so hard at making sure we were well rounded. She came from a horrible situation and made a great life for herself, and that has always been a strong influence on me. She has been such an important part of my life and we are very close to this day."

When Nanea reached her early teens, the effects of her childhood erupted into a self-destructive behavior: cutting. Her motivation to share this very personal experience is to help remove the stigma around mental health issues. "The cutting was really strange because all I understood about it was that it wasn't a suicidal ideation. I had a therapist when I was around sixteen, whom I started seeing after I had a breakdown and ended up in the hospital. She was the first person I ever told about my cutting, and she helped me to understand it by suggesting, 'Maybe you're trying to feel something.' It all made perfect

sense; I had become so numb. Once I understood, I didn't want to do it anymore. It was an instantaneous healing. She was a game-changer for me."

That therapist, Victoria Riskin, also introduced Nanea to a mindfulness practice that would serve as a lifelong healing tool. "While I was having a panic attack in her office, she taught me a Tibetan breathing technique where you visualize breathing into your nose and mouth at the same time: a gentle breath. You feel the breath going into your mind and body, specifically the heart area, because when you have a panic attack, it's all in your chest. After seeing the immediate tonic effect it had on me, she started to carve out sessions for meditation time. I was going twice weekly, pro bono by the way, after my Medi-Cal ran out and I couldn't pay anymore. I sent her money many years later to thank her for her support. I didn't want my lack of payments to make her feel that she didn't have value, because what she did for me was huge. It was a great feeling to go full circle with that."

Nanea continued to expand on these practices: "My therapist invited me to a weekend meditation workshop that she and another therapist were putting on that was done in complete silence. They had both studied in Nepal, and the teachings were based on Vipassana meditation and some Tibetan practice. That led me into a regular practice, and I ended up doing a ten-day Vipassana retreat, which I highly recommend. It's difficult, but transformative. I feel like it was a turning point for me at a very young age, and helped me to take the time to rewire my decision framework, which was life-changing. I could

decide to not engage with a negative thought and choose a more beneficial one that would promote happiness, peace of mind, and focus, without dismissing the way I was feeling. It was more honoring of it."

At one of Nanea's speaking engagements, she made the most beautiful analogy of this process: "I had taken the canvas of my life and painted a dark, painful picture, and then a miracle happened for me when I realized I could reprime it and paint a new picture. Earlier experiences may not define my life anymore, but they add texture to the painting I create now."

In her early twenties, she explored various careers in the arts: acting, theater, and graphic design. She met the love of her life, Victor Anderson, during this time, and the two married when she was twenty-seven. "I was an actress briefly because it was easy to fall into while living in LA. While I was acting, I also did graphic design. My early interest in the internet came as a direct result of playing video games. I had a CompuServe account when I was very young, mainly to find out how to play this game called Zork! When the Web came out, I got interested in making a website for

myself. I even made one for my poetry. I wanted to learn everything I could the moment the programs became available.

"I became adept at Photoshop and Quark, so I would do graphic design jobs that earned me thirty to fifty dollars an hour. My friends were waiting tables for minimum wage and tips, so I could see why this was a good skill set to have. I was very active in theater and that community, but I'd come in on the creative track and end up in management. I started to realize that people listened to what I had to say, even as a young person. The feedback I got was that people felt like things would get done if I took care of them. In many ways, that's what I had been doing my entire life with my sisters and my mom—I always stepped up."

This was the beginning of establishing a monumental career in leadership and technology. Nanea unexpectedly stumbled upon invaluable words of wisdom that would become guiding principles for her future. "This book caught my eye at a garage sale one day, *Games Mother Never Taught You: Corporate Gamesmanship for Women,* by Betty Lehan Harragan. I read that book and thought, 'Oh my God, I'm doing

> "I feel like it was a turning point for me at a very young age, and helped me to take the time to rewire my decision framework, which was life-changing. I could decide to not engage with a negative thought and choose a more beneficial one that would promote happiness, peace of mind, and focus, without dismissing the way I was feeling. "

it all wrong. I am not being strategic and playing to win. I'm not enjoying the game of business and what it means to advance and level up.' Exactly what I loved about playing video games. This book asserted that women don't have a playbook, and we have been playing by different rules than the ones in place. She brought up a good point that, if enough of us can get into positions of power, we can evolve the rules to be more inclusive and have different modes of play, because the game that men play in business is not supportive of men either. Look at the way stress has impacted their lives and this culture of *business first, family second*. A man at work with a sick child wants to be home with his kids as much as a woman, but they've never been allowed to express that. We need a more well-rounded work environment."

Once again, she was able to reference the hidden advantages of gaming, especially for women. "I bring it back to the benefits of playing video games. You learn resource management, strategic thinking, and more importantly for young women, see yourselves as heroes, makers, and builders. It makes you feel a bit like a badass, and as women, we don't get enough of that. I needed to find the fun in business and play to win. Initially, I was playing for my own winning. I was trying to advance, which was the game all the men were playing around me. Then I realized I also needed to include others in my success and advancement. That's when I started to truly be happy at work, with a team dynamic where everybody felt they achieved something together. In gameplay, it's co-op mode. The tech industry lends itself to that."

Now that she's the CEO of her own company, she can provide a window into what the other side of the desk is thinking. "I've made many people employment offers, and I have a defined budget like everybody else. There's always a low, medium, and high number. I will often put the first offer out there on the low side to give myself some headroom to negotiate up and still keep my budget in range. Unfortunately, what I do see is that women often accept the first offer. The most leverage you have is in that very first engagement, which is when they want to hire you because they would like to end the process and get somebody good in the role. Now that there's more data, we're seeing it's not just all on the women. When women do negotiate, they're perceived more negatively than men who negotiate, and there's actual research behind that. We have to find our way of doing it nicely, which sucks. There are definitely some double standards. Thankfully, all these conversations are happening in the workplace. With so few women available in the talent pool for coding, I told my team to interview any female who applies for a coding job, whether you think they have the experience level or not. Gabriella Poczo, a Chief Technology Officer who worked with me, shared that early in her tech career, when she submitted her resume for coding jobs, she'd get the customary, 'Thank you for submitting your resume, but we're looking for someone with more experience and qualifications.' She heard that so many times that she craftily decided to drop the 'a' off her name and be Gabriel Poczo. That's when she started getting interviews. It's an unconscious bias that's very real."

How did Nanea go from working as graphic artist to becoming the COO of some of the biggest tech companies in the world, and now the CEO of her own company? It all started when she reluctantly had to get an office job. "My husband, Vic, was diagnosed with hepatitis C and was unable to work while he was being treated with interferon: it made him very sick. So, I had to suck it up and leave my artsy lifestyle behind. I started working at a web development shop, and once I got into that environment, I loved it. Here was this seemingly tragic experience that was forcing me to get a job I didn't want, and it uncovered an unexpected passion for building software and creating online services. Ironically, my husband's illness gave me a wonderful career, and my career ultimately gave my husband the freedom to create a meaningful life of service."

Her husband Vic, a practicing Buddhist, started a nonprofit, Bodhicitta, Inc., that focused on small acts of kindness. A few of their accomplishments included rebuilding a monastery and a Buddhist school in Tibet, and an orphanage in Vietnam. Vic's next project was building a school in Tibet for nomad girls who are normally not educated. It came to completion in 2018.

Nanea continued to thrive at work and quickly ascended to the top of every mountain she climbed. She went from SVP of Enabling Technologies of JAMDAT Mobile (a mobile games company that EA acquired in 2006), to Chief Strategy and Product Officer at Gaikai (a cloud gaming company acquired by Sony PlayStation), and after that, she became the COO of Machinima (an online video network focused on video games now owned by Warner Bros). Next, she became President and COO of TextPlus (one of the top mobile communications applications on iOS and Android platforms).

But Nanea's personal life was about to experience a tidal wave of change that would wash away all that didn't serve her and leave behind only what remained in her heart. Her priorities would change forever when husband Vic was diagnosed with stage 4 liver cancer. "We were told we had eight months together, which ended up being only eight weeks." Because Vic had a dedicated practice of Tibetan Buddhism, he had specific requests that honored those doctrines regarding how he wanted to spend the last weeks of his life. He asked that he only be around joyful energy during his time of transitioning. He believed that, if you're surrounded by intense emotions of sorrow, your state of mind at the time of death could become conflicted and bring on feelings of sadness, worry, or even worse, fear, as you move on to your next journey. Vic's last two months featured an outpouring of daily love, with visits from family and close friends.

Those final weeks with Vic required Nanea to open herself up to an inner strength of spirit that would raise her mindfulness practice to a new level. "This life can be very painful, but there's also a lot of joy and sublime beauty. I saw this while I was with my husband as he took his last breath. Had I been attached to the emotion of what was happening to me in that moment, I would have fallen into a pit of despair. Because I made a choice to not cave into that, and to be present with him, he got to feel

the presence of my love, compassion, and support for him, so he could depart here knowing I would be okay, knowing that he was deeply loved. I had so much time afterward to allow myself to feel the pain and loss. That's where meditation can allow you to be present in your life in ways that are more deeply connected. In Vic's final moment, there was a connection we'd never had in our entire relationship. It was so profound and meaningful, and I would have missed it if I had made it about how I was actually feeling and let my emotions overwhelm me."

Vic passed on April 22, 2015. He would continue to speak to her through little notes he had hidden. The night before his memorial she found one in his jacket pocket that said, "I cannot be separated from this or from you. Our many hearts have only a single beat."

Moving forward, joined at the heart with Vic, a new light was cast on how she saw the world and her life's purpose. That purpose was the actualization of her company, TRIPP, a start-up initially focused on creating mood-altering experiences in VR that is now expanding into building the "Mindful Metaverse." It's a wellness platform based in scientific research that has won several awards, including being named one of the Most Innovative Companies of 2022 by Fast Company, and the Lumiere Award for the best use of VR for health and well-being. TRIPP is referred to as *the fitness solution for your inner self*. She and her team started it in 2017. "I feel like everything that I've gone through in my life has prepared me to run this company, and I'm just in love with it! There have been so many incredibly moving experiences throughout my journey with TRIPP. For example,

right now we're involved in an addiction recovery research initiative, and we're able to see it making a difference in that process. I saw addiction destroy my mother's life, and seven years ago, my sister Vicki lost her life to a drug overdose. To be able to make a difference, even a small one at this stage, is huge for me. I feel very grateful to have the opportunity to make a contribution. We have people using our product now who write to us about the difference that we're making in their lives. I want to stay healthy and alive so I can keep doing this always; it's my passion. I feel as though I have found why I am here on this earth. My entire journey, the challenges, the joys, and the losses—it all gets utilized now."

Nanea's compassionate spirit, strength, courage, and propensity to stand up for what's right has enabled her to find a way to live a life of service while still being a leader—this time, leading with love.

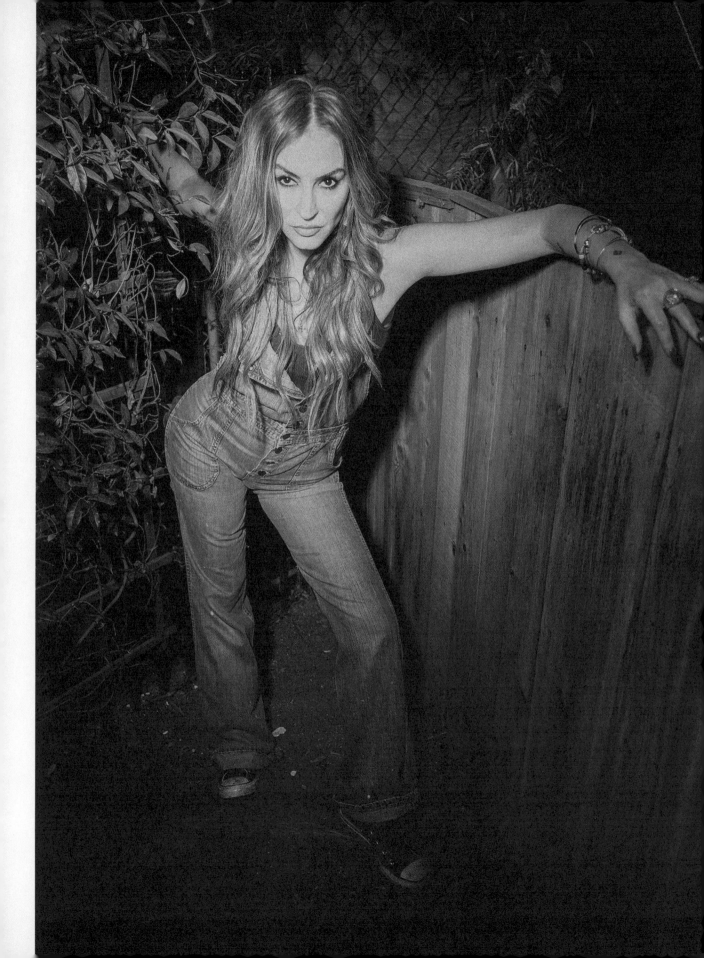

GANGSTER GODDESS DREA DE MATTEO

MOM | ACTOR

"LADIES AND GENTLEMEN, TAKE MY ADVICE.
TAKE OFF YOUR BLOOMERS AND SLIDE ON THE ICE."

—SIDNEY FREEMAN

(A FAVORITE SAYING OF AL DE MATTEO)

Drea de Matteo can hardly walk down the street without someone yelling out, "Hey Adriana!" Her Emmy Award-winning role as Adriana La Cerva in *The Sopranos* debuted over twenty years ago, and it still resonates with audiences worldwide. An entirely new generation of viewers has had a chance to fall in love with Drea's characterization of Adriana since the coronavirus pandemic made it the most watched show of 2020. What made this role so beloved were the glimpses of herself she allowed to shine through the veil of this character. Her warm and generous heart never runs out of love to give. Drea's loyalty to the ones she loves is unwavering: She would take a bullet for them. She had a childhood that was cradled in chaos, but grounded in devotion, with a cast of colorful characters worthy of their own show!

DREA WAS BORN AND RAISED IN QUEENS, NY, BY ITALIAN-AMERICAN PARENTS. HER MOTHER WAS A SUCCESSFUL PLAYWRIGHT AND TEACHER AT HB STUDIO IN MANHATTAN, AND HER FATHER WAS A FURNITURE MANUFACTURER. DREA'S MATERNAL GRANDMOTHER LIVED WITH THEM, SO THAT DREA AND HER TWO OLDER BROTHERS HAD SOMEONE AT HOME.

A situation that would be challenging at times: "My mother didn't have a good relationship with her mother, and they fought constantly. My grandmother was the quintessential martyr who cooked all day but complained about it. We would tell her, 'You don't need to cook; we can go out to dinner.' She would come back with heavy Italian guilt and say, 'Ahhhh, you can all fuck yourselves!' A little bit like Livia Soprano (Tony's mom), but not as vindictive and mean. She had those qualities and was very manipulative and self-centered, but still did everything for everybody."

Another woman who was there from the day she was born would leave an everlasting imprint on her heart and be the guiding force to turning Drea's life around when she was twenty-one; that cherished soul was Munkey. "She was the lifeline of our home. As much as my mother was a huge influence in my life, I was with Munkey all the time." She literally fought her way into Drea's life: "She left her husband in Nicaragua, and when she asked him for money to support his daughter, he went to hit her. She defended herself by grabbing his gun and shooting him in the arm. He took her to court, and his mother started verbally attacking her, so she leapt across the courtroom and started punching; after that, she had to get out of the country."

Munkey was exactly who Drea's father was looking for: "One of my dad's employees at his furniture factory told him he had to bring someone over from Nicaragua. My dad said, 'No, we have enough people working here.' Then he asked what she'd done that forced her to leave. Once he heard her story, he said, 'I have a job for her: She is exactly who I need to take care of my son.' From the moment I came into this world, she was there—she has always been in my life."

Drea was a young girl with a sharp mind and uninhibited energy. Sadly, those qualities would be overshadowed by feelings of neglect. Her desire to be seen and heard would soon mask itself in rebellion. "When I turned twenty-one, the party was over, and I went into rehab after years of destructive behavior. It was the same week that Munkey went to Florida to visit her family. When I got to rehab, I didn't know

I had a screwed-up history, I didn't know that my past wasn't the right kind of a past for a young girl—I thought I had a regular life. You sit in those rooms, and they tell you why you're fucked up, why you did drugs, and why you don't have a clear sense of yourself, and they point at your parents. My mom is the one that put me into rehab. She said to me, 'I am going to take full responsibility for this, and we're going to get through it.' My mom did what she said she'd do and took responsibility for everything; so did my father. They did every kind of family therapy they could have done. They were knee-deep in it, probably even more than I was. All that time they spent being too busy to deal with their children when we were little was being dealt with at this time. It was the most parental they had ever been."

This experience helped to form her own opinions on parental communication: "I think it is so important to be accountable as a parent. At least say, 'You know what? I did do that, and this is why I did what I did. This is where I came from, which was why I wasn't the best parent.' Just have the conversation. There is a kind of psychological and spiritual understanding of how genetically you can pass down the horrors of your life as a parent to your child, as well as the vibes of your life getting passed down from generation to generation. My parents were very conscious of that, and I think they were also fascinated by it. As a writer, my mom was captivated by the whole human condition and how to evolve for the better; only she didn't apply that to herself."

Her parents may have stepped up for Drea, but she would still have to step up for herself. Being fresh out of rehab, living at home, and working for her father's furniture company would not prove to be successful for her sobriety. She was a caged bird with clipped wings—no outlet for creativity. "When I got out of rehab, I tried life on my parents' terms. I lived with them in Queens and had no money. They wouldn't send me back to college, and I was selling sofas for my dad. I relapsed hard because I was so miserable—there was no art anymore, no excitement."

She left Queens and moved to an apartment in NY with a bunch of wild roommates. On top of that, Munkey was gone. "She never came back from Florida when she went to visit her daughter. On her way back to NY, she had a heart attack on the plane before it took off. When she got to the hospital, they said she needed a heart transplant. She was there dying, for almost a year, while waiting for a heart; it was too much for me to wrap my head around."

At this point, Drea's life and spirit were broken, but following her heart would once again prove to be the impetus for change: "I'll tell you how I actually got sober. I'll never forget the day the call came into my dad's store. A young boy died in a motorcycle accident, and a heart was on the way to the hospital for Munkey. I was really fucked up on drugs, and I didn't even go home to get anything. I left my dad's store, took a taxi to LaGuardia airport, and got on an airplane to Florida. I just took off and showed up in Florida in the waiting room of the hospital. They had already taken Munkey's heart out. The transplant wasn't being accepted by her body and she was on life support. My mother heard what happened, and she knew I wasn't right in my head. She took the next

flight to Florida to take care of me, while I thought I'd be taking care of Munkey. When she got there, I lashed out at her, and she said, 'You do what you need to do, Drea, but I'm right here for you.' I was blown away—that was the beginning of second chances for everyone. After a few weeks, the heart finally started to work for Munkey. I stayed for about a month, sleeping on the floor of her hospital room. While I was there, the nurses helped me to get sober. When she recovered, I moved her into my room at the apartment and slept on the couch. She lived with me ever since. After this experience, my mother wrote the most beautiful play called *The Heart Transplant*—it's unbelievable. She wrote it for me for my twenty-fifth birthday."

These three women had all been in Florida together fighting for their lives in different ways. Drea was fighting to find herself; Munkey, for her life; and Drea's mother, Donna, for her relationship with her daughter. "My mom and I had healed our relationship after that, and we were so close and in love until about six years ago, when she became a drug addict. In my mind, she was one of the strongest women I had ever known. As she got older, I realized that wasn't the case. She has dementia now, and I think a lot of it is because she refused to deal with her own past. She dealt with mine with me so that I wouldn't be scarred for life, but she wouldn't deal with her own issues. I tried to get her to do this at the onset of her dementia, but instead, she became addicted to drugs, and all these years later, she was the one in rehab; our roles had been reversed. It has been devastating to watch her deteriorate. This brilliant fucking mind that didn't have time for her

kids because she was so busy writing all of this really profound and amazing shit for years. She was also an exceptional teacher who taught playwriting. I learned how to act by watching her teach writing because it's all about analyzing and discussing the actor's intentions. It's been so hard to watch her fall apart and to lose her completely to her disease."

When Drea returned home from Florida, she finished getting her BA at NYU's Tisch School of the Arts, intending to become a director. All that time spent around actors through her mother's work made her certain she never wanted to become one. You can't hide from talent, and while she was acting in student films at NYU, the positive response to her performances was overwhelming, and her acting career was born. She had been training for it her entire life and was adept at every facet of the genre: acting, writing, directing, and producing.

She has starred in films and some of the biggest television shows of our time: *The Sopranos*, *Desperate Housewives*, and *Sons of Anarchy*. The story about her audition for *The Sopranos* is a classic one. She originally thought it was a show about opera singers, so she put her hair back and hid her fabulous NY accent. Despite this, she got a part in the pilot as a restaurant hostess with one line. The show's creator and producer, David Chase, saw the spark we would all soon see and ended up writing her into the show as a series regular. Her undeniable raw talent took that character to places only she could, charming everyone with her portrayal of Adriana.

"AS FAR AS MOVING INTO THE FUTURE—THEY ARE THE FUTURE AND HAVE BEEN THE CATALYST TO HEALING MY PAST. IT'S A NEVER-ENDING CIRCLE. I BELIEVE CHILDREN CAN HEAL THE WORLD. THEY'RE SO MUCH MORE POWERFUL THAN ANYBODY GIVES THEM CREDIT FOR BECAUSE THEY'RE THESE LITTLE SPONGES PICKING UP ALL THIS INFORMATION, AND WE'RE HERE TO GUIDE THEM. BUT REALLY, THEY'RE HERE TO GUIDE US JUST AS MUCH."

Strong women weren't just in her life, they were in her blood. "My mother and I wrote a script about my great-grandmother. It's seen through my mother's eyes when she was ten years old. It's set in 1950s Harlem, where she grew up. My great-grandmother was this spirited young woman, a trait not embraced by her parents. She cut her hair into a flapper hairdo, and her parents said, 'Are you fucking crazy? You'll go to Bellevue and get a lobotomy.' There was no way they would allow their daughter to be a free thinker like that, so they married her off at fifteen to some older Italian guy she didn't even know. She had a baby, my grandmother, and she started going to museums every day because she wanted something more and lost herself in the art. She stayed too long one night and was late to cook dinner for her husband. She got home with my grandmother in the baby carriage, and her husband punched her. She grabbed a knife in the kitchen and stabbed him. She said, 'You have a choice. I can keep this quiet and make sure that nobody in this neighborhood knows what a pussy you are to let your wife stab you, and you'll give me a divorce, or I can go out in the streets and tell everybody that I stabbed you. They'll think I'm crazy, but you'll still be stuck having to take care of this baby by yourself when they put me in an institution. Your choice.'

"Then she went to her parents' house and caught her mother having an affair with the neighbor. She said, 'You hypocritical bitch. Well, I can either tell my father that you're fucking the neighbor, or I can give you my daughter to watch while I go to Bellevue, but not to get a lobotomy; I am going to get a nurse's degree.' She started her life by blackmailing

everybody, but it was for the greater good because she ended up becoming a nurse-midwife. She also took care of women who needed abortions. Back in the '50s, a lot of women were dying trying to do it themselves or going to butchers. My great-grandmother provided them a safe and impeccable service. She had everyone from Washington to Hollywood coming to her to be hidden and dealt with. She would perform abortions, but what she preferred to do was let the women stay at her house in New Jersey and carry their babies full term. Then she would put those babies up for adoption."

Drea elaborated on the script she and her mother wrote, telling these extraordinary family tales: "We are doing a three-part mini-series about the beginning of my mom's life, the middle of my mom's life, and the end of my mom's life. My great-grandmother's story is the first one, *The Heart Transplant* is the second one. Unfortunately, I don't have any more stories or details that I can get from my mother because she doesn't remember any of it due to her dementia. I had hours of interview footage from my uncles and my mother that were rich in information and details from this time, but all those tapes burned in the fucking fire."

The fire Drea referred to was the one that took her home of twenty-two years in the historic St. Mark's district in Manhattan's East Village five years ago. She was in LA at the time with her children, so they were all safe. The fireball that erupted out of the flames took with it priceless, irreplaceable items: family photographs, films, and heirlooms—the sentimental things that are the most treasured in one's life. Of

course, her initial reaction was to feel immense gratitude that she and her family and the rest of the building residents were all safe. It wasn't until later, once the shock wore off, that the effects of this tragic blow would start to unravel.

"I still live with major anxiety in the aftermath of this fire. It was totally not a conscious thing because consciously, my thinking was that we got away unscathed. I was in LA and got a phone call telling me to turn on the news because my building was on fire; it was actually the entire block. There was an explosion at the restaurant underneath my complex because the landlord in the building next to mine was messing with the gas lines, trying to connect them so she wouldn't have to pay for gas. My building went down first because it was the smallest and probably

"The world is the way the world is. Take away your past, take away the future, and stay in the actual moment."

the most vulnerable. It exploded and then fell to the ground; we watched it happen on television. My thoughts at the time went to all the people who lost their homes and had nowhere to go—I still had my house in LA, and we were okay. I felt very lucky and fortunate, and I didn't want any handouts from the city. Nor did I want any attention put on it. I just wanted to forget, because I lost everything that I owned from my childhood; it all started to hit me over the next few years."

New York is Drea's home and where she feels the most grounded. A part of her will always feel

displaced without it. "I realized that I couldn't afford to go home to NY anymore—that's home; LA is not home for me. My house in LA was a second house. I couldn't financially afford to go home anymore because of the prices in NYC. NY is my safe place. This was when I felt the loss in a big way. NY means freedom to me; it's the Statue of Liberty right there for you to see every day. I am not an LA girl in any way—I don't even drive. I only bought this house because there was a recording studio; I got it for my ex more than for me."

The ex she referred to is musician Shooter Jennings, son of country singers Waylon Jennings and Jessi Colter. It was a relationship filled with extreme highs and lows, and it ultimately ended with a tumultuous and painful breakup. The two may not have been officially married, but they were husband and wife in every sense of the word. Out of this fire came the most beautiful gifts she would ever receive: her daughter, Alabama Gypsy Rose, born in 2007, and her son, Waylon Albert "Blackjack," born in 2011.

"Before our breakup, not only was I taking care of our kids, but my father had just had a stroke. I was spread so thin that I wasn't focused on Shooter and his art as much as I had been in the past; I think that's when we fell apart. But mind you, it was a breakup that's worthy of its own book, and I won't expound

on it too much because I don't want to piss anybody off. When I've told anyone about the details of our breakup, they always respond the same way: 'Are you fucking kidding me?' You don't recover from events that shocking and hurtful easily unless you're a fucking superhero. So, I'm going to go ahead and say that I must have been wearing a fucking cape for the past eight years."

She donned that cape for her children and continues to be their superhero and champion in every aspect of their lives. "Motherhood means everything to me. Alabama is now twelve, and Blackjack is nine. Once I had children, I knew that nothing else mattered. I couldn't believe I didn't start having them sooner. As far as moving into the future—they are the future and have been the catalyst to healing my past. It's a never-ending circle. I believe children can heal the world. They're so much more powerful than anybody gives them credit for because they're these little sponges picking up all this information, and we're here to guide them. But really, they're here to guide us just as much."

Motherhood has also had Drea revisiting her childhood in order to understand the men she has chosen to have relationships with in the past. "It made sense that I would pick somebody a lot like my mother; I was continuously dating my mom. I wasn't picking men like my father. I look at my kids, and even the involvement that the men in my life had in my kids' lives, including their dad when we were together. I have to say that being with a musician, which I swore I would never do again, is not easy; they're always heartbroken. I think they're

born heartbroken. I always say that I was born with a broken heart, so I can identify with this. The industry that we're in is heartbreaking, but that's not how you get it—it's already broken. That's why the arts resonate with you. For an actor, it's playing another role, being somebody else. As a musician, you get to transcend everything that's happening in the world and go off into another realm with your music, which is pure magic to me."

Drea's home is always rich with the arts, activities, and fun! She talked about the different personalities and talents of her children: "Blackjack is more like I was at his age. He doesn't know where his focus is yet, but I have a feeling he will sing; that's his thing. He says he likes to rap, and he likes to perform. He would be a great actor. He's very outgoing, and I never was. I was painfully shy, and that's why I have been in therapy my whole life. As far as my daughter's talents go, she's not a triple threat, she's a six-threat! She is a fine artist, plays piano and guitar, and is now writing a TV series. She wants to make costumes, do a makeup line, a clothing line, and write a children's book. It doesn't stop with her! She goes to bed at night saying, 'I don't know how I'm going to have enough time to do all this!' My parting words to her are, 'I will be your momager, and I will make sure that you have time to do everything. I'll take care of all the bullshit!'"

The intensive internal work and insights into her innermost self have prompted Drea's healing in many ways: "I feel like I can finally exhale. I've been trying so hard to breathe and to work through my anxiety. Last year, I started to feel all those hormonal

changes that make your anxiety go through the roof. That's not something you can control. I could feel a surge of it really tampering with my emotions. I started doing this thing that my holistic doctor advised. You do it when you go to bed at night, and it's so simple. I say this mantra, 'I truly want to release my unconscious emotion of fear and anxiety and replace it with the power of infinite love now and forever.' If you say it twenty times before you fall asleep, you will literally reprogram your mind to not be hung up on fear. Same thing with shame and guilt. The world is the way the world is. Take away your past, take away the future, and stay in the actual moment. I know it's easier said than done, but just try to be in the present. Your subconscious is always fucking with your brain. The minute you go to bed, and every waking moment, your subconscious is doing a number on you. How easy is it to stay in the moment? It's fucking hard, but it works!"

Drea may feel as though she was born with a broken heart, but she has spent her life keeping everyone else's intact. She will always be that woman, but now she is ready to start addressing her own. Her personal inventory and reflection have her growing as a person, as a mother, as an artist, and in her relationships—including with herself. "How much individuality can each of us have as parents when it has to do with what our needs are? When do we start thinking about our needs before theirs? It's a fine line. I feel like I've given up a good eight years of my life to be in LA for Shooter, to be near the kids and do what I felt was right for them. Now, at this age, this many years later, it's time for me to take a piece of my own life back. Moving home to NY is a part of that. I am a nomad, and my daughter and son are as well. Now that we're not doing it, they miss it. They want to go back to NY. They don't like being in one place either."

It's nearing the time for her to go back to where she feels the most freedom. To rise from the ashes and rebuild her life in the place she calls home. Only now, she will bring with her wisdom, self-awareness, and the power of infinite love—now and forever.

THE GIRL WHO SLAYS ELICIA CASTALDI

ARTIST | DESIGNER | ENTREPRENEUR

*"THERE'S ONLY ONE THING IN LIFE,
AND THAT'S THE CONTINUAL RENEWAL OF INSPIRATION."*

—DIANA VREELAND

Artist and designer Elicia Castaldi is setting the stationery world on fire with her company, Girl w/Knife. Girl w/Knife is an extension of her impeccable style, unabashed humor, and empowering messages, all showcased on the covers of greeting cards, wrapping paper, notepads, journals, and home decor. This award-winning illustrator looks as though she came to life from the pages of a storybook or off the big screen, evoking visions of a modern-day Audrey Hepburn. There is nothing make-believe about this strong Italian woman from Rhode Island; she is candidly honest about who she is and what she believes. The desire to help other women through her experiences, struggles, and successes immediately drew her to be a part of this book. She herself has experienced creative illumination from a variety of diverse artists. "As a huge fan of Kate Spade and her exceptionally designed lifestyle empire, I was absolutely gutted when she died. I adored the prolific writer, Nora Ephron; her signature honesty and humor are deeply inspiring to me. I'm also inspired by women like Gwen Stefani, Dita Von Teese, and Iris Apfel, who are unapologetic about their style and fully committed

to their look. Every single one of my friends inspires me, as well as my mother. She always finds reasons to be happy and believes happiness is a choice and chooses it every day—her positive energy is infectious."

ELICIA DESCRIBED LIFE GROWING UP IN THE CASTALDI HOUSE AS RICH WITH LOVE AND EXUBERANCE. "MY CHILDHOOD WAS IDYLLIC IN EVERY WAY. I COME FROM YOUR TYPICAL LOUD ITALIAN FAMILY WITH LOTS OF LARGER-THAN-LIFE PERSONALITIES."

"I grew up in a big house with my parents and older brother Joseph. Later, my maternal grandparents moved in on the first floor. They were hilarious and shaped so much of my life and humor! In fact, my maternal grandmother, Lena, was the inspiration for one of my bestselling cards, 'You're on My Shit List.' It was her favorite saying! My dad was a comedy show. He had this off-the-wall dry humor steeped in his Federal Hill Italian roots; his brilliant wit and gift of storytelling had you on the edge of your seat. He was legendary for that. My brother was the exact same way. People

have always said he's the funniest kid they have ever met."

Though Elicia's parents weren't particularly artistic themselves, they encouraged the undeniable natural talent she and her brother possessed. "We were two Scorpios, but polar opposites in personality. I had the quiet sarcasm and sensitivity. He was wild, like a bolt of lightning. Our common thread was that we both excelled in art. My parents were hugely supportive of our creative endeavors and had us in all sorts of art programs. My father would take us both to the art supply store just outside the Rhode Island School of Design campus, and we loaded up on pencils, crayons, markers, and those quintessential *Learn How to Draw* booklets. I think secretly wanting my brother's approval was also a big motivator: it was our connector, our unspoken language. In that way, he nurtured my talent."

Art quickly became everything to Elicia. "In school I was happy to be an average student, skating by, mostly interested in gabbing with my friends about the boys we liked. But art class was where I naturally excelled. Other kids would ask me to draw them things, and my teacher would give me a lot of praise. It quickly became my favorite subject, the place in my school schedule where I felt the most joyful.

Unfortunately, that joy was short-lived when I got into high school."

Elicia's free-spirited childhood was about to suffer a devastating blow: "When I was fourteen, during my freshman year of high school, the rug was pulled out from underneath my feet. My brother Joseph died in a car accident. Life was never the same for any of us. I now define my life in two parts: pre- and post- February 18, 1993. After that, I couldn't see the point of life. I questioned everything and, most of all, God. I didn't think there would ever be a rightness to our family again. My whole life was ahead of me, and yet, I couldn't see a reason for living it with so much brokenness. Life remained broken in many ways, but I also found deep magical connections with other people who suffered similar losses. One was my husband, who lost both his parents, and another my close friend Cheryl, who lost her brother tragically in the same way."

The heaviness of her broken heart was all-consuming, but somehow, instinctively, she knew the only way to start on the road to healing was through her art. "The summer before my junior year I found out about a very progressive independent high school dedicated to the arts, called School One. Two weeks before school started, in true Elicia-fashion, I unexpectedly ditched my prep school and begged School One to squeeze one extra pupil into their crazy small (by design) student body. School One was heaven on earth. I thrived there—we all did. The culture was one of inclusion, compassion, experimentation, creativity, respect, and above all else, fun. There I got to choose my schedule, adding in extra art classes. My teacher, Aurel, was a graduate of Rhode Island School of Design and worked closely with me on my pursuit of RISD, which was nearly impossible to get into; moreover, they only accept a handful of local residents per year."

The close bond she and her brother had with art only made her calling to pursue it that much stronger. Elicia explained how her teacher guided her through the RISD application process: "Aurel taught us to think outside of the box; she was incredibly motivating and just plain cool. As part of the application, you had to do three drawings: a bicycle, a still life, and an interior/exterior environment. I spent thirty hours drawing my cat's litter box, of all things! I was accepted to RISD, and when I got there, I met a kid who drew a tiny stick figure in the middle of the page with a Sharpie. He actually got in

> "I thrived there—we all did. The culture was one of inclusion, compassion, experimentation, creativity, respect, and above all else, fun."

"BY CONTRAST, MY IDEA-GATHERING IS HIGHLY CHAOTIC, AS I FIND SPARKS OF INSPIRATION FROM EVERYTHING AND ANYTHING IN MY ENVIRONMENT. I'M CONSTANTLY TAKING PHOTOS AS A SORT OF VIRTUAL BOOKMARK FOR AN IDEA I MAY HAVE. THE 'NOTES' SECTION OF MY PHONE IS CLOGGED WITH RANDOM RUNNING LISTS. I MAKE VISION BOARDS AND USE PINTEREST AS A VIRTUAL ON-THE-GO VISION BOARD."

with that! RISD loves risk-takers who say *here is my expression*. They are looking for someone who is going to stand their ground creatively. Confidence is everything to them."

She had realized her childhood dream to go to RISD, one of the top art schools in the world. Located only two miles from her house, it had functioned over the years as an enormous vision board. She earned her bachelor of fine arts degree in illustration and set her sights on writing and illustrating children's books.

After graduating, she got an art rep and within two years illustrated her first book. "My illustration professor owned an agency that represents artists, and despite not usually taking on former students, told me to see her after graduation. We had a great connection at RISD, and she made an exception because of that. She helped me put together my portfolio and then shopped it around New York. In 2003, an editor had a book for me to illustrate by British author Pamela Duncan Edwards for Penguin Putman. Pamela had written about fifty children's books, so it was huge for me. After that, I moved to New York City in 2004 and worked at Macy's from 2005 to 2010 as an art director designing ready-to-wear ads for their direct mail campaigns. Simultaneously, while working at Macy's, I illustrated several children's books for major publishers like Simon & Schuster and Random House. I will say this, RISD opened tons of doors for me. It was well worth it in every way. My parents were very generous

in investing in my education, and I still hold endless gratitude for that."

Elicia had a keen understanding of who she was and what her emotional boundaries were. That is one of the reasons she chose to continue working at Macy's, because it gave her the freedom to only take on the creative projects she wanted to. "I have always been disinterested in being a hired gun as an illustrator. It's hard to stomach that collaborative process between you and a non-creative person. It was easier for me, mentally, to pay the bills as an art director and illustrate books on the side. If I wasn't truly into an illustration project, I could say no and still have my rent money."

Eventually, Elicia reached a crossroads in her career. She had always had the life plan to do children's books, but something inside of her was changing. "I used to think you have to see your childhood dream through until you reach complete stardom, and anything less is a failure. Because of that belief, my decision to pivot away from children's books was a weighty one. Though I fulfilled it by being published four times, I felt my career hadn't skimmed the surface of its fullest potential. Sometimes I felt helpless; some of my favorite book ideas were passed on or had fallen apart in the incubation stage. Each of my children's book ideas felt like little pieces of my heart; therefore, it was such a painful place when something was rejected by a publisher.

"On the flipside, the highs were equally as exhilarating. One of my books, *Middle School is Worse Than Meatloaf*, received a lot of press and accolades, and that was an absolute rush. Becoming a published author in 2013, when I both wrote and illustrated *The Food Parade*, was a dream come true. But around the corner would be another low. The upsets I experienced would include spirals of negative talk, nagging what-ifs, and lengthy creative voids."

Elicia shared what helped pull her out of that dark and creatively empty period in her life: "Call it divine timing, because this is precisely when I got hold of two books. I had been in New York, lamenting over dinner to a songwriter friend of mine about my creative rut. He told me about a couple of books I needed to read: *The Artist's Way* and *The War of Art*. *The Artist's Way* was helpful. *The War of Art* changed my life. After reading it, I made a pact with myself that, as long as I felt utterly useless to move forward with books, how about I do this instead: create art every single day for a year, seven days a week, morning until night, without any judgment. I was to use complete freedom, no strings attached, not for anything, not for it to become a product, a kid's book, or otherwise—just for the pure pleasure of it. Let it *be* for the sake of *being*. Paint the first thing that comes to mind, paint anything, just make art. I followed through, and after an entire year, not only had my soul mended, but I had gotten to a safe space, creatively and spiritually, that I hadn't even thought was possible. I never

questioned or doubted myself again. I had rediscovered not only my talent but my joy. I highly recommend *The War of Art*, especially the audiobook version."

Now that she had reconnected with her innermost artist and was free of all preconceived notions of who she should or shouldn't be, Elicia was ready to manifest her dream: "Paper has always been a big obsession of mine. There used to be this amazing store in New York called Kate's Paperie, which was my favorite place on earth. It was like Barney's, but for paper. So, designing illustrated paper products that could sit on those shelves has been in the back of my brain for many years. During that year of painting, I started to see a card line emerging through my artwork, so I began writing cards—I couldn't stop! I wrote about 300 cards the first time I sat down to start writing them! It seems like a crazy amount, and it was! It just came so easy to me to come up with ideas, and it felt right. Fast forward to December of 2018, when I launched Girl w/ Knife with ninety-six greeting cards, four journals, three notepads, and four gift wrap designs; I said to myself, 'This is already a success because I've gotten here—I've created this body of work and this company—every aspect of it. From the name to the products, logo, website, catalog, social media, and everything in between. I wholeheartedly love all of it, every single piece, because it is *me*, full stop. My career is completely on my terms now,

and I could not be happier or fuller of ideas for the future.'

"Looking back, I think the missing piece for me in children's books was that I wasn't fully *me*; I was being PG-rated me, which isn't the most compelling version, actually. I still sometimes click open the files of old manuscripts and page samples. I still love them all deeply; they are a part of me. Maybe I will find my way back to those scrapped ideas. But for now, I'm on a mission. You'll see within my artwork that I paint a lot of snakes. As a Scorpio, I love transformation and rebirth. Shedding one's skin to make way for the new. As the creative director of Girl w/Knife, I tell myself that my only job is to be 100 percent authentically myself and work really fucking hard every day! If you do that and create quality goods, your customers will find you and remain loyal. I have found true fans of my work all over the world."

Not only is the entire line unique to Elicia, so is the name: "Oh, how I struggled with that! I made lists upon lists of words—nothing resonated. And then I spontaneously blurted out 'Girl with Knife' one time and that was it; distilled down to the basic elements, it has always been just me and an X-Acto knife. That's how the name Girl w/ Knife was born. The best part is that no one says my career is 'cute' anymore, like they did when I was in kid's books." A side note to the name is that Elicia comes from three generations of knife aficionados and collectors. Her great-grandfather owned Ideal Knife Co., a pocketknife business, and passed that down to her grandfather and his siblings. So, Elicia is carrying on her version of the knife legacy in her

> "It's so important for me to constantly be in touch with my creative fire. I can so easily be derailed, and once that happens, it's a whole process to get back on track. In the last few years, spiritual ceremonies have been a game-changer for me. I have a plate of crystals, family jewelry, and various small meaningful objects. I burn sage and Palo Santo and just sit and speak to my higher self, as well as loved ones who have passed on. I tell the universe exactly what I want, and I set intentions, speaking very powerfully to myself. After doing that, my mind is completely straight, and I'm so productive."

family, only doing it with her own classic style and flair!

Amidst all this creative discovery, Elicia met and married David Kokakis, the man she describes as "the most amazing human being I've ever known." This union would also result in Elicia having to relocate and move from her beloved New York City. "David got a job promotion that landed us in LA in 2012. I came here kicking and screaming. We had just landed the motherlode of all NYC apartments: it was a drop-dead gorgeous loft in Chelsea, and all white! We had just gotten engaged, and I was starting to plan our wedding. It was the absolute worst time to be ripped out of my life there, a place I had never in my wildest dreams imagined leaving. Planning our NYC wedding from across the country kept me very busy for a while, but after that, I had to face the reality of the move head-on. I met a few key girlfriends in that first year whom I clicked with, and then things turned around. The first time I told David, 'I don't hate it here,' he nearly fainted. Everyone asks me which I like better, NY or LA, and I always say I could never choose, but having recently designed two concept homes, Knife/House Palm Springs, Knife/House Bel-Air, and an extremely blush-pink Girl w/ Knife warehouse, I have literally built my happy place here in California."

Elicia's sharply defined style and taste encompass her art, attire, and home. Her signature Knife/House aesthetic is clean,

bright, and predominantly white, with touches of black, gold, and of course, her favorite blush pink color. The house is the inspiration behind her illustrated home decor pieces. Even her ever-so-sophisticated white cat, Princess Vespa, blends seamlessly into the elegance. "It's funny how art and chaos play off one another. Some artists thrive in chaos, while other artists can't work under those conditions. I need everything in order, or I just can't think." Sometimes picturesque surroundings aren't enough to fan the flames of creative inspiration. "It's so important for me to constantly be in touch with my creative fire. I can so easily be derailed, and once that happens, it's a whole process to get back on track. In the last few years, spiritual ceremonies have been a game-changer for me. I have a plate of crystals, family jewelry, and various small meaningful objects. I burn sage and Palo Santo and just sit and speak to my higher self, as well as loved ones who have passed on. I tell the universe exactly what I want, and I set intentions, speaking very powerfully to myself. After doing that, my mind is completely straight, and I'm so productive.

"By contrast, my idea-gathering is highly chaotic, as I find sparks of inspiration from everything and anything in my environment. I'm constantly taking photos as a sort of virtual bookmark for an idea I may have. The 'notes' section of my phone is clogged with random running lists. I make vision boards and use Pinterest as a virtual on-the-go vision board. It's especially helpful considering all the directions

my brand is going in, including lifestyle products such as pillows, candles, and art prints. Of course, what's always growing is my massive pile of sketches for new cards. I don't think I could ever run out of ideas for greeting cards."

Girl w/Knife can be found at Anthropologie, Barnes & Noble, Paper Source, Francesca's, New York & Company, and in hundreds of retail shops in the US and around the world. Elicia has been featured in publications such as *WHAT Women Create*, *Palm Springs Life*, *LA Business Journal*, and *HGTV*. Elicia was also named one of the "10 Designers to Watch in 2020" by *Stationery Trends*. Her cards have won seven *Noted Awards from the Greeting Card Association, and she has received five prestigious Louie Awards, including Artist of the Year for 2022.

Elicia has unquestionably cut out a permanent place for herself in the stationery industry and is leaving no creative stone unturned for the future. "I'm building something that gives me nothing but happiness, and other people are responding to it as well. It's so rewarding. I'm able to enjoy my career in a way I hadn't thought was possible, and this is just the beginning! I have so much exciting stuff on the horizon this year, next year, in five years, and beyond. I'm never going to stop creating."

GIRL ON THE GO
LISA GOICH ANDREADIS

AUTHOR | PODCAST HOST

"DON'T CHASE BOYS."

— MILLY GOICH

How many hats can a woman wear at one time? Lisa Goich is going to find out! She is prolific in every genre that speaks to people: she's an award-winning author and copywriter, public speaker, talk radio and podcast host, comedian, blogger, and manager for the Jazz and Comedy genres of the Grammy Awards. The teacher's comments on her report cards from as early as kindergarten hinted to a future in communicating with others: "Too talkative—cut out some of your social activities during class time," "You have to learn to control your talking," "Talking nonstop." She took and parlayed that gift of gab into a lifetime of work. Personally, I feel it is only a matter of time before she has her own talk show and is a household name.

WHEN SHE ISN'T TALKING, SHE'S WRITING. LISA IS THE AUTHOR OF THE BOOKS *THE BREAKUP DIARY*; *14 DAYS: A MOTHER, A DAUGHTER, A TWO-WEEK GOODBYE*; AND *THE GUIDED GRIEF JOURNAL, I WONDER*. *14 DAYS*, WINNER OF THE NATIONAL INDIE EXCELLENCE AWARD, IS LISA'S DEEPLY MOVING ACCOUNT OF THE LAST TWO WEEKS OF HER MOTHER MILLY GOICH'S LIFE. THE BOOK AFFIRMS LOVING, HONORING, AND SAYING GOODBYE TO OUR LOVED ONES WITH DIGNITY AND GRACE.

A quote from the book that has been shared worldwide embodies the emotion one feels when losing a parent: "I wonder if my first breath was as soul-stirring to my mother as her last breath was to me." It is a perfect example of the depth and talent of this brilliant writer. She just started her own publishing company, A Girl on the Go, that coincides with her brand of the same name, including books, podcasts, and events to inspire, guide, and motivate girls twelve and up.

She was born and raised in Detroit, Michigan. The baby of the family, she was practically an only child most of her life. When she was born, both her siblings were already in high school. "My dad was a blue-collar worker—a tool and die maker at Chrysler for most of his life. My mom was a stay-at-home mother, a homemaker. We grew up in a tiny neighborhood in Detroit, in the inner-city suburbs. It was a fun childhood. Because my mom was home, it was our own little world."

Lisa's life of multipotentiality started in her childhood. "I did a lot of stuff as a kid. I played the violin and piano and took art and ballet lessons. I was kept very busy. I think that definitely transferred into my life now. I can't imagine ever being bored. I'm a *multipotentialite*!"

Music has always played a significant role in Lisa's life. Once she moved on from her piano and violin lessons, she found which musical styles truly resonated with her—including quite a few crushes! "My taste in music started with my first crush on Glen Campbell, and then, in order, Bobby Sherman, David Cassidy, Donny Osmond, and finally Alice Cooper. That was the trajectory of my musical loves until I smoked pot once in sixth grade and started listening to Pink Floyd and Led Zeppelin." Little did she know that years later, she would marry Alice Cooper's keyboard player, Teddy Andreadis, and

become lifelong friends with Alice's wife, Sheryl Cooper.

Lisa graduated with a degree in journalism from Central Michigan University. One of her first jobs after college was working in the marketing department for the Chuck Muer seafood restaurants. One day at work, she answered the phone, and it was a man calling about the restaurant's radio campaign. His name was Chato Hill, someone Lisa greatly admired. "Chato Hill was this supercool and eccentric writer who won all these awards and worked for W. B. Doner, a very creative advertising house with amazing clients. I was so mesmerized by Chato in college that I cut out an article about him and put it on my bulletin board. I told myself that I was going to work with him someday."

"I would've remained stagnant if I stayed on the island. I always felt that there was something bigger for me."

Never one to mince words, Lisa took the opportunity on that call to tell Chato about how he had inspired her, how she wanted to be just like him, and about that article. She obviously made quite an impression, because soon after, Chato asked if Lisa wanted to interview for a receptionist position at his office. "I interviewed, got the job, and we are still friends to this day. I worked with him at two different advertising companies. The funny thing is, while I was working as a receptionist, I wrote an ad that ended up winning an award. That was my first advertising award!" She wasn't the receptionist for long, and she won many more advertising awards during her career

as a copywriter. "I wrote print ads, press, TV, radio, slogans, theme lines, and jingles."

One might assume she would be too busy with her work in advertising to consider anything else, but not Lisa! She started doing stand-up comedy just for fun. "The first night I got up to do stand-up, I killed it. The second night, I went up, and I ate it like you can't even believe! It was awful, I was terrible, and I cried. I never wanted to do it again! Then, one of the other comedians encouraged me not to give up and to go with him the next night to another comedy club in Ann Arbor called the Mainstreet Comedy Showcase. I reworked some of my material, and I went up the next week and did great, and that was it. I ended up doing comedy for years and years after that. When I turned twenty-nine, I quit my day job and pursued comedy full-time. That first year, I moved to Grand Cayman in the Cayman Islands, where I became the house emcee at Coconuts Comedy Club. It was super fun. There's no better way to go from a day job to comedy than moving to an island and working in one place. I didn't have to go on the road and tour—I just had to roll out of bed!

"I made three hundred a week, and after approximately one year, I came out with thirteen thousand dollars in cash. I had no overhead! I left after a year because seeing the guest comics coming in from the States every week made me feel like I was

missing out. I would've remained stagnant if I stayed on the island. I always felt that there was something bigger for me." She decided her next move would be to either NY or LA. Not quite sure about either, she rolled the dice on Los Angeles.

It wouldn't take long for this gregarious girl to connect with people in LA and get a job. "I was playing poker with a bunch of comics, and one of the comedians I sat next to was working at the WB as a writer, doing commercials and promo work. He told me they were looking for a promo writer. I told him I was an advertising copywriter for fifteen years, and he set up a meeting for the next day. I got the job. I was very fortunate, and let me tell you, it was the best paying job I've ever had since I've been out here."

She may have been getting the most significant paycheck she'd ever seen, but she wasn't fulfilled. Lisa's exuberant mind needs to be challenged and energized, so she moved on to comedy and radio. Right after her move to LA, Mitch Albom, bestselling author, radio, and television personality, flew Lisa back to Detroit to cohost a test broadcast for his new radio show. When the show was picked up, he wanted her to move back to Detroit to do it with him. She had already uprooted her life in Detroit to move to LA and wanted to continue settling into her new home. "I basically gave up doing Mitch's radio show to move here for nothing. Then, I thought if I could do radio in Detroit, why can't I do radio in LA?"

She did just that for many years, hosting and producing radio shows on KLSX, KFI, and K-TALK. She eventually got tired of the unstable world of

radio and landed at Playboy, working for the Playboy Jazz Festival. Then, about four years later, someone asked her if she knew anyone who would be good for a Grammys position, and Lisa replied, "What about me?" She went in, interviewed and, of course, got the job. She has now been there for ten years. Lisa was also able to continue her work with Mitch, and is currently producing and cohosting his podcast, *Tuesday People*. Having a full-time job working for the Grammys isn't about to stop Lisa from pursuing all her other creative endeavors. Remember, she is a *multipotentialite*!

During her career as an author, she has acquired a wealth of wisdom for prospective writers. "I've written my entire life, ever since I was a young girl. I think in my times of sadness, writing is what helps me. It certainly helps me sort out things I have stored up inside.

"My advice to aspiring writers is first to hone whatever it is you want to write. If you aren't a writer, you better educate yourself on everything to do with writing a book. Learn grammar, punctuation, and sentence structure—so many people think you don't need to know these things. Get all the books you can on the subject. I have a ton of these books, and I am a writer. Some of the ones I read before writing my memoir are *Writing and Selling your Memoir, The Memoir Project, Writing Down the Bones,* and *The Art of Truth*. By the time I wrote *14 Days*, I knew what I was doing. I wanted it to be my own style, but I wanted to know the elements needed to write a good memoir. Then, once you write your book, you have to think about how you want to publish

"I'VE WRITTEN MY ENTIRE LIFE, EVER
SINCE I WAS A YOUNG GIRL. I THINK
IN MY TIMES OF SADNESS, WRITING
IS WHAT HELPS ME. IT CERTAINLY
HELPS ME SORT OUT THINGS I HAVE
STORED UP INSIDE."

it: self-publish, a big publishing house, or one of the smaller ones. Then, to get a publisher, you need an agent, which requires a book proposal. To do a book proposal, you have to do a lot of research first. A proposal is your sales tool to sell yourself and your project to somebody, so it's imperative to make it the best it can be.

"The publishing world isn't quite what it used to be because it's got so much competition, and not just with self-publishing houses but all kinds of entertainment: YouTube videos, social media, and blogs. This is a world in which everybody has ADHD. Nobody can sit down with a six-hundred-page book anymore because there are six hundred thousand things to read online every day! So, when a publisher takes somebody on, they want to be assured that they can make money on the project. A lot of that has to do with what they call your platform: your social media reach. If they're a small publisher, they would be happy with around three to five thousand books sold. A major publisher is looking at ten thousand and over."

Another element necessary for the promotion of a book once it's published is endorsements. *14 Days* got some high-end celebrity support: "Maria Shriver tweeted about the book the day it came out, which was great. I was very fortunate to have some incredible endorsements. I am terrible at asking people for things, and when my book came out, I didn't follow up with any of the people who gave me endorsements to promote it on their pages. Marilu Henner, who I did a podcast interview with, loved the book and posted it on her social media.

But for people like Carole King, who gave me an endorsement, I was reluctant to ask her to put it on her social media. Once a book comes out, you have three months to sell it. They give you about ninety days to make it or break it. You've got to make sure you set your publicity up at least a year before your book even comes up for sale. In a nutshell, it's a lot of work to do a book, and it doesn't just stop at writing it."

It wasn't until about a year after Lisa lost her mother that she started considering the idea of writing a book about the experience. It all started with her eloquently written and emotive Facebook updates about her mother's last days. She had an overwhelming response from people telling her to save the posts and do something with them. When she decided to write the memoir, she used them as the initial outline for the book.

In *14 Days,* Lisa paints a picture so real that it feels as if you are sharing this experience right beside her. It is the same sensation as when you first wake up from a dream and every detail is so vivid you wonder if it really happened. Despite this being an experience personal to her, the book's themes are relatable ones, dealing with the dynamic amongst a family when losing a loved one. Humor is one of the best diffusers, and Lisa hits us with it at just the right times, every time, to ensure we don't stay down too long. When I closed this book, I was touched by a myriad of emotions, but most of all, I felt the celebration of life. Carole King put it perfectly: "Written with love, empathy, and humor, Lisa Goich's story of

her mother's final journey is at once heartbreaking and inspiring."

Her creativity doesn't stop at the written word. She is incredibly crafty, and is obsessed with accessories of all kinds—especially sunglasses! For years, Lisa had her own greeting card company, carried in forty-seven stores, and has created jewelry and tote bag lines. Another fun fact about her is that she has been on not one or two, but three home improvement shows on the HGTV and OWN networks—*Trading Spaces*, *The Outdoor Room*, and *Home Made Simple*. On *Home Made Simple*, they did a kitchen redo perfectly reflective of Lisa's vintage-eclectic-modern chic style featuring vibrant colors, retro accents, and most of all, fun!

Lisa is an open book whose pages reveal what's in her heart: the love of children, animals, and people everywhere. She's a true girl's girl who instantly makes you feel like a longtime friend. She says her biggest regret is not having children, but that doesn't mean her maternal instincts aren't firing. She is the mommy to four rescue dogs, a devoted auntie, and a loyal friend to many. Her warmhearted energy has been channeled on a grand scale as the shoulder we can all lean on, the hand we hold for comfort, and the voice that lets us know we are not alone in our pain, all through the beauty of her words. Everyone should have a Lisa in their life, and fortunately, through her work, we do.

CHAPTER 11

LENS OF LIFE
ALISON WRIGHT

DOCUMENTARY PHOTOGRAPHER | AUTHOR | SPEAKER

"GO CONFIDENTLY IN THE DIRECTION OF YOUR DREAMS! LIVE THE LIFE YOU ALWAYS IMAGINED."

—HENRY DAVID THOREAU

Alison Wright, an award-winning documentary photographer, author, and speaker, has traveled to over 160 countries photographing indigenous cultures and documenting social issues, all with the intent to uncover the decency amidst the discord. Alison has the exceptional ability to become one with the landscape, creating photographs that reveal both the truth and authenticity of the human condition. Her photography has graced the pages of publications such as *National Geographic*, *Smithsonian* magazine, *Islands*, CNN, and *The New York Times*. She has authored ten books and started her own nonprofit, *Faces of Hope*, after a near-death experience brought an even higher sense of purpose into her heart. It's not surprising that she gets inspiration from true explorers like Amelia Earhart and Alexandra David-Neel.

ALISON FEELS IT'S NOT EASY TO BE A TRUE PIONEER LIKE THAT THESE DAYS. "I THINK WE CAN BE ADVENTURERS, BUT IT'S HARD TO BE AN EXPLORER BECAUSE THERE IS SO LITTLE LEFT TO EXPLORE." THERE IS NO QUESTION ALISON IS AN ADVENTURER; HOWEVER, I STILL SEE HER AS AN EXPLORER WHO DESCENDS INTO THE DEPTHS OF HUMANITY, AS A SEEKER FOR THE WORLDWIDE HUMAN CONNECTION THAT UNIFIES US ALL.

Her photo presentations and lectures are so powerful they have moved people to tears. That's exactly what drives her to do it—to bring awareness to the fact that no matter how different we may look physically, we are all spiritually one, living in one united world.

It would seem as though Alison had been preparing for her life's work from the day she was born. Flying around the world with her mother, along with three birthday gifts given to her as a child, proved the perfect foundation for her life's work. "My mom, a flight attendant for Pan Am, met my father on a flight. She was from England, and he was from Belgium, and I spent my formative years traveling, especially in Europe. I remember the excitement of going through the airports and riding with her on the planes. I loved being in motion and transported to new places. On my tenth birthday, my parents gave me a small tape recorder, a journal, and a little pocket instamatic camera. Unknowingly, they were influencing my life path with those gifts because it formed and inspired my desire to document.

"I have a profound need to write everything down. It's the same with my photographs. I have photographs going back to when I was ten from that first camera. I was on the high school yearbook committee and the school newspaper. My amazing English teacher, Mr. Lee, took me aside and said, 'You could actually make a living doing this.' He introduced me to the word *photojournalism*, explaining that 'A photojournalist travels the world and tells stories with their camera and words.' I was sold—that was exactly what I wanted to do with my life." She has never wavered from this vision. It only grows stronger as the years go on.

Alison prefers to travel the world on her own and has definite reasons for this: "There are bouts of loneliness for sure, but it's fleeting, as I actually enjoy my own company. For the most part I

prefer to work autonomously, especially when photographing communities in foreign locations. I find that when I am accompanied by another photographer, or other people, there can become a cultural divide of them and us. While making photographs on my own, there develops a sense of trust and a dance of vulnerability that creates a deep heartfelt connection with my subject. This genuine manner of communicating is important in the way I document traditional cultures in remote countries where I don't always speak the language. As the process unfolds, I'm so immersed that I forget I look different, and I lose all sense of self. I love that feeling of becoming one with humanity—a human tribe. It's the best feeling ever. This is my passion; it's what motivates me to move through the world at the inexhaustible rate that I do."

Alison chronicles the steps she took on this colossal climb to the top of her field: "I'm a big advocate of always having a personal project and creating your own path. Also, I take advantage of every door and opportunity that cracks open. You're the one who needs to take control and make things happen. This lifestyle and career didn't just appear; I created it for myself.

"I worked through college and saved my money to go to India. When I graduated, my dad said, 'India is so far and dangerous. Why don't you go backpacking in Europe instead?' I agreed only to appease him. I did go all over Europe, but when I got to Spain, I sent postcards saying how much I loved the beaches there and then jumped on

a boat to North Africa. That was a defining trip because it was my first real glimpse of poverty, refugees, and children in need. That's when I knew what I wanted to do with my camera: help people in some way with my work. Next, I went to Greece and had someone there mail postcards to my parents for me, then I took a boat over to Israel and hitchhiked all over the Middle East.

"I lived with the Bedouins of the Sinai, I worked on a kibbutz in Israel, and I went into Beirut after they had just been bombed. I was twenty-one and fearless. Then I had this idea to go to the Australian outback and did that for a couple of years. By the time I came back to the States, I had an extensive travel portfolio, which I showed to an editor at a San Diego newspaper. I asked if she thought I had any chance of making a living out of doing this. Much to my surprise, she hired me on the spot for my first real job. I worked for the *Chula Vista Star News*, then moved on to the *La Jolla Light*, and the *San Diego Union* followed. I covered whatever was going on in the community. It was very interesting, and I loved it. I was in San Diego and had a third world country in my backyard. I heard a lot of stories of border brutality even back then. When I had time off, I would cross the Mexico border and make photos at orphanages and of the local children because I cared a lot about children and children's rights. That cause stayed with me from my early travels."

Then, one day, Alison unexpectedly manifested what she longed for most. "I was in the newsroom flipping through a magazine and saw these

121

"WHILE MAKING PHOTOGRAPHS ON MY OWN, THERE DEVELOPS A SENSE OF TRUST AND A DANCE OF VULNERABILITY THAT CREATES A DEEP HEARTFELT CONNECTION WITH MY SUBJECT. THIS GENUINE MANNER OF COMMUNICATING IS IMPORTANT IN THE WAY I DOCUMENT TRADITIONAL CULTURES IN REMOTE COUNTRIES WHERE I DON'T ALWAYS SPEAK THE LANGUAGE. AS THE PROCESS UNFOLDS, I'M SO IMMERSED THAT I FORGET I LOOK DIFFERENT, AND I LOSE ALL SENSE OF SELF. I LOVE THAT FEELING OF BECOMING ONE WITH HUMANITY—A HUMAN TRIBE."

beautiful doe-eyed children from India. I thought, *I am never going to make it to India!* I called the photographer who took these striking images to tell him how much I loved his work. He told me, 'I'm a UNICEF photographer, and if you're ever in New York, come by and show me your portfolio.' I flew to New York the following week and showed him the work I'd been doing with the kids in Mexico. When he offered me a three-week assignment in Nepal, I paused for dignity, and then replied, 'Yes!' Once I arrived, every morning before I opened my eyes, I would think about how I was exactly where I wanted to be, doing exactly what I had always wanted to do—it was like a dream."

The power of the law of attraction became supercharged for Alison, affirming that we are all capable of willing our dreams into reality. "I was in the Nepal UN building at the UNICEF office looking for some photos, and I discovered their files were completely disorganized. I am an extremely organized person, so I offered to clean up the files and get their photos in order. I did that in my extra time when I wasn't photographing the assignment. They must have noticed my enthusiasm and initiative because they asked me, 'If we created a job for you, would you consider staying in Nepal?' I couldn't say yes fast enough! I stayed in Nepal for five years and loved every minute of it. That was a big part of my calling. I have tribes all over the world, but I am very close to my Nepal tribe. I have these incredible friends and family in Nepal, whom I adore so much—my heart is there. Asia is my stomping ground."

During that time, she was able to focus on another passion: "I have always been consumed with anything Tibetan. That has been a huge cause I have advocated. I realized that more of the Tibetan culture was outside of Tibet than in it. There were fifty-seven Tibetan refugee settlements throughout India and Nepal. I started photographing the whole Tibetan diaspora. I focused on this idea of how a culture can survive without a country. So, I photographed all fifty-seven settlements from top to bottom in India, Nepal, and even Bhutan. I was fascinated with their culture and learned a lot about their religion, customs, and how they survived as refugees. The Dalai Lama left his country on March 10, 1959, and over a million Tibetans followed him, all living in refugee communities. That became a huge focal point of my work. I even adopted a Tibetan girl, not to bring home with me but to help support her in Dharamsala to go to school. The Dalai Lama, who is based in Dharamsala, heard what I was doing, and his secretary contacted me to meet him. I spent six weeks there, and we became very close. He gave me a Tibetan name, and I would visit and photograph him often. This was before he won the Nobel Peace Prize, so not many people knew who he was. We have stayed friends over the years. He is a remarkable and incredibly intelligent man with a great sense of humor."

The intensity of her travel did have its consequences, but as always, she would find a way to turn it around. "Because I was living at all these Tibetan settlements, I ended up getting sick throughout those years: malaria, typhoid,

hepatitis, giardia, dengue fever, and dysentery. One time I was a case study for a mysterious disease they couldn't diagnose, so they sent me to London's tropical disease hospital, where they treated me for three months. As it turned out, I was allergic to the cure. The doctors told me I couldn't go back to Asia for at least a year. Since I didn't want to waste any time, I decided to apply to UC Berkeley to do my master's degree in visual anthropology. They wrote back saying they had no idea what visual anthropology was, but they take on one special-project person a year, and I got in. It was great because I was able to write my own program, and my thesis examined Tibetan culture in exile. Again, I explored the question, 'How does a culture survive without a country?' We had a big exhibition of the photos and interviews at the Phoebe Hearst Museum of Anthropology. That became my first book, *The Spirit of Tibet— Portrait of a Culture in Exile*, that I published many years ago. That was a big dream of mine; I have wanted to do books since I was a kid. I love books: the smell, the feel, and the places they can take you."

To get her first book published, Alison would once again access her steadfast determination. "I pounded the pavements of London, Paris, and New York trying to get a publisher. After twenty-two rejection letters, I got the book published, and then everything became a bit easier after that.

The publishers asked if I had any photos of the Dalai Lama, which of course I did. That became my second book, *A Simple Monk*, which was pretty successful. I decided my next book would be on children because that was such an important topic for me. That's how my third book, *Faces of Hope, Children of a Changing World* came to be."

During this exhilarating time in Alison's life, she was living her dream. Then life threw her a curveball. She guided me through the chilling event that she almost lost her life to: "I was in Laos on a work project, traveling by bus as I usually do. I was going from Luang Prabang down to the south. The bus came around the corner too fast on a very narrow mountain road and was sheared in half by a logging truck. I sat right at the point of impact—it was gruesome, and people were killed. I was the most injured of the survivors, unable to move my legs as everyone else fled from the bus. People were screaming to get off because it was on fire. I was alone and unable to walk, but knew if I didn't get off, I would burn inside. Two brave men returned to save me. I'm reminded every day that I'm alive today because of the kindness of strangers."

The men carried her off the bus and laid her on the ground. Alison looked over at her left arm and saw that it had been punctured by broken glass and metal shards. She went to take a deep breath and

> "I'm reminded every day that I'm alive today because of the kindness of strangers."

was unable to get any air into her chest. "I quickly realized that I was severely injured, and since I couldn't move, suspected that I had broken my back. I laid there for about an hour because there were bandits—guerilla warfare was going on and people weren't about to risk getting caught in the crossfire to help me. Once it was safe, villagers brought me to a small cowshed used as a makeshift clinic for the injured. This young man proceeded to sew my arm back up with no painkillers, using an upholstery needle and thread. I was out of my mind with pain—it was horrendous. I never lost consciousness because I wouldn't allow myself to go into shock. I knew I had to stay awake, because if I didn't, I would not get out of this alive. They explained that they didn't know what to do with me; there were no phones, and nowhere for me to go. At this point, it was clear that this was where I was going to die. I managed to write a note to my family and told them how and where I died.

"I guess it just wasn't my time because a British aid worker, Alan Guy, found me, and he and his wife Van put me in the back of a pickup truck and drove eight hours to a hospital in Thailand. He saved my life. The doctor couldn't believe I had made it this far. He told me that without medical care, in another two hours, I would have died. They rushed me into surgery, but the odds of my survival were still very low. I was in intensive care for three weeks, and I had many surgeries—it was touch-and-go the whole time. When I look back at the accident, I just remember this fight inside me to survive. I was finally med-evac'ed back home to San Francisco, where they told me that I would

probably never walk again. As an avid scuba diver, yogi, skier, swimmer, rock climber, and most importantly, photojournalist hopping all over the world, I didn't accept that diagnosis for a minute. I had broken my back, my pelvis, and all my ribs on the left side. My arm was totally shattered, and I am so lucky that I still have it and can use it. I had major internal injuries and practically bled to death on the operating table. My spleen was lacerated, my diaphragm ruptured, my heart was herniated, and my lungs were collapsed. Not being able to breathe was the scariest thing for me."

After being riveted by this harrowing survival story of absolute strength and courage, I had to ask Alison how she was able to not panic from the pain, especially when she could barely breathe. "It was frightening, and created a sense of anxiety, but I have a deep meditation practice that I adopted from my years of living in Asia, Vipassana meditation, which is really about the breath. I have done these long retreats with monks in Burma, Thailand, and India. I would sit for three weeks at a time in total silence. I honestly feel that without this skill set, without those tools, I would never have survived. I can pass out at the sight of blood, so when I was lying on the side of the road and saw my injured arm, I thought, *don't go there, just breathe—just breathe in and just breathe out.* Everything was about the next breath. I bring that into my daily life. I have this mantra tattooed on my wrist in old Tibetan script: *breathe in, breathe out.* If you do that, you can get through anything."

Alison had survived and wanted to return to doing what she loved the same way she did before the accident. "I think when you have such a profound near-death experience, it makes you reassess your life. I wanted the life I loved, and the work I loved, what I had created my life to be. I was on the right path before the accident. This was a huge motivator to get back to doing what I love again. There were major challenges to overcome because my body was so completely damaged. It was up to me to do the work. The power of the mind is so intriguing and is all you have to rely on, especially when you're working with fear. What is fear? To me, fear is just a thought. It's a very human instinct to feel fear about what could happen and start spiraling on a story you have created in your mind. Be in the moment, and if you can stay in the *here and now*, you're not worrying about the future, and you're not regretting the past. I try to stay in this state of mind: clear and present."

Once again, Alison would use her recovery time well: "I've made a living as a photographer for my entire career and then suddenly the ability to do that was taken from me. I couldn't photograph anymore, so I started writing. I wrote an article about my accident for *Outside* magazine, and it ended up being their most-read."

After one of her many surgeries, the doctor encouraged her to think about a different career, now that it was likely that she would never walk properly again—which meant giving up her work as a photojournalist. Alison's response was a defiant one. "I told him I planned on climbing

Mount Kilimanjaro on my birthday the following year. I don't know where that came from; I just threw that out there because I was so annoyed, and I needed a goal. I'm very goal-oriented. Then I became obsessed with this idea of climbing Kilimanjaro. I changed all my doctors and rehab people. I used a combination of Western and Eastern medicine including reflexology, yoga, Pilates, massage, Rolfing, chiropractic work, and a lot of acupuncture. I stopped all pain medication and instead turned to herbs and supplements. I worked so hard, and there were many ups and downs, surgeries, and setbacks. It took me two years, but I did make it to the top of Kilimanjaro, and that felt huge."

The editor of *Outside* magazine asked Alison to write a follow-up article about climbing Mount Kilimanjaro, and that was equally successful. The next thing she knew, agents started calling her from New York, urging her to write a book. The last thing she wanted to do was something that would keep her sedentary. Having just gotten her legs back, she only wanted to start photographing again. She explained what changed her mind: "I got this great agent who worked with me to write a book proposal. I figured this would be a back-burner project, so I took an assignment in Antarctica for six weeks. I had just gotten on the ship, and my agent called me saying there was a bidding war going on. He wanted to know which publisher I would prefer. I said, 'Well, I am looking out of a porthole in Antarctica, and all I see are penguins, so let's go with Penguin Publishing!' " That was how Alison's memoir, *Learning to*

Breathe: One Woman's Journey of Spirit and Survival came to be. This book is a powerfully moving and inspirational memoir, featuring a foreword written by the Dalai Lama.

Many years ago, Alison started a nonprofit named after her third book, *Faces of Hope*. The FacesofHope.org mission statement aims to globally support women's and children's rights by creating visual awareness and donating directly to grassroots nonprofit organizations that help sustain them through education and healthcare. "I give back to the communities that I photograph by donating money to help them. The big motivator for me was the experience of my accident. It took me years to recover from that, and I truly understand what it means to suffer. It brought a whole new sense of empathy to my work. I have always hoped that somehow my work will help people in some way and that when I make a photo, it will make a difference. I am always hopeful that someone might see it and be compelled to help. Then, there was a point where I asked myself, 'Why not me?' Now that I was selling books and lecturing, it opened me up to meeting people who wanted to help; so that's when I set up the fund.

"When I covered Haiti's earthquake, which was the most horrific thing I had ever seen, I was able to raise thousands of dollars to provide tents for them. The fund has also helped supply tents after the earthquake in Nepal, send girls to school in Africa, provide support for a burn unit in Nicaragua, provide medical help for Burmese refugees, and, most recently, help sex workers in Mumbai, India. It's small potatoes, but at least it supports the spirit of giving back."

When the coronavirus pandemic hit in March of 2020, Alison was in Vermont for the opening of her latest photo exhibit, *Grit and Grace, Women at Work*, at the Battleboro Museum. The project focused on the empowerment of women at work in global communities. The opening, the exhibit, and the scheduled lectures were all canceled

> "The big motivator for me was the experience of my accident. It took me years to recover from that, and I truly understand what it means to suffer. It brought a whole new sense of empathy to my work. I have always hoped that somehow my work will help people in some way and that when I make a photo, it will make a difference. I am always hopeful that someone might see it and be compelled to help. Then, there was a point where I asked myself, 'Why not me?'"

due to the COVID quarantine implemented the weekend of the show. These images are the source of a critical message and conversation that the world needs to be a part of, and are all included in her book of the same title.

Alison arrived at this topic while again looking at the things that connect us worldwide. "Work is one of them; we all must work in some capacity. An image deeply moved me while I was on assignment in Nicaragua: women digging through a giant garbage dump, collecting recyclables that would bring them a dollar a day. I listened to their stories and found out they were all single women—widowed, divorced, or their husbands had left them for other reasons. They were now alone and forced to be self-sufficient. I was moved by the power of these women who will do absolutely anything to support and feed their families. I was inspired to explore what work means to them. That's what became the basis of this rather meaty project that I've been working on for the last few years, mostly off-assignment work in Africa, Asia, and Latin America. My focus is on developing countries because it's such an interesting snapshot of time to see how women are making their mark in the world.

"These women are my heroes; they inspire me because, despite being in challenging conditions, they get up every day and soldier on. Look at the sex workers in Mumbai: many were drugged and sold by their husbands, and suddenly they wake up trapped in a brothel. How do you come back from that? Nearly every woman I met in the Congo had been raped. I ask them, 'How do you still effuse such joy?' They say it's the work. It gives them a sense of purpose and a sense of community. That struck me. I've seen so many strong women in difficult situations. That is what the *Grit and Grace: Women at Work* project is all about. I look at them in wonderment and think, 'How do you find that strength to rise above your circumstances?' If they can do it, I certainly can."

Alison is a hero in her own right, inspiring people everywhere who have read her story and viewed her photography. Her work has been highly recognized, with honors such as the Dorothea Lange Award in Documentary Photography, the Lowell Thomas Travel Journalism Award—twice—and in 2014, she was awarded *Premier Traveler* magazine's Most Compelling Woman in the Travel Industry Award and was also named *National Geographic*'s Traveler of the Year—someone who travels with passion and purpose.

Not many of us can travel to the places Alison has been, but thanks to her fierce dedication to sharing her art, we can be visually transported to these destinations. She is a conduit to show us the world. We need only to listen to the messages emanating from her photography—to open our hearts to the fact that we live in a global community where we are all as one. The Dalai Lama said, "Share your knowledge, it is a way to achieve immortality." Alison has achieved that with the gift of these hypnotic, immortalized images documenting our planet for generations to come.

HONORING ALISON WRIGHT

More than a year after Alison's chapter was written, our beautiful lone warrior departed from this world to the next, while doing what she loved— exploring. Alison had a cardiac episode while on a diving boat off São Miquel Island in the Portuguese Azores. After a week in a coma, Alison transitioned. She brought her light into a new realm, but she left an abundance behind through her words and photographs. Her legacy of love brings faces to the faceless from around the globe, exposing the universal truth that we are all united by the same human existence. Alison felt the fear of death was nothing compared to the fear of not having lived life to its greatest extent. The unremitting drive to do so had her living the equivalent of a thousand lives. The primary objective for her work was to become one with humanity. So, in the spirit of her intention, let's carry on that message into our own lives with love, compassion, and gratitude for ourselves and each other. As Alison would say, "We are all one human tribe."

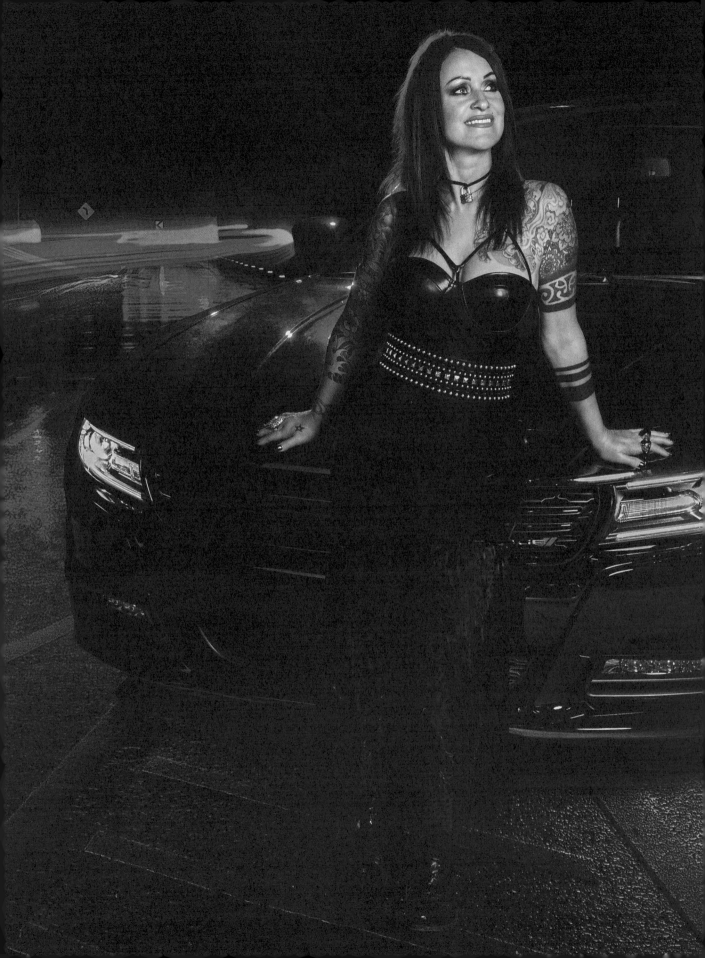

HOT-ROD HAIR GURU CAZZIE MAYORGA

HAIRDRESSER | MAKEUP ARTIST

"SHAKE 'EM, YOU WON'T BREAK 'EM."

—CAZZIE MAYORGA

At fifteen, this hot rod of an Australian knew exactly what she wanted to do with her life. Never one to waste time, she left high school to become a hairdresser. By nineteen, she owned her first salon, and by twenty-two, she sold it to travel the world doing hair and makeup on an adventure of a lifetime! The daughter of a race car driver, Cazzie grew up as a racetrack pit girl and was permanently infused with fast motion and excitement. Only Cazzie didn't want to go around in circles; she wanted to propel herself to new and exotic lands across the globe. It would take love to find the place she would call home. Cazzie's personal style reflects her reverence and exhilaration for life, radiating vibrant pops of color and makeup sparkling like her personality. Just a few minutes in her presence is better than any energy drink on the market! You are instantly lifted by the positivity that radiates from this electrifying woman.

CAZZIE WAS RAISED IN THE MELBOURNE SUBURBS THIRTY MINUTES OUTSIDE OF THE CITY. "I HAD A GORGEOUS MOTHER WHO WORKED FOR MARY KAY COSMETICS AND A BUTCHER FATHER WHO BOUGHT AN ALFA ROMEO DEALERSHIP AND BECAME A RACE CAR DRIVER. I HAVE A BEAUTIFUL SISTER, TWO AND A HALF YEARS OLDER THAN ME, AND A BROTHER, EIGHT YEARS OLDER. MY BROTHER WAS AN OUTRAGEOUS EVIL KNIEVEL TYPE WHO WOULD HAVE ME AND MY SISTER DOING ALL KINDS OF CRAZY THINGS."

"My childhood was always boy-related, with having to go either to watch my dad in car races or my brother in motorcycle races. Most of my early life was watching my father and brother go around and around the racetrack.

"When I was thirteen, my sister's best friend, who did hair, told me I should be a hairdresser and that it was the best job in the world—I would get to travel and meet people. She hired me as her assistant at a men's salon called Chaps. I was her shampoo girl, coffee maker, and apprentice for the first couple of years. I was dyslexic and wasn't that great in school, so when they offered me a four-year apprenticeship at the salon, I took it. My mom let me leave school and start my hairdressing career at fifteen. I went to school once a week and apprenticed for the next four years. That's how it works in Australia; you can't just go to school and be a hairdresser. They're very strict. At nineteen, I started my own salon with a girl I had worked with, and then when I was twenty-two, we sold it—I just wanted to leave Australia to travel."

Cazzie's first trip at sixteen awakened the wanderlust within her. "The girl I was apprenticing for took me to Bali. My parents allowed me to go because she was so much older than I was. After we arrived, she missed her boyfriend and went home. I told my parents I was staying. It was during this trip I discovered meditation and spirituality. Bali is a gorgeous place where the people are beautiful, soft, and spiritual. The food and everything about it made it my type of place: it's tropical, and you can live a peaceful life in a hut on the beach for no money while blissfully watching the ocean. At night, there are always great parties with radiant people and amazing music. I went back every year when I lived in Australia, but haven't been back for twenty years now."

After she had sold the salon, Cazzie set the course for her travels. "At the time, my boyfriend had been in London for a year and suggested I come out. When I got there, I started working at a salon that's still there to this day: Basecuts in Notting Hill. After three years, I left London, as well as my boyfriend, to travel through India, Nepal, and Thailand. After that, I spent a summer in Greece, cutting hair on the beach during the day and working at a bar at night. Eventually I ran out of traveling money, so I had to return home."

Now that her lust for traveling was satiated for a while, she was able to focus on her career. "When I went back to Australia, I opened up my first Gorgeous salon at twenty-five. It was across the road from a needle exchange, and I was surrounded by prostitution on Grey Street in St. Kilda. It was a very wild time in my life with a great community, and I miss it madly! There were lots of eccentric characters coming around who were always in my life. If anyone asked me where in Australia I would call home, it would be St. Kilda. I may not have grown up there, but that's where I felt I belonged. It's very alternative—great rock venues, restaurants, and lots of vegetarian food."

When Cazzie turned thirty, she sold her Gorgeous salon, bought some boobs, and purchased an around-the-world ticket to Thailand-Japan-Los Angeles-San Francisco-Thailand-Australia. "In Australia, you are allowed to get working visas, which is why I was afforded the opportunity to work in all these countries. I started in Thailand, since I needed a little break after five years of running my own business

and just chilled out on the beach, read books, and ate pure delicious food. I lived the simple life of a local beach girl on my own in a hut—beautiful solitude. Then I was off to Tokyo. I had a true fascination with Japanese culture, the hairdressing, the colors, and style. I wanted to learn all I could about the Japanese style of hairdressing, so I got a nine-month working visa for Japan. Unfortunately, not speaking Japanese kept me from working in a salon. Instead, I had to work as a hostess until I got a job in a Western salon. After my visa was up in Tokyo, November 1999, I was off to Los Angeles. I used my local travel guide to figure out where to go in LA and chose Venice Beach. I stayed at a hostel for three months and every Saturday night I would catch a bus to Hollywood and go to clubs. I just couldn't meet the right people. I kept asking myself, 'What am I doing here?'"

Just when Cazzie was about to give up on LA, a serendipitous decision changed everything. "I found a business card in my backpack from a guy I met at a tattoo convention in Tokyo who lived in LA, so I called him up. He invited me to a party he was having that night, and this crazy girl and I immediately connected. I moved into her house the very next day! She was a photographer, and instead of paying rent, I did hair and makeup for her. I was also doing haircuts at a home salon, and three nights a week I worked at the Burgundy Room in Hollywood. One day, she had some photos out on the table, and I pointed at one and said, 'I know that guy. I saw him at an after-party for a music festival in Australia.' She said, 'That's Roy Mayorga. He's a drummer and one of my best friends from New York, who just moved here. I am going to set you two up!' I had a birthday coming

up, and she invited him to my party at the Dragonfly Club in Hollywood. When he walked in the door, I jumped in his arms and wrapped my legs around him—we actually have a photograph of it! We partied all night and ended up in each other's clothes, and we've been together ever since!"

Cazzie and Roy's marriage story follows their swift and unconventional courtship perfectly. "I was here on a three-month visa and had overstayed by 180 days. Roy was about to go on a big tour with the band Soulfly, and I was about to get kicked out of the country. We were talking about this while shopping at Foods for Less in Hollywood, right in front of the tomato section, and that's when he got down on one knee and proposed! Beverly Hills City Hall was booked, so we raced down to Van Nuys courthouse and got married. I was later issued my green card, in 2006, and became an American citizen."

During this time, Cazzie worked at a few salons and freelance jobs, and did home haircuts. Then, in 2003, she finally saved enough money to open a salon on Melrose with her Aussie friend and business partner. It would be the second Gorgeous salon! "I did all three jobs until I built up a clientele." Cazzie's love of music and her rock 'n' roll style quickly made her the go-to hair stylist for almost every rock star in town. After many successful years there, the Melrose salon moved to another location. "In 2011, Roy and I bought a house that had dwellings on the property for both of us to have studios, so I was able to have a wonderful space for a home salon. Unfortunately, the Melrose shop had a lease until 2015. Until then, I would drive two days a week to work there, then work from home the rest of the week."

Between the new house, working at two salons, and doing freelance jobs, Cazzie's plate was very full, and it was about to get even fuller. "That same year I got pregnant after trying for four years and having three miscarriages. I found out that I had Hashimoto's Disease, an autoimmune hypothyroid condition, and once I got that under control, I was able to have a successful pregnancy. After all those fertility doctors, what helped us to conceive was a night on Penfolds wine from Australia! I was four months pregnant when we moved into the new house in April. Then, when I was on a job in Malibu, I got a phone call that Roy had a stroke while on tour. I was six months pregnant, had just signed a thirty-year mortgage, and had a forty-one-year-old husband who had just suffered a stroke. I raced off to Fargo, North Dakota, to be with him in the hospital. This was an uncertain and frightening time, not knowing what type of recovery Roy would have. Incredibly, he fully recovered by the time we had Nico on September 27."

The stressful twists and turns of 2011 continued with Nico's arrival. "I had to have a planned C-section since she was a week late. The birth seemed to go smoothly until the nurse found Nico's belly all blown up in the middle of the night. They immediately rushed her to another hospital with a neonatal intensive care unit. Since I'd just had a C-section, they wouldn't release me to go with her, so I escaped. No way would I be without my baby! I don't remember my C-section or healing from it at all

"I LOVE THE FREEDOM OF MY JOB. EVERY SINGLE CLIENT WHO SITS IN MY CHAIR HAS A DIFFERENT HAIRLINE, FACE SHAPE, TEXTURE, AND STORY TO TELL. EVERYTHING ABOUT MY JOB IS EVER-CHANGING AND THERE IS ALWAYS ROOM FOR IMPROVEMENT. I LEARN SOMETHING NEW EVERY DAY EVEN AFTER THIRTY-EIGHT YEARS IN THE BUSINESS. IT'S ALWAYS MOTIVATING WITH SO MUCH MORE TO LEARN."

because I was so upset about Nico. We found out that her colon wasn't fully developed, and she had to have six inches of it removed. She stayed in the NIC unit until she fully recovered. Roy helped me take care of her, but then he got an eighteen-month-long tour with Soulfly when she was eight months old. Nico went to work with me every day. The first time she crawled was across my salon floor covered in hair, and by the time she got to me she looked like a little Yeti! Being able to work full-time from home made things a lot easier. I had always done freelance hair/makeup for photographers, commercials, music videos, and tattoo magazines, but that slowed down after Nico."

Cazzie never wallows in something once it has passed. She brushes herself off and moves forward with an *onward march* attitude. "I don't dwell on things; I just move on. Everything is always going to be okay, and it's over in a second. Things can only get better, and if they don't, oh well. I am emotional, but not one to feel sorry for myself. Maybe that's the Australian in me—'Toughen up, mate, toughen up!' After going through the recession with my parents, I learned the importance of keeping it together. Yoga, music, incense, and candles really help me to maintain my peace; I need a lot of that around me. I need to be surrounded by happiness since I am very sensitive to darkness. Yoga is something that gives me balance, control, and

> **"I don't dwell on things; I just move on. Everything is always going to be okay, and it's over in a second. Things can only get better, and if they don't, oh well. I am emotional, but not one to feel sorry for myself."**

power to be a good mom. I need that hour to think, stay positive, and to keep strong. The only time I get down is when Roy is on tour too long. That's how he makes a living, but when he's gone more than four weeks, it's too much. It's hard because when he is home, it's harmony." This harmony and beauty are wholly reflected in their home decorated with artifacts Cazzie has collected from all over the world. There is a giant ten-foot Buddha that overlooks the property, maintaining love and peace throughout the space.

She is truly passionate about her career, and I couldn't imagine Cazzie doing anything else. She is a master at hair and is constantly educating herself to the newest techniques and training. She is also a talented makeup artist. Most of all, she loves working with her clients. "I love the freedom of my job. Every single client who sits in my chair has a different hairline, face shape, texture, and story to tell. Everything about my job is ever-changing and there is always room for improvement. I learn something new every day even after thirty-eight years in the business. It's always motivating with so much more to learn." The love for her clients is abundantly reciprocated by everyone fortunate enough to sit in her chair, as well as the photographers and directors she has worked with over the years. Acclaimed

director/photographer Dean Karr describes exactly what it is like to have Cazzie on your team: "Cazzie is a lucky charm who came into my life almost twenty years ago. She has such creative vision and is always full of positive production vibes when things get tough on set. She has been an integral part of my glam squad department. Australia's best export ever! I absolutely love her!"

Becoming a mother came with many changes for Cazzie, not only for her career but as a reset to her priorities. "Having a child made me take a step back from myself and my career, especially since I have a husband who's away so much. I have my busy little private home salon, Gorgeous Hair That Rocks, and that keeps me happy and motivated. Nico's the best part of my life, and letting go of all the other stuff

doesn't matter because I have this beautiful little girl. Nico is my everything, my happiness, my fun, my party. She is a part of every aspect of our lives, including our social and chill time: it's Nico, my husband Roy, and my dog Rosie. This is my first dog, and sometimes I think I love her more than anyone! She is such a huge part of our family, and I am so grateful she chose us at the shelter."

A perfect day for Cazzie is all about being grounded in nature. "I would be sitting on a rug in a beautiful park or beach looking out beyond the horizon with no thoughts in my head and my family by my side. The sun is shining, and my smile reflects an enormous sense of gratitude." You may also find her there wearing hot pants, glitter, and of course, a vibrant shade of lipstick!

ROCK CHILD
PEARL ADAY

SINGER | SONGWRITER

"YOU HAVE TO UN-LOVE YOUR LIFE TO BECOME A BAD GUY."

—REVEL YOUNG IAN

Pearl Aday exudes gratitude—for her life, love, motherhood, and the beauty that surrounds her. She is a gifted singer-songwriter whose voice effortlessly erupts into that of the quintessential rock 'n' roll vocalist. She attributes her staunch professionalism and strong work ethic to the example set by her legendary father, the world-famous Meat Loaf. She is fiercely passionate about what she believes in, especially when it comes to human rights. The depth of her heart is endless, for love to her is everything.

I WANTED TO GO BACK TO WHERE IT ALL BEGAN FOR PEARL. QUITE FITTINGLY, IT STARTED IN WOODSTOCK, NEW YORK. "I WAS RAISED IN WOODSTOCK UNTIL THE AGE OF FOUR, WHEN MY MOTHER MET MY FATHER, MEAT LOAF."

"That timeline might be confusing for most people, but the man who my mother conceived me with is not my dad and never has been. My 'bio-dad' is Clark Pierson, drummer for the Full Tilt Boogie Band, Janis Joplin's last lineup, and for Dolly Parton for a brief while. From what I understand and remember in tiny slivers, he proved to be someone my mom and I needed to break away from. My mom met Meat Loaf at the end of 1978, and they married in January of 1979 at Todd Rundgren's Woodstock home. I was the flower girl. Meat Loaf immediately adopted me as his own and changed my name to Aday on my birth certificate. We began our lives together in Stamford, Connecticut, and Manhattan, NYC. Both were our home bases and where I was raised, along with my sister Amanda, who was born in 1981."

Under a strong suggestion by her father, Pearl went to Emerson College for a major in creative writing. She had always loved writing and considered herself a writer. She also loved music,

and singing had been in her life since before she could speak. She graduated with a BA in creative writing and has found it very helpful for writing lyrics. During Pearl's first year at Emerson College, her father recognized music was not only in her blood, but rooted in her soul. He offered her the opportunity to audition as a backup vocalist in his touring band. The idea was that she would tour with him over the summer break from Emerson. Meat Loaf's album *Bat out of Hell 2* was coming out, and it was going to be a massive world tour. By no means was this going to be handed to her. "My dad said, 'Do you want to audition to be in my touring band?' and I said, 'Of course, yes, I would love to.' He said, 'All right, I have this gig at Madison Square Garden coming up. I am not going to put you on the stage. I want you to stand on the side of the stage, and we'll give you a live mic. George, the front-of-house guy, is going to record your mic. You learn these songs the best you can and sing along with them. I will then listen to your vocals after the show.' I passed his test, and pretty soon, I was up on stage in front of thousands of people singing along. I was given wardrobe to wear, a schedule, day sheets, and per diems. My dad said, 'All right, you are an employee, so when we are at rehearsal—when we are at sound check or at the gig—you are an employee and treated no differently than anybody else.'

"We were playing at places such as Wembley Arena, the Royal Albert Hall for Prince Charles, and later in the year at the second inauguration of President Bill Clinton. We did *Top of the Pops* several times, *The Tonight Show* with Jay Leno,

and *Late Night* with David Letterman, as well as many other TV appearances. I had these amazing opportunities. We traveled to South Africa, the Middle East, Australia, New Zealand, and Japan. Then I went back to college, and I was just like everybody else. So, it wasn't, 'You want to do music? Here's a tour bus. I'll get you a record deal.' If it's all just handed to you, what the fuck do you learn from that? When you're just given things you haven't earned, there's no appreciation for it."

Pearl's father wanted to provide her with the complete school of life, to be fully independent and to accomplish achievements on her own merit. Pearl elaborated, "It wasn't, 'You're my kid, you can do whatever you want on the road.' It was, 'This is my fucking show, don't you fuck up my show. Baby, if you can't stick with it, then you're out.' My dad always said to me, 'It's a privilege to be on stage, not your right. It's not my right to be on stage. I have to earn my audience every single night. Every album I create, I'm earning my time in front of the camera, my time in front of the audience. So, I'm going to put one million percent and every bit of myself into that because my audience deserves it. You don't just walk onstage because you get to, and never show up late! You give them everything you have!' So, he really instilled that in me. Why are you here if

you're not going to make the best show that you can? Why are you here if you're not being the best artist you can be? Otherwise, you're just wasting everybody's time."

Pearl's family is one that plays together, travels together, and even works together. Her husband, Scott Ian, guitar player and founding member of the band Anthrax, has been a part of all Pearl's solo projects. Pearl and Scott are also members of the band Motor Sister. Some might think crossing over into multiple musical collaborations would bring tension to their relationship; in fact, it's quite the opposite. "There are a lot of reasons Scott and I work so well together. The most important thing is that we respect each other— we are each other's biggest cheerleaders. We grew up making music separately and bring with us the knowledge of doing our job respectfully and properly. When Scott was in my bands, we toured in a van with a bunch of dudes driving across country. We were in Europe opening for Velvet Revolver, and we worked together like a charm. Of course, you can get frustrated with each other, of course you disagree—if you didn't, it would be weird. You have to know how to disagree, and you have to remember what's most important by recognizing what's behind the other person's opinion. You can

> "Why are you here if you're not going to make the best show that you can? Why are you here if you're not being the best artist you can be? Otherwise, you're just wasting everybody's time."

"ONCE YOU BECOME A MOTHER, YOUR CHILD IS EVERYTHING TO YOU. YOU WOULD BLEED, YOU WOULD TEAR YOURSELF IN HALF, THERE ISN'T ANYTHING YOU WOULDN'T DO FOR THEM. I CAN'T SPEAK FOR EVERYBODY, BUT I THINK THAT ONCE YOU HAVE A CHILD, YOU ARE A MOTHER TO EVERY CHILD IN A SENSE. A MOTHER IS THERE FOR OTHER MOTHERS. YOU'RE ON THE MOM TEAM. IT'S LIKE MOTHER EARTH: YOU PROVIDE FOR WHOMEVER NEEDS IT AND GIVE WHATEVER YOU HAVE."

argue, but trust that this is not a deal-breaker; they are still your favorite person, and you will just work it out. Scott and I tell each other, 'You're my favorite person, and together we made our other favorite person.' " That other favorite person is their son, Revel Young.

When asked to describe motherhood, her voice fills with emotion: "Once you become a mother, your child is everything to you. You would bleed, you would tear yourself in half, there isn't anything you wouldn't do for them. I can't speak for everybody, but I think that once you have a child, you are a mother to every child in a sense. A mother is there for other mothers. You're on the Mom Team. It's like Mother Earth: you provide for whomever needs it and give whatever you have."

Our discussion turned to how she balances motherhood and her own personal identity, her response was an honest and genuine one: "I don't think I am quite there yet, but I am on my way to figuring it all out. I wrote a song on my newest album called 'Who Am I?' The lyrics went more in the direction of a love story, but the original idea for the song came out of being completely sleep-deprived and having what I now know was serious postpartum depression. It didn't take the form of rejecting my baby, in fact, the complete opposite. I wanted to hold him and never let him go. The world became a terrifying place. The only thing that mattered was my baby and protecting him. I lived in a constant state of panic, of intense fear, constantly checking windows and doors, keeping

an eagle eye on strangers out in public, finding the fire exit in every room. I was terrified most of the time. A friend of mine who'd had a baby around the same time said, 'Isn't life and the world so much more beautiful now that we're parents?' I started crying because I was so stuck in a world that was anything but. Don't get me wrong, in my personal moments and safe time at home, I was in heaven. I had never felt love like that in my life and I think it completely overwhelmed me. I just wanted to do it right. I didn't know how to exist as an artist and a mother at the same time. I thought I had to give up myself and give it all to my baby.

"It's important to understand your life is for your child now, but not to the degree that you lose yourself. You don't get a chance to think with a totally clear head, which sounds crazy because you're taking care of a baby. Somehow the mothering and the baby stuff comes to me on autopilot. I know exactly what to do to take care of somebody else, but I dropped what it meant to take care of me. I turned myself inside out and gave every last shred to my baby, leaving me with no identity outside of motherhood. My career was gone, my body was different from pregnancy and the physical trauma of giving birth, my short-term memory was suffering, my social skills and conversational rhythm were just about gone, and my self-esteem was smashed. I could never sleep because of the panic. I didn't know who I was anymore—I got so lost. Then I started to think, 'Who am I? Where am I going? I have failed.' "

Pearl revealed how disconnected she had become from one of the most familiar and comfortable places in her life—the stage. "I played a local gig with my band during this time to test out some new songs I was working on for this latest album. I stepped onstage with my band in front of that same microphone, and I felt like I was wearing a costume. I didn't belong there like I used to, and it crushed me even more. After that, I thought I lost my fire; I thought I lost what made me feel like a worthy contender professionally, and on this earth. I truly love being a mama and a homemaker. I take tremendous pride in all of that. I just didn't only aspire to be a housewife. This postpartum depression that I didn't know I had at the time lasted for seven years and kept me in that mental space. The black cloud of depression lies to you. Like a demon possession, it takes you over and poisons you with this intense darkness—it can be debilitating."

Postpartum took her mind to places she had never been before: "The pit gets so deep and so dark, with fear and hopelessness, self-loathing, suffocating feelings of sheer failure, but I knew in my gut that there was no fucking way I was going to give up. On the other side of these extremely brutal and very real emotions is this built-in coach, this cheerleader, that keeps me alive and going. Quitting is not an option, because look who's watching. I don't mean to make it sound like it was just misery for years; it has also been learning, laughing, and an absolute head-spinning joy."

Taking a holistic approach to treating her PPD, using acupuncture, herbs, yoga, diet, meditation, and exercise, is what returned her body and mind to a balanced state. She enlisted the care of a doctor of Traditional Chinese Medicine, a healing cranial-sacral and therapeutic mind/body wellness practitioner, and a kickboxing trainer. She acknowledges this may not be the route for everyone, but it was right for her. Her wish is for anyone who needs help to get it, encouraging women to do whatever it takes for them to heal.

Pearl sets a high bar for herself regarding her musical performances. She spent years watching her legendary father's work process. "He's an unbelievable force of nature, and he's a tenacious guy who was told by everyone, 'You'll never make it, this is ridiculous! You're a fucking joke—you're some fat guy—you're Ethel Merman!' He even kept—and turned into a victory—the nickname his abusive father gave him when he was a baby because he was born a big kid. I have that as an example. So, I am forging ahead, still saying 'yes' to every opportunity, especially the ones that scare me."

Her latest album *Heartbreak and Canyon Revelry* is a raw melodic blend of California country rock. This is the follow-up release to her critically acclaimed 2010 debut album *Little Immaculate White Fox*. It's a deeply personal album that chronicles the ups and downs of her journey into first-time motherhood and starting a new life in Topanga Canyon. The desire to unify us through music is what drives this gifted artist to open her

heart and expose a vast color wheel of emotions for all to see.

The completion of her album was the catalyst to propel her into new and exciting projects: "I started writing songs with and for several country music artists, including Ward Davis, Cody Jinks, Sunny Sweeney, and Erin Enderlin. Our band Motor Sister has a new album releasing May of '22 with a tour to follow, and I've been working on a new album with my solo project. I'm performing and booking shows and pushing myself to be the best I can be. I respond really well to positive reinforcement, and I owe the world to my husband Scott and my son Revel, my rocks, and my incredible friends for being the amazing support system that they are. When I give myself the love I need, I

immediately recognize that I am surrounded by it also. It took me a long time to realize that."

One of the predominant traits I have recognized within the families of artists has been parents openly willing to access their inner child. This philosophy is one practiced within the Ian/Aday home: "Scott and I have a saying about the difference in matured humans. We ask, 'Is he a grown-up or is he an adult?' An adult is somebody who has lost the idea of what it's like to be a child; a grown-up is somebody who has matured, understands responsibilities, how to exist in a civil way in society, but still feeds that child within them. I think that's what a lot of artists are. Not everybody's the same, but that's a common element I have seen. You have to be able to let go and know how to use your imagination;

"Scott and I have a saying about the difference in matured humans. We ask, 'Is he a grown-up or is he an adult?' An adult is somebody who has lost the idea of what it's like to be a child; a grown-up is somebody who has matured, understands responsibilities, how to exist in a civil way in society, but still feeds that child within them. I think that's what a lot of artists are. Not everybody's the same, but that's a common element I have seen. You have to be able to let go and know how to use your imagination; an adult is somebody who has lost theirs. Most of the artists I know are grown-ups who still fully embrace their imaginations. That magic is your life force."

an adult is somebody who has lost theirs. Most of the artists I know are grown-ups who still fully embrace their imaginations. That magic is your life force."

Pearl's delicate arms are beautifully embellished with tattoos representing all that she holds dear. I was immediately drawn to the totem on her left inner forearm of three spirit animals: a black bear, a black panther, and a white fox. The bear and white fox are from experiences that occurred when Pearl's mother was pregnant with her, and the black panther was from one when she was pregnant with Revel: "Every night for two weeks, I had the same dream; it was as though I was awake in my room looking out the window at our tree, except in the tree there was a female black panther draped over one of the branches. She was peaceful and calm, her front paws crossed, and head held up high. She looked right into my eyes and made me feel safe and that everything was going to be okay."

It made perfect sense that this powerful animal appeared to Pearl. The black panther comes to people who live their lives honestly, gracefully, and authentically. It's the symbol of the feminine and provides courage, protection, and guardian energy. When in your dreams, it represents walking along a new path in your life without fear, and the courage to stand up to whomever and whatever may try to block it. This prophetic dream couldn't be more suited for this extraordinary woman, who devoutly adheres to all these principles in her life. She is a champion for all whom she loves, a voice for all she believes, and an artist who touches you with her song—all the while being guided by her heart of gold.

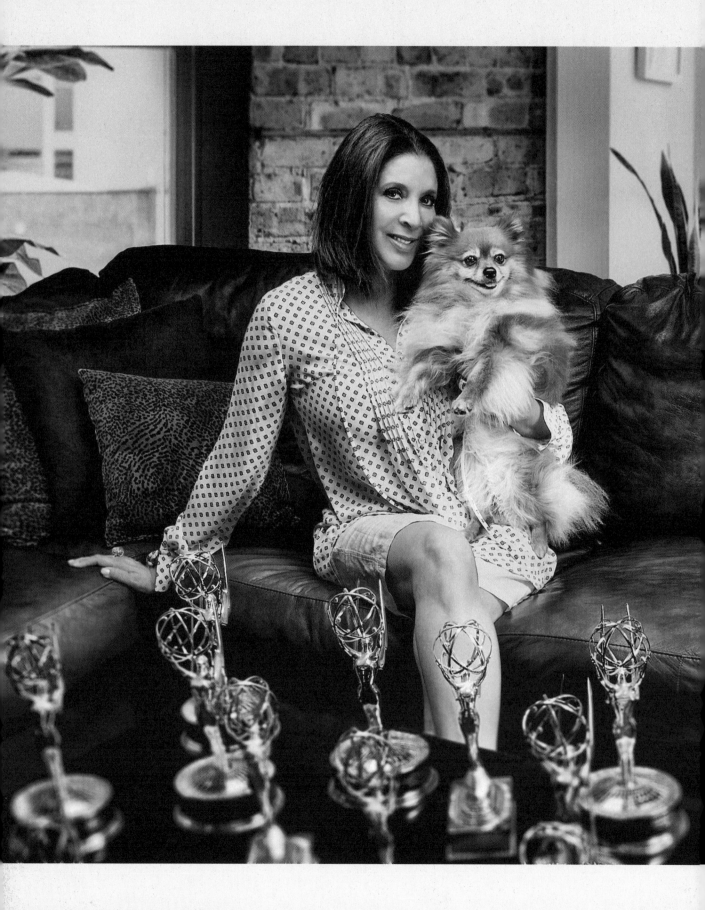

GUARDIAN ANGEL OF L.A.
CHRISTINE DEVINE

TELEVISION NEWS ANCHOR

"TO WHOM MUCH IS GIVEN, MUCH IS EXPECTED."

—CHRISTINE DEVINE

(INSPIRED BY LUKE 12:48)

You would think being a news anchor for thirty-two years at Fox 11 News in LA, being inducted into the Walter Cronkite School of Broadcast Journalism Hall of Fame, and receiving sixteen Emmy Awards, two Gracie Awards, and a Golden Mike Award for lifetime achievement, would be enough for any one person to achieve in a lifetime. Not in Christine Devine's world! She is wholly devoted to both her career and a life of service to her community through many philanthropic causes, which was celebrated in 2012 when *Los Angeles Magazine* named her one of "50 Women Changing LA." When asked about her core values, she replied, "I live with being a responsible employee and a responsible and contributing citizen. I do believe we all contribute in many different ways; you don't have to participate in

big charity events to be a contributing part of society. I also try to maintain mind, body, and spirit. Wellness is a very important part of my life and striving for balance is a big part of that, especially for a busy career gal!"

CHRISTINE WAS BORN IN HAMBURG, NY, BUT RELOCATED TO ARIZONA AT AGE TWO WITH HER MOTHER, KAREN LEE SEUFERT. HER MOM MARRIED JACK DEVINE, WHO ADOPTED CHRISTINE; THEN THE COUPLE HAD A DAUGHTER TOGETHER AND ADOPTED A YOUNG BOY. CHRISTINE IS EMPHATIC ABOUT WHO SHE CONSIDERS HER FATHER TO BE, REGARDLESS OF GENETICS."JACK ADOPTED ME WHEN I WAS YOUNG. I DON'T KNOW MY BIRTH FATHER—MY MOM'S DECISION, AND THAT'S THE WAY IT WAS."

"That was a chapter from my mother's life when she lived in Brazil. I only know he was of Latin and Black descent and danced on a television show. When I refer to my father, it's Jack Devine."

After Christine left for college, her parents took in five siblings, who were refugees from Vietnam, on a long-term foster care program. She attributes her ardent work ethic and commitment to philanthropy to the example set by her parents. They were both award-winning educators and dedicated members of the Peace Corps who focused heavily on educational, economic, and racial concerns as they worked in inner cities and Job Corps.

Christine lost her father, Jack, over twenty years ago in a tragic scuba-diving accident, and more recently her mother to cancer. She is the woman who has inspired Christine the most throughout her life. "My mother fought against poverty, racial injustice, and for empowerment through education. Those values will forever be instilled in my heart. The biggest lesson I learned during my mother's illness was that a medical issue can hit any family. We always thought my mom's healthy and spiritual mindset would keep her immune from the realities of healthcare traumas. We were all shocked. It's a reminder that our time on this planet with the people we love is limited."

As a young girl, Christine was fascinated by current events and realized early on what direction her career would take. "I'd say I knew for sure in high school because I took broadcasting classes. I always wondered how I could know about the world at all times. I thought about being a teacher like my parents, but I realized with the news, you're always studying the world. In a way, it's an extension of what they did, because you are literally studying every day." An interesting aside to her high school years was that her father, Jack Devine, was the principal. She described what that was like for her: "On the pro side, I loved it because it made me feel like part of the school and the process; but it did not work so well for my adopted brother."

Christine's adopted brother ended up in juvenile hall and prison several times. He died in his thirties of a cocaine overdose. She reflected on what might have brought on this tragic end: "He was never able to overcome the early childhood traumas, that included foster care before being adopted by my parents. We were told that his birth mother was a heroin addict who had him when she was incarcerated. He went into foster care at five. You can imagine how traumatic that would be, to lose the only family you had ever known. He was a smart kid, but he used drugs, perhaps because of depression. My mom and I were the first to admit that we don't necessarily know if we were the best family for him. Maybe he would have thrived more in a family with boys and sports. Perhaps that would have meant there would be less discourse for him than with a nerd family centered on academia like ours."

After graduating Arizona State University with a degree in broadcast journalism, Christine started on a fast track to a career in the newsroom. "Luckily, I had an internship that resulted in a great resume tape when I exited college. Nowadays, the kids have a lot of programs at school where they can produce one, but back then there weren't many ways to achieve this. I credit my teacher, who had taken my resume and pinned it on the bulletin board at a news directors' convention hall, where a small-town news director saw it and offered me a job in San Angelo, Texas. I was supposed to be the weekend anchor, but, by the time I got there, the weekday anchor spot had become available; I got the main anchor job right away. Six months later, I got very lucky because a Tucson job opened up as a morning anchor. I did this for two and a half years, then came the Fox LA anchor position." She elaborated on how this opportunity came so quickly: "I had an agent who was able to move young people with potential to bigger markets in

> "I have a team of mentors that has always been there for me providing strength in a lot of areas: career, relationships, and finance."

entry-level positions. I always say I was hired on potential, because I certainly wasn't hired on experience. Sometimes stations are looking for somebody to groom for the future. People ask me how it is that I have been at Fox for over thirty years, and I really don't know!" Anyone who has watched Christine on Fox 11 news knows why—career excellence and the mastery of her profession.

Christine stresses the importance of having a strong support system in your life. "I have a team of mentors that has always been there for me providing strength in a lot of areas: career, relationships, and finance. I met a woman, Emily Card, when I first came to LA at twenty-five, who was all of that for me. She has written seven financial books on women in finance; she is a true accountability partner and life coach. She kept me very straight, on track, and focused on a greater future. I must also give a big credit to my agent, Ken Linder, for his belief in me early on."

In 1994, she was given a weekly segment to host that would profoundly change her life. The segment was titled Wednesday's Child—

highlighting the stories of a different foster child every Wednesday in hopes of finding an adoptive home for them. This segment has helped erase the stigma of the foster care system and personalized the kids as children with hopes and dreams of their own. Over 500 adoptions were made possible because of it! Wednesday's Child has been a vital part of Christine's life for the past twenty-five years, so it was surprising to find out how she reacted when first presented with the assignment.

"Actually, I didn't want to do it, because of the pain associated with my brother. But it was through doing Wednesday's Child that I found my healing. I got to see the children as kids who had been through trauma through no fault of their own, and to see the results of that trauma."

"Actually, I didn't want to do it, because of the pain associated with my brother. But it was through doing Wednesday's Child that I found my healing. I got to see the children as kids who had been through trauma through no fault of their own, and to see the results of that trauma. My Wednesday's Child Coordinator, Dr. Will Wong, a phenomenal social worker and tremendous advocate for children and their well-being, acted as my therapist with healing my own baggage and heartache regarding my adopted brother—it's devastating to have a brother go to prison and lose his life to drugs. Now that I've worked through that, I've got a true passion

"BEING A MULTIRACIAL WOMAN, I COULD NOT HELP BUT REFLECT ON THE DAYS OF TELEVISION NEWS THAT EXCLUDED BLACK AND BROWN PEOPLE. I'VE SPENT YEARS CALLING FOR INCLUSION IN THE NEWSROOM, BOTH IN FRONT OF AND BEHIND THE CAMERA. YOU CAN'T COVER A CITY THAT IS 9 PERCENT AFRICAN AMERICAN AND 48 PERCENT LATINO WITHOUT DIVERSE INPUT.
THE NEWS STATION NEEDS TO NOT ONLY REFLECT LOS ANGELES'S DIVERSITY, BUT INCLUDE IT IN THE STORY SELECTION PROCESS AND PERSPECTIVE."

for it—compassion for it—and the rest is history." In fact, that healing came full circle when Christine wrote a book in 2011, *Finding a Forever Family,* a memoir around her experiences with Wednesday's Child intermingled with her personal story growing up in a family that fostered and adopted.

Christine has been an angel in so many children's lives that it's no surprise she received the Angels in Adoption award. She talked to me about this very special honor. "It put Wednesday's Child on a national platform and was an important recognition in Washington, DC, with the Congressional Coalition of Adoption. They always honor someone of national prominence who has made a difference, either an adopted parent or someone who

contributes to the knowledge of adoption. What's so cool about it is that you wonder if you're doing anything good, and then once you've gone to Washington a couple of times, you know you are making an impact."

Over the years, Christine has stayed in touch with many of the children from Wednesday's Child by always leaving her door open for them. This has led to her mentoring many young people. "I stayed connected with some of them by finding opportunities they could be involved in. One time, we did a segment with a girl who wanted to sing in the studio, and it was a lot of fun. That made me think, 'Hey, can I write a rap song?' So, I wrote a rap song. (I was informed by a colleague that '*Christine Devine,* the news

> "It's funny, because sometimes you get into a rut in your life—any career can have its own rut. Experiencing a renewed excitement for something was really fun for me. I thought, 'Oh my God, what am I going to do after news?' I've been very lucky in that area, but I'm not trained to do anything else. I had found a new passion that spoke to my heart and soul. I think that's what life is all about, embracing your passions and feeling alive. Honestly, I thought I would have nothing after the news, and that I wouldn't matter anymore. I had the best time championing these young people as a producer and content creator in all genres of the arts—experiences I will treasure always."

anchor, should not be writing rap songs!')
I looked for someone who could record my
song—I wanted to have it for nostalgia. Then,
I remembered the young rapper that was
once on Wednesday's Child. He was so good
that the producer and I looked at each other
awestruck. We ended up working with him for a
couple of years.

"Little by little, I had young people coming
around for me to mentor. We put a kid we
met at the gym in as a backup singer with the
rapper and did a ton of music projects with
him. Then we met a girl who said, 'I want to do
everything!' We got her work as a dancer. Little
did I know she had auditioned for *American
Idol*. We mentored her, and she's started
performing all over! Then it expanded into
helping the kids with music videos, fashion
shows, modeling, and photo shoots. Wherever
their passion and talents were, we worked
with them to bring it to light. It became this
entourage of creative young people." She has
the perfect description for this: "I called it being
a cheerleader for children, even though they
weren't really children; most of the kids were in
their twenties. Since the pandemic, I have had
to shift my focus back to work 110 percent, and
I haven't had the time to mentor. Before that,
I was doing a lot of work expanding creative
opportunities for all kinds of youth."

Her time as a mentor deeply affected Christine:
"It's funny, because sometimes you get into a
rut in your life—any career can have its own
rut. Experiencing a renewed excitement for
something was really fun for me. I thought, 'Oh
my God, what am I going to do after news?'
I've been very lucky in that area, but I'm not
trained to do anything else. I had found a new
passion that spoke to my heart and soul. I think
that's what life is all about, embracing your
passions and feeling alive. Honestly, I thought
I would have nothing after the news, and that I
wouldn't matter anymore. I had the best time
championing these young people as a producer
and content creator in all genres of the arts—
experiences I will treasure always."

Christine may not have had a biological child,
but she has touched and encouraged the lives
of countless children and young adults. She
took her personal struggle with infertility and
made it public through a news special, *Fertility
over Forty,* to help other women afflicted
with the same issues and bring awareness to
younger women as well. "I talk to young people,
especially women in their thirties, about the
realities of being so engrossed in your career
that you delay the choice to have children.
You have to think about options like freezing
eggs. This affords an opportunity to still have
that career and preserve the choice of making
a family. I tell them, 'You may meet the right
guy and want to make a little you with him.
If you don't freeze your eggs, you won't have
that opportunity.' I didn't get married until my
forties." Christine married actor/musician Sean
McNabb in 2016.

In 2020, her routine at Fox News changed drastically due to the coronavirus pandemic. "My days would start with television morning news conferences about the coronavirus and then launched into an afternoon and evening news shift that didn't end until midnight. At one point, in an effort to reduce contact, Fox 11 cleared out much of the newsroom and sent people to work from home. I was among the news anchors to receive a set-up and go live from my couch. For two months straight, I did not leave my home but for one day a week, which was a trip to the grocery store. I will never forget the lines at the store, the closures, the hoarding of food, and the quest for toilet paper and hand sanitizer, only to find empty shelves for weeks on end. Then there was the death of George Floyd at the hands of Minneapolis police officers, and nationwide protests. That breaking news brought me out of the coronavirus hibernation and back into the studio, to better handle the immediacy of live coverage on a technical basis. This shift in our country will also be marked in history. As the world refrained from coming together due to COVID, people poured into the streets after the death of George Floyd in police custody. It was an era of politics, pandemic, and protests, all at a feverish pitch.

"Being a multiracial woman, I could not help but reflect on the days of television news that excluded Black and Brown people. I've spent years calling for inclusion in the newsroom, both in front of and behind the camera. You can't cover a city that is 9 percent African American and 48 percent Latino without diverse input. The news station needs to not only reflect Los Angeles's diversity, but include it in the story selection process and perspective. Staff and full-time employment with benefits is something I have always championed for people of color. I remember a painful time in my life when I took my second job in the news business. A colleague (who later became a dear friend and solid partner in journalism) told me when I arrived that I was merely the 'token minority hire.' It saddened, yet empowered me. I was my high school valedictorian and attended Arizona State University on a full-ride academic scholarship. I was by no means given preferential treatment, as this was an entry-level anchor reporter job, and I'd already had my first job as a main anchor for a CBS affiliate in a small town in Texas. The concept of a 'token minority hire' is ridiculous. Why can't it just be…a hire? Today, there are plenty of organizations, colleges, and mentoring programs grooming young people for the news business and every other industry.

"Embracing inclusivity might require outreach, mentorship, scholarship, and effort. If there is one matter for which I am most proud, it's the reminder within my own industry that oversight might not mean racism, but oversight and lack of diversity can equal an unjust and inaccurate portrait of our society. We are in an important and critical time of change in our world, and as I marked my thirtieth anniversary in 2020

as a Los Angeles news anchor, I am proud and honored to continue to report on this unfolding chapter in history."

Christine's pursuit of the truth will always find her seeking knowledge and justice. Serving her community, children, and humanity will forever be in the forefront of her life's work. Her priorities and integrity are resolute, and now, so is her creativity. The exploration of her creative side has unveiled an abundance of projects and ideas rich with inspiration and artistry. Her love of fashion has been fully manifested into her life by hosting fashion shows and emceeing Metropolitan Fashion Week in Los Angeles. She has achieved balance—diving into work, philanthropy, and play with equal enthusiasm,

and acknowledging the beauty in everything and everyone.

"I think we are all beautiful in our own way. I've learned to appreciate the various ways that people create beauty on this planet. Obviously, I would find someone beautiful who is kind to children, and animals, someone who empowers and lifts others." Christine is the embodiment of these traits, and the dedication to serving her community is a lifelong one. Her outlook on life expresses her accepting and compassionate nature. "Life is ever-changing, and the lessons keep coming despite your age and accomplishments. We are all a work in progress, with our failings being part of those lessons."

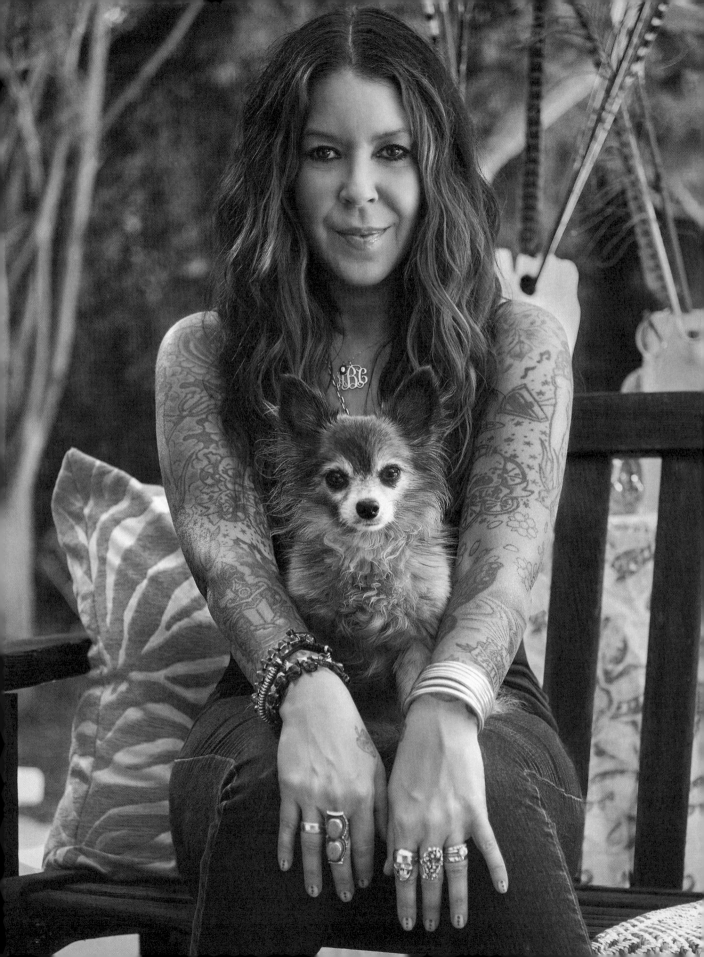

EVER-EVOLVING ARTIST
ALLISON BURNS COOPER

MAKEUP ARTIST | DESIGNER

"DON'T BE LIKE THE REST OF THEM, DARLING."

—COCO CHANEL

Allison Burns Cooper is a multifaceted makeup artist and designer who is fearless in the pursuit of new artistic challenges and experiences. In fact, she seeks them out. This has produced a career filled with a unique arsenal of talents, including one she learned from world-renowned Japanese makeup artist Shu Uemura: doing makeup with both hands. Allison has a large clientele of celebrities and rock stars and is the founder of a multimillion-dollar handbag line. One of her most important accomplishments has no monetary value at all: twenty-five years of sobriety. When Allison was eleven, her parents divorced, and she moved from her home in New York City to Newport Beach, California, with her mother. Up to that point, her life was in discord. "I had a traumatic home life as a child, and I have few memories below the age of nine or ten; it was an

unhealthy and abusive environment." It's hard to believe the shy little girl who could not respond to someone asking her name is now the outgoing and expressive woman she is today.

HER FRESH START ON THE WEST COAST WAS NOT A SMOOTH TRANSITION FOR THIS NEW YORK NATIVE. IN TIME, ALLISON WOULD FIND THAT SENSE OF BELONGING SHE SO DESIRED. "COMING FROM LONG ISLAND, I LOOKED DIFFERENT AND FELT DIFFERENT, AND THE KIDS IN MY JUNIOR HIGH SCHOOL CERTAINLY TREATED ME THAT WAY."

"In high school, I found the crew I fit in with: the punk rockers. I was surrounded by musicians and all these amazing bands. They had such a tight community and were all very supportive of each other. It was the first time I felt accepted for being myself."

There would be a price for her newfound social life. School had fallen off the list of her priorities. "In my junior year I was kicked out of my high school, then I transferred to a different one that only lasted another six months. At seventeen, I took my GED and moved out of my mom's house. I had a brief stint at Orange Coast College, but I was on drugs, so I dropped out of all my classes. I went on to beauty school, but dropped out of that and got my manicurist license instead."

A manicurist job at a local department store was hardly something that could keep Allison's attention for long. "I stopped doing nails and I started working for Winterland Productions as a touring merch-girl. Some of the bands I toured with were Red Hot Chili Peppers, Jane's Addiction, Faith No More, and Kills for Thrills. Then I decided that I wanted to go to makeup school and do special-effects makeup for horror movies."

Allison began her makeup career when she was twenty-three. Although she trained in special effects, horror movies were not in the cards for her. Instead, her career took an exciting turn and merged two things she loved: makeup and music. "One of my close friends, bass player Robert Trujillo, asked me to do makeup for his band's music video. He was playing with Infectious Grooves at the time. Then my friend who owned Epitaph Records asked me to do makeup for one of his band's videos, which was Rancid's first video for their song *Ruby Soho*. I

fell deep into the music video world, which was a dream job for me because I love music so much. I continued to work with many different bands on countless music videos. I did all genres of music—punk, rap, rock, metal, and alternative. I worked with directors like Dean Karr and Diane Martel, and bands such as Seether, Distillers, Evanescence, Damageplan, Queens of the Stone Age, Cypress Hill, Puddle of MUDD, and Busta Rhymes."

Everything appeared to be moving along ideally in Allison's life, but unresolved issues were erupting under the surface that prompted her to make a surprising decision. "I moved back to New York City because I wanted to drink. I had been living a sober life here, and I started drinking again. I knew I couldn't continue doing this in LA around all my sober friends. Nobody would care if I drank in NYC."

Allison's move back to NY led to some incredible professional and social experiences, but would end on a downturn. "The first freelance job I got after moving back was working with Annie Leibovitz, shooting Nan Goldin in a series for *The New York Times* about photographers shooting photographers. It was such an honor to work with both of them, and an experience I will always cherish. I also did a lot of runway jobs and worked with François Nars. Unfortunately, I was a mess: a high-functioning drug addict and alcoholic. I had been sober many times before, and at this point, I knew that if I continued using, I would live the rest of my life in a state of internal insanity while still functioning on the outside. It was the first time I saw the truth of my life as an addict. I felt like I was running on a hamster wheel. Nothing brought me happiness anymore; I didn't care about my art, career, or life. I was numb to everything. In AA, they call it spiritually bankrupt, and that's exactly what I was."

Fortunately for Allison, she had the will and foresight to know exactly what to do: "I'd been on-and-off sober throughout my twenties and been through many rehabs. There was no way I could do this in New York. Both my sisters were sober at the time, and I had sober friends in LA and Orange County and knew that's where I had to be. I called my mom to help me get into a treatment center. The sober community I had run away from would be there for me when I

> **"In high school, I found the crew I fit in with: the punk rockers. I was surrounded by musicians and all these amazing bands. They had such a tight community and were all very supportive of each other. It was the first time I felt accepted for being myself."**

"ONE DAY, WHEN I WAS UPSET ABOUT SOMEONE NOT BEING THE FRIEND I THOUGHT THEY WERE, LORI SAID, 'ALLISON, GO WHERE THE LOVE IS.' IT WAS SO SIMPLE. WHY GIVE ANOTHER THOUGHT TO PEOPLE WHO DON'T LOVE YOU? ONCE YOU FIND THAT OUT, MOVE ON. IT TOOK ME MY WHOLE LIFE TO LEARN THAT LESSON. FOR EVERY SITUATION THAT HAS LEFT MY LIFE, IT HAS OPENED THE DOOR TO SOMETHING NEW THAT IS MORE BEAUTIFUL THAN I COULD HAVE EVER IMAGINED."

returned. I stayed in a women's recovery home for a year.

"My AA sponsor told me, 'You can't build a house without a strong foundation.' She was willing to help me build that foundation, but I would have to commit to staying. You had to be there for three months before you could work again, and I wouldn't be able to continue being a makeup artist. She said, 'This isn't working for you. Life isn't working for you. You don't know what's making it not work for you, and it could be your career. When the year is up, if you are meant to be a makeup artist, you will get it back tenfold. If not, and you're working at Blockbuster, it will probably be the happiest you have ever been.' It was time for me to concentrate on saving my life, and that's precisely what I did."

As it turned out, Allison was able to resume her lucrative career as a makeup artist and started working on commercials and music videos again. It was at this time that a girlfriend introduced her to someone who would further advance her career: "Deb was working as Rob Zombie's assistant and introduced us. I worked on all his music videos and the ones he directed. Working with Rob was one of the most creative times in my life. He gave me so much artistic freedom. Some of the music videos we worked on had up to sixty extras. I would hire a team and oversee everything. It was amazing, and we had such a great time."

Allison met Sharon Osbourne while doing makeup for the Ozzy Osbourne video *Dreamer*, which was directed by Rob Zombie. Sharon would introduce her to another new and exciting opportunity: the world of reality TV. "Sharon Osbourne, who loved the work I had done, called the next day to ask if I could do the whole family's makeup and hair for a photoshoot. After that, I went on to do the first two seasons of *The Osbournes* on MTV. I left my makeup kit set up in their house, as I was working five days a week around the clock." This began a rapid succession of reality TV gigs for Allison, including shows such as *The Simple Life*, *Sorority Life*, and *The List* on VH1.

After doing *The List* with producer Andy Lassner, she also worked on his show *The Test* in 2001. This show featured Jillian Barberie, a cohost from the morning show *Good Day LA*. "I would do everyone's makeup, and while they were filming, I would sew. I was always sewing and making things. I only worked the weekends on *The Test*, so I had all week to run wild with my imagination and create things. I started making denim bags from used Levi's, and Jillian said if I started a bag line, she would put me on her *Good Day LA* segment called "Style File." This first attempt with the bags didn't go very far, but it set me in motion toward a clearer vision of what I wanted to do. At that point, I decided to dive in and commit a hundred percent to the handbags because I loved doing it. I began to focus on using leather, and I created a line with six styles and a few belts. I

sold them to a couple of stores in LA, and Jillian did another Style File segment on the new line, which produced a lot more activity. I had fifteen accounts around California, then a couple out of state. A lot of the musicians I knew started wearing the belts: Michael Stipe, Dave Navarro, Perry Farrell, and the guys in Green Day."

It was at a party after a Hollywood Bowl concert, thrown by R.E.M., that Allison had a chance meeting that would indirectly help sales for her bag line blow up! "After the show, I met this incredible woman, Dr. Sharon, who had been working with Michael Stipe for many years and worked with Kurt Cobain and Ozzy. She loved my bags and wanted to trade me a treatment from her for a bag. She was staying at the El Royale, and when I got there, she said, 'I love your bags, and I have a girlfriend whose birthday party is tonight, and I would love to give her one.' It turned out her friend was Cameron Diaz. I gave her the *Faithfull* bag in gold (named after Marianne Faithfull). Celebrities such as Paris Hilton and Nicole Richie were already wearing

my bags, but when Cameron started wearing it, things took off! Cameron was photographed wearing it everywhere—even on the red carpet for the movie *Shrek 2*. There were so many articles written about her wearing this gold hobo sling bag of mine. She continued to be photographed wearing it everywhere." At this point, celebrities like Cate Blanchett, Julianne Moore, Debbie Harry, Dita Von Teese, and Eva Longoria were all wearing Allison Burns bags. Each bag had a name honoring the women, musicians, models, and everything that has inspired her over the years.

After the boom of the *Faithfull* bag, her sales went through the roof. The company went from making $15,000 in the first year to $1.7 million in the third year. "There I was, a high school, college, and beauty school dropout, as well as an alcoholic and drug addict, who now had become a famous handbag designer to celebrities. I couldn't believe I had achieved a second prosperous career. I had attained

> **"I hit this point where I wasn't happy. I was stressed out and waking up in the middle of the night worried about money. My spirit was broken, and I knew my sobriety was in jeopardy. One hundred percent of my life was this company. I hadn't dated or gone on a vacation during the ten years I owned it. I had no balance. On the outside, it appeared I had everything I had ever wanted. In reality, I was back to the place I was in the day before I got sober, which was spiritually bankrupt."**

such success with my makeup career that I thought I'd be doing it for the rest of my life. The handbag company was a whole different thing. It was amazing, and I learned so much, but I also made so many mistakes. I prefer to call them *lessons*. I feel that from every mistake I made, I learned a lesson that changed me for the better."

Then in 2008, the recession hit, and things started to change. "Sales went down quite a bit, but everything was still fine. I got a smaller office and downsized." Though her company was able to weather the recession, an internal force would shut down her business. She had become more of a CEO and less of a creative. "I hit this point where I wasn't happy. I was stressed out and waking up in the middle of the night worried about money. My spirit was broken, and I knew my sobriety was in jeopardy. One hundred percent of my life was this company. I hadn't dated or gone on a vacation during the ten years I owned it. I had no balance. On the outside, it appeared I had everything I had ever wanted. In reality, I was back to the place I was in the day before I got sober, which was spiritually bankrupt. Only this time, I was sober. I knew that I couldn't live like this anymore. I didn't have a business manager or partner—I didn't know I needed those things. I was by myself, doing absolutely everything. So, by myself, I decided to close my company.

"I closed it out of fear—fear that I would lose my sobriety and fear that I would feel this numbing emptiness for the rest of my life. In my mind, I only had two choices: me, or my business and money. I felt I needed to strip myself down to the raw me to live again. What I didn't expect was how difficult this would be. Getting sober was hard, but closing my company was even harder. Sadly, it affected me more than anything ever before. I not only attached my creativity to the company, but it also had become who I was. It was my name, and losing it felt like losing my identity. It was a tough time, but so many people surrounded me with love. I have very few material things left from that time, and I owed a lot of money. I had to sell my house and some cherished art pieces. All these things that I thought were so important became unimportant because I got my life back. I was able to resume my makeup career, which I have always loved. I truly believe if I hadn't shut down my company, then I wouldn't be married to my husband Keith today." In 2016, Allison married entertainment attorney Keith Cooper. "In our first month of dating, I told Keith I wanted to get married by the time I turned fifty. A year later, he proposed to me at his mom's birthday party, and we've now been married for five years. Keith appeared at the perfect time in my life—when I had truly found myself."

Something else she holds dear is friendship. She considers her friends to be like family and would move heaven and earth for anyone she

loves. She has had many lessons in discovering what a true friend looks like, especially during the ups and downs of her life and career. A dear friend of hers, Lori Barker, who recently passed away after a long and heroic battle with cancer, gave Allison the mantra she adheres to today. "One day, when I was upset about someone not being the friend I thought they were, Lori said, 'Allison, go where the love is.' It was so simple. Why give another thought to people who don't love you? Once you find that out, move on. It took me my whole life to learn that lesson. For every situation that has left my life, it has opened the door to something new that is more beautiful than I could have ever imagined."

Allison's sensitive and empathetic nature makes her the kind of person who will always stop and help someone in need. She is a devoted rescue advocate and has rescued numerous fur-babies over the years. In fact, she recently brought home an adorable Shepherd-mix puppy named Leo. Allison recently lost her sweet angel Foxy,

not too long after this beautiful photo of them was taken. "Foxy is the pup that opened my heart and made me a more compassionate woman." Her arms may be adorned with tattoos, but she also wears her heart on her sleeve. "I feel as though my insides don't match the appearance of my outsides. I am very spiritual and free within my heart and soul, and not as wild and rebellious as I appear to be. I think once people get to know me, they are surprised to find that out."

Some of the women who inspire Allison are Patti Smith, Debbie Harry, and Vivienne Westwood. Debbie has been a client of hers for many years and is a cherished friend. Allison reflects aspects of all these women while venturing into new projects, including an ABC Pottery collection and a makeup and clothing line. Whatever artistic medium she is mastering becomes a symphony of creativity serenading her mind. This creative explorer will never stop seeking new territories for her talents to thrive.

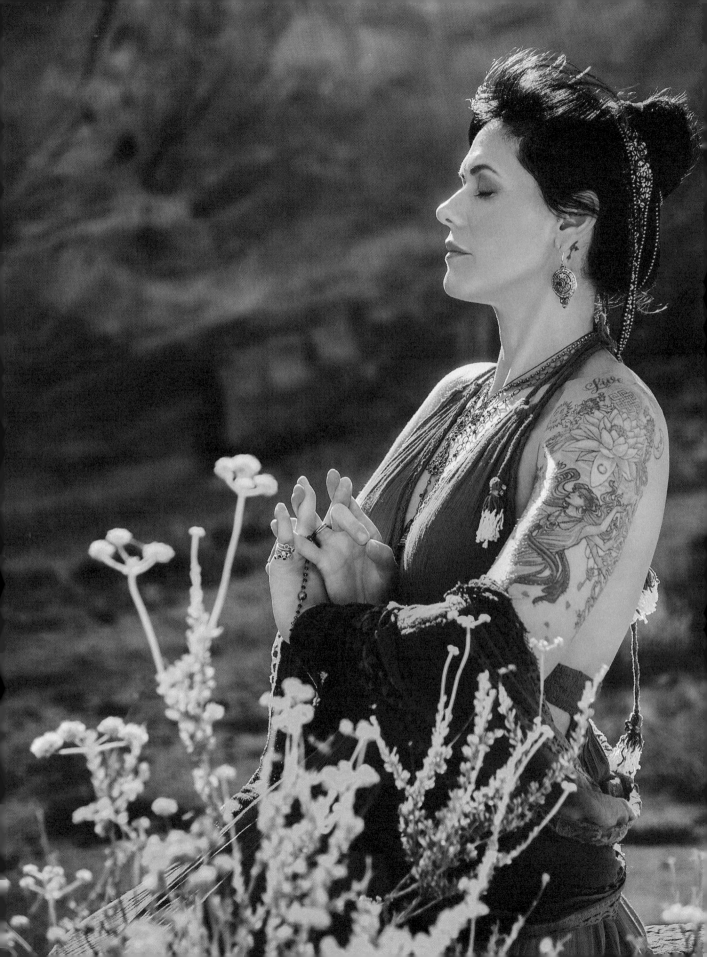

THE SEEKER DANICA LYNCH

YOGA & MEDITATION INSTRUCTOR | AYURVEDA PRACTITIONER

"WHAT YOU SEEK IS SEEKING YOU."

—RUMI

Danica Lynch is a seeker—a seeker of knowledge, connection, and growth. She was delivered by her mother's hands, a strong woman who believed in natural medicine and the power of one's own body. This act was a symbolic passing of the torch from one spirited and independent woman to another. The foundation of an *I am woman* mentality continues to thrive in Danica's innermost self, and it has been highly utilized throughout her life. She discovered her true calling in her thirties, when she became certified as a practitioner of Ayurveda, meditation, yoga, and Somatic Experiencing.

SHE IS CONTINUOUSLY EXPANDING HER EDUCATION IN THESE AREAS OF STUDY ALL OVER THE WORLD. IN 2018 SHE OPENED A YOGA/ MEDITATION SHALA, YOGA YOGA, IN SANTA CLARITA, CALIFORNIA, AS A HOME BASE FOR THESE PRACTICES WITH RESOURCES FOR THE COMMUNITY. DANICA HAS LONG BEEN A SUPPORTER OF CHILDREN'S CAUSES THROUGH ANTI-BULLYING CAMPAIGNS, YOUTH GROUPS, AND FOSTER PROGRAMS.

She reminds me of the Hindu goddess Durga, Divine Mother, who protects humankind from evil forces such as jealousy, prejudice, hatred, anger, and ego. Danica may not have eighteen arms, but most of the time, it certainly seems like she does.

Danica is an LA native who was raised, along with her three brothers, by a divorced single mother. Her father was an addict who disappeared from their lives when she was very young, never giving her mother financial support for their four children. She had to revisit this part of her life to let go and heal. "I have had to come to terms with a lot from my childhood that was bottled up for years. That's been my process, looking at things in a different light and purging the pain of the past."

Marriage and children came at an early age for Danica. "When I graduated high school, I married my high school sweetheart. I was twenty and working in property management when I got pregnant. At the same time, I went to college and became certified in child development, as I wanted to teach preschool. I had planned to get a degree in child psychology, but I quickly realized I was attachment-oriented and would get too personally involved. Instead, I went into home loans and got my real estate license. I built a clientele and was heavily referral-based." Following in her mother's footsteps, Danica found herself divorced at twenty-four, with two kids and no financial support. She kicked ass in home loans and bought her own house, creating a fresh start for her family. There was no drama with her ex, and she maintains a positive outlook on the situation. "We were just kids having kids. Nobody gave me the owner's manual to life, so I take it as it comes, and that is the direction I go. Watching my mother do it all those years showed me it could be done."

A few years later, in 2003, Danica met guitar player George Lynch, the man she would share her life with. Shortly after their initial introduction through a mutual friend, Danica and George

began running into each other. "Dakota was three, and every morning we stopped at the local Starbucks before I dropped her off at daycare. I walked in one day, and he was there at a table with his laptop. We started talking, and Dakota fell in love with him. He continued to be there every day, and I came to find out he had been talking to my girlfriend about how to find me. He was living on his own with his daughter Mariah, who was twelve at the time. We hung out with our kids, just as friends, for about six months. Then we went to a local concert in the park and had our first kiss under an old oak tree. Despite the age difference and disapproval of a couple of peers, I decided I would give it a shot! Here we are, seventeen years later." George also has a daughter, Tasha, and a son, Sean, along with four grandchildren. Danica's children and George's grandchildren all grew up playing together and became one big extended family.

Motherhood for Danica has taken many forms: she has two biological children and three stepchildren. She will occasionally work with the foster system as an emergency foster placement home until they find a forever home. "I have to say that being a mother is something I can't define in words, but it is one of the strongest loves anyone can ever have. You have many roles: the protector, the provider—to love, to teach, and to guide. It confuses things a little with a blended family. You wonder, 'How am I going to do this?' We work at respecting and honoring everyone in our very large family, seeking to unify and not create a damaging division. The icing on the cake for me as far as being a mother is that you never really understand the concept of unconditional love until you get put into a moment when you truly have to be a loving and patient parent."

> "I have had to come to terms with a lot from my childhood that was bottled up for years. That's been my process, looking at things in a different light and purging the pain of the past."

She continued in home loans and doing management work with George, and even started her own music publishing company. She thought this was the direction her life would take. Then, as if a bolt of lightning hit her, she had a divine awakening to her purpose that all started with the right mentor. "I have had a few powerful meditative experiences in monasteries and retreats over the years, and had continued to pursue the path of meditation. I met a wonderful lady named Susan at Yoga Works. Susan was hosting a free meditation in my local valley that I had chosen to attend, and we immediately bonded. I was going through a lot at the time, so it was meant to be. She guided me a little, and then I was completely off and running. I wanted to know everything I could! I went to the Chopra Center for training, and that only whetted

my appetite for more knowledge and information. During my studies at the Chopra Center, I met Dr. David Frawley and fell in love with his wife, Yogini Shambhavi. After seeing them speak there, I knew I had to go study with them in India; it was an incredible experience, and I couldn't wait until I could go back again."

Danica wanted to dive further into the spiritual side of yoga and pursued more traditions of yoga practices. "Prior to my yoga teacher training, I had learned about Vipassana at the Chopra Center, which is a deep meditation practice that requires ten days of silence. I found a retreat center in Twentynine Palms. I always look at things as though they're going to be easy, and I figured this would be a piece of cake. I truly believe this experience is one that everyone should have at least once in their life. If you want to get to the bottom of what meditation is, you need to go to a Vipassana retreat. On the first day you sign in, they take all your belongings. I had my own room, but some spaces consisted of four people to a room, separated by gender. My room was three feet by five feet, with a small restroom. Then they took my cell phone. I had so much on my plate: kids, loans, the music business, and I had to let it all go.

"They nominated me as the gong girl, which meant that I had to take the gong to wake everyone up at 3:30 a.m. and walk the desert grounds. At 4:00 a.m., you had to be inside the chapel to meditate for sixteen hours a day. You got a break and three meals: breakfast, a light lunch, and only fruit or tea at night. You don't exercise, so that's why they have you eat so light. You are not allowed to speak or have any

eye contact, and you must keep your head down and follow all the rules. The first three days is breathing exercises to get you ready for the fourth day, when Vipassana begins. Vipassana is a self-exploratory journey that focuses on the interconnection of the mind and body. It intends to get into the deeper roots of one's self and to let go of everything. You are to learn how to become humble with yourself and, in turn, teach love and compassion, resolve versus reacting, and to keep a steady balance."

Though challenging, the next phase of the retreat would be an important step in self-discovery for her. "By day four, I said, 'Nope, I gotta go. No way am I going to last for six more days of this!' When I asked to leave, I was told, 'No.' You see, in my mind, my daughter could have been kidnapped, my son could have been in a car accident, my cat probably got out. Everything you always controlled or thought you controlled, you just lost. Not being able to text my kids or talk to anyone made me realize how much control I felt I had over everything, and if I didn't, the whole world would collapse. That was a big wake-up call for me. She told me to go rest until the next session. I remember lying in this tiny bed, and then my intuition kicked in. I saw my stepdaughter, Mariah, and I knew she was at the house. I knew she was there to help, and I was immediately comforted. As we continued, I dug deep. After I got released, I sat at Crossroads Cafe in Joshua Tree and called my daughter. Dakota started telling me about everything that had been going on and then stopped and said, 'Oh, Mariah has been here the entire time helping.' Once I completed the Vipassana retreat, it was a whole different ballgame for me. After Vipassana and

"WE SEE SO MUCH SUFFERING, AND MOST OF IT IS DRIVEN BY FEAR AND PAIN. WHEN WE CAN WORK CLOSELY WITH OTHERS AND EXPRESS THOSE EMOTIONS FREELY, WE BEGIN TO LEARN HOW WE GO THROUGH TRAUMAS—HOW THE MIND CREATES THOSE EMOTIONS, AND THE TRAUMA BECOMES STUCK IN OUR BODIES."

India, I went to the Sivananda Ashram Yoga Farm for my first yoga teacher training. The program was one month long." She got down and dirty on the farm, which included cleaning public bathrooms for thirty days, exercising the selfless service part of the practice. Danica had brought her daughter Dakota with her for the first two weeks of her teacher training, as she could not imagine leaving her, since she was thirteen at the time. "Dakota had quite the experience, but could not wait to get home!"

She made some lifelong friends at the farm. "You can't not bond with someone after cleaning toilets together for thirty days! It doesn't get more exciting than spending a month living the study they are teaching. How else are you going to truly learn it from the inside out? The Yoga Farm is what got me into Ayurveda. When I was at the Chopra Center and the Yoga Farm, they would feed us Ayurveda meals and talk to us about the six tastes: sweet, sour, salty, astringent, pungent, and bitter. You want to fulfill those tastes based on these body constitutions: *Vata*, *Pitta*, and *Kapha*. Depending on which one you are, you will have different tastes. By eating the six tastes, you have fulfilled your body. You tend to eat less because you are getting what you need. I was intrigued by this.

"One of the cooks from the Yoga Farm mentored me, helping me to understand how the spices work with the body. I started doing research and signed up at the Kerala Academy with Dr. Jay in Freemont, California. I had to go to San Jose two to three times a month for the last two years for my workshops, and LA every other weekend, where we met for live classes out of a physical therapy office. I soon realized that all these practices I was doing—yoga, meditation, and Ayurveda—were all about knowing yourself and your digestive system for a well-balanced life. The entire concept of yoga is the union of the mind, body, spirit, and self-realization. What I didn't realize was that, during this time, I had been hitting every angle of this study, and everything was falling into place for me."

Danica completed her Ayurvedic study, becoming a practitioner, with her thesis in mental health. "I am very intrigued by the mind and its effect on the body." She is also into Western herbology, took a certification course in it, and started an herbology line called Mindful Blends—a range of products focused on healing.

There is a long history in her family of reaching out to help communities in need. Twelve years ago, she and her brother, both divorced, found themselves without their kids on Christmas day. They decided to make food and go down to Skid Row, as they had with their neighbors when they were kids. They also brought toys and money to hand out. "We decided to do it every year. My brother owns a nursery and works for the studios, so he has access to big work trucks. We started with gathering donations every year, and now we even have sponsors. Last year we got backpacks from a sponsor and filled them with supplies, sweatshirts, and sleeping bags. We became better at targeting what everyone needed to survive, and acquired the appropriate sponsors. We went from making and handing out ham sandwiches in baggies to having our own nonprofit, Greetings with

Gratitude. We now have big trucks of supplies and are able to reach a much larger group of people. The kids come with us, and we walk the streets giving out what people need. It's a safe way to help others and experience gratitude."

She is also on the board of the SCV Youth Project, headed by Kim Goldman. "At first, I didn't think I had time, but when I went to my first meeting, I knew I had to join. I am so happy I did. Over the years, I have done presentations and worked with kids with trauma who are able to go anonymously to Kim with any issues of abuse. We provide free mentoring, therapy with interns and certified therapists, and confidential counseling. The organization doesn't have the recognition it should. It is donation-based, and we bust our butts doing fundraisers every year. Now that I have extended degrees and knowledge, I am going to introduce more programs. I have been so blessed to be able to take my passion and teach at places like Children of the Night, where underage prostitutes are saved from the streets and brought to a safe place to live. They are given a second chance and shown that there is something better for them out there."

Danica will never stop growing her education, knowledge, and awareness to help people in every way possible. She has recently finalized her practitionership at Dr. Peter Levine's Somatic Experiencing Trauma Institute. The institute teaches a body-oriented approach to healing trauma and other stress disorders. Danica has worked in the field of trauma for years. She teaches trauma-informed yoga in the prison system, in high schools, and with the homeless and foster youth. She shares her feelings about the subject of trauma: "We see so much suffering, and most of it is driven by fear and pain. When we can work closely with others and express those emotions freely, we begin to learn how we go through traumas—how the mind creates those emotions, and the trauma becomes stuck in our bodies."

I have had the honor of knowing Danica for many years, and I honestly do not know how she finds the time to do all that she does for people, for her family, and to constantly acquire knowledge. Even with everything on her plate, she is still that friend who will always show up for you. Maybe she really is Durga—her arms are just invisible to us mere mortals.

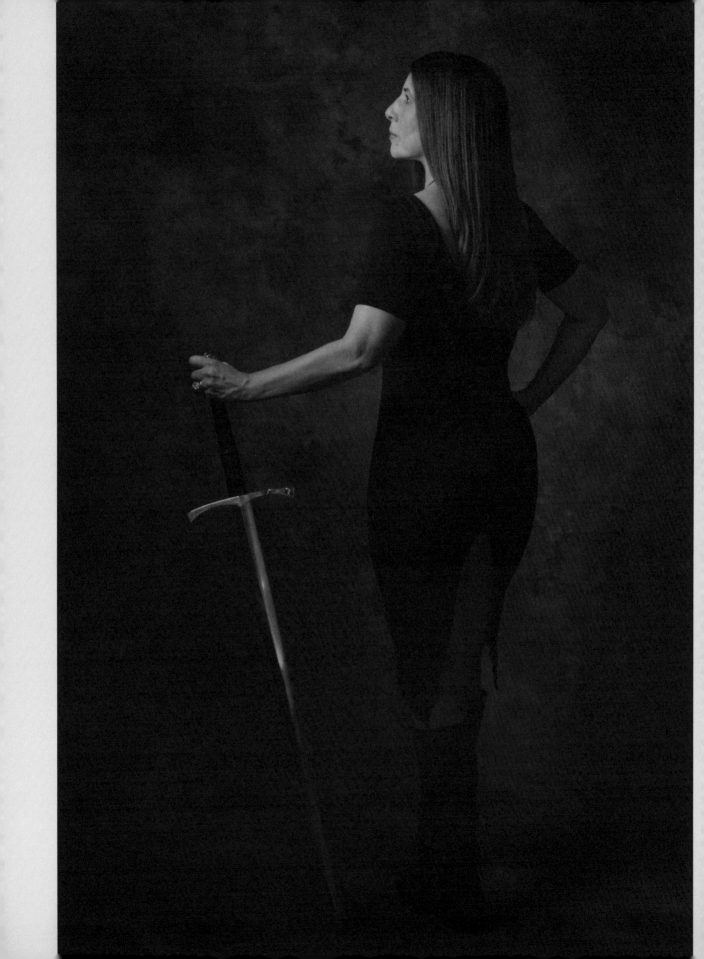

MODERN RENAISSANCE WOMAN
TRACY VERA

RECORD LABEL PRESIDENT | ARTIST

"LEAVE THE GUN, TAKE THE CANNOLI."

—RICHARD CASTELLANO, *THE GODFATHER*

Tracy Vera is a modern Renaissance woman who has always been passionate about two things: art and music. She has managed to achieve careers simultaneously in both. Tracy worked her way up to the top of one of the most male-dominated genres in the music industry: heavy metal. She is now president of Metal Blade Records. While maintaining her position at the record label, she went back to college to get her master's degree in fine art and painting. She is currently an established oil painter in Southern California, where she exhibits her hauntingly beautiful, large-scale oil paintings in local art museums. Her art is character-driven, with a focus on bone structure and a deep emotional connection to the viewer. How does she find time to run a record label *and* create these magnificent works of art? She has no choice: art is what keeps her sane.

TRACY WAS RAISED ON A SMALL ORGANIC FARM IN ASHAWAY, RHODE ISLAND. "MY PARENTS WERE HIPPIES IN A SENSE, AND MY DAD WAS AN EARLY PROPONENT OF ORGANIC GARDENING, BEFORE IT WAS IN FASHION. IN THE 1960S, HE DECIDED TO BUY A HOUSE WITH THREE ACRES AND SOLD VEGETABLES." HER PARENTS EXPOSED HER NOT ONLY TO HEALTHY EATING, BUT TO MUSIC AND ART AS WELL. "MY LOVE OF MUSIC CAME FROM MY PARENTS. THEY HAD AN EXTENSIVE RECORD COLLECTION THAT INCLUDED ARTISTS LIKE THE DOORS, JIMI HENDRIX, BOB DYLAN, JANIS JOPLIN, CREAM, AND FRANK ZAPPA."

"I built my interest in music off that. I remember as a young girl having a giant poster of the band Chicago on one entire side of the pitched-roof ceiling in my bedroom; I can still picture looking up and seeing that poster."

Tracy reflected on the evolution of her musical taste once she started discovering artists outside of her parents' music collection. "The first artist I got into on my own was Elton John. I had all his records, and he was my first concert in 1976, when I was eleven. After that, I got into Hot Tuna, Queen, Steely Dan, and then Kiss, Aerosmith, Rush, and Black Sabbath—all when I was around twelve. During that same time, I saw both Bob Dylan and Aerosmith in concert. By the end of high school, I was listening to the Scorpions, Iron Maiden, and Judas Priest. My taste in heavy metal and hard rock kept expanding as I started collecting imports and reading *Kerrang!* magazine. Later, when Metallica released *Kill 'Em All,* it was a revolution and revelation for me."

Tracy explained some of the therapeutic effects of heavy metal: "I love heavy metal as well as Joni Mitchell and Bob Dylan, but the aggression in heavy metal is a wonderful place to channel any pent-up anger I may have. I just start head-banging and yelling the lyrics of the song, and it's all gone! I think some metal singers are the best of all time: Rob Halford, Ronnie James Dio, Bruce Dickinson, John Bush—just amazing! The hard part for me with a lot of the modern music these days is that I need real drums and rock 'n' roll in there."

What was the first step toward becoming a record label president? A job at a record store! "When I was nineteen, my friend called and said, 'Get over here. There's an opening for a salesclerk at the record store I work at, and it's the best job ever!' I got the job. Later, I became the heavy metal buyer, and then went on to manage three of the stores in southeastern Connecticut. I realized there was a business side to music, and I knew I wanted to work in it. I made a lot of contacts at record labels from working at the store and from doing a radio show on a local college station. Through those contacts, I got a job at Metal Blade Records and made the move to Los Angeles in 1990. I started in retail marketing in June, and by September, their production person had left. I had no idea what production was or anything about it, but I was ready and willing to try! It turned out to be art production, which meant working with the manufacturing of the records as well as with the bands recording in the studio. Then, I moved into operations. Every time I didn't know something, I would try and figure it out or ask someone (that was before Google)! I learned as I went; I always like to learn new things. I'm never afraid to try something new."

> "I love heavy metal as well as Joni Mitchell and Bob Dylan, but the aggression in heavy metal is a wonderful place to channel any pent-up anger I may have. I just start head-banging and yelling the lyrics of the song, and it's all gone!"

Tracy's integrity and principles are just two of the many attributes that contributed to her long-standing presence in the industry. "The owner of Metal Blade, Brian Slagel, always seemed to believe in me and trust me to take on greater responsibilities. I also think I have a great work ethic and try to think outside the box to find solutions to issues and problems as they arise." She appears to have an effortless ability to walk boldly into unknown territory. "Have you heard of the saying 'Fake it 'til you make it'? I pretend I have self-confidence even when I'm feeling self-doubt."

Tracy has found that, after thirty years of experience in the music industry, her idea of success has evolved. "Professionally, I think it has changed because, at one time, I really wanted to work at a major label. I thought that I wanted to be a different kind of mover and shaker, but I learned that I loved being exactly where I was. I don't know if I would have gotten the same satisfaction out of another person's measure of what professional success is. I was able to shine more in this environment, and I love the people I work with. I think Metal Blade has the best people in the business. I intentionally hire good people, so it's a strategy! We are a family here who truly respect and support one another. I

"AS AN ARTIST, I AM IMPASSIONED BY PAINTING PORTRAITS OF THE HUMAN FIGURE; AS A PERSON, I NEED TO EXPRESS THE PRIMARY EMOTIONS OF THE HUMAN EXISTENCE WE ALL FEEL."

couldn't ask for a more positive work environment."

That atmosphere is due to the way Tracy leads: an honorable, straightforward approach, backed by kindness and commitment to the work. Just because she is in the top position doesn't mean she isn't still learning and experiencing new challenges: "I am still learning today; I want to keep an open mind. The music business changes all the time, and you have to be on your toes and anticipate the changes where you can, weather them, or capitalize on them. Brian Slagel is opening a Metal Blade Museum in Las Vegas, and I am taking on that new challenge, which includes building a company around it, securing a space, and obtaining items on loan from the bands."

Tracy has a combination of complementary talents that produce balance in her life: high-powered executive meets bohemian artist. We discussed another side of her that powers a different kind of passion that's essential for the vitality of her soul. "I come from three generations of house painters. My great-grandfather would use his house paint to do paintings, and my father is artistic as well. To this day, my father is carving birds and fish, painting, and making furniture. I always sketched as a means to the end of telling a story as a child. I thought I wanted to be a writer but, when I was sixteen, I took a watercolor class in high school, and after seeing my work on the first day, the teacher switched me to oils and trained me in the basic techniques. Later, I went to college and got a master's in fine art and painting.

Currently, I am a member of the Los Angeles Art Association—a wonderful organization that helps established and emerging artists in Los Angeles."

There are so many people who want to go back to school to get a degree and don't feel they could do it while working. Tracy took on this challenge and got her master's degree in fine art and painting at Cal State Northridge. "I really have to say my husband Joey and my boss Brian Slagel made it possible. Brian allowed me to have some flexibility in my schedule, and Joey took care of most of the stuff at home. It took a lot of focus, hard work, resilience, and a husband who backed me up when I got overwhelmed."

Tracy's paintings take an inward look into the psyche of her subjects. The *Los Angeles Times* impeccably described her work after an exhibit at the Orlando Gallery: "A kind of neo-noirish atmosphere mixes with the psychological imagery to create narratives without closure. We end up as voyeurs, projecting our own character judgments on the figures in the paintings." There are a few artists who have inspired Tracy most: "Artists such as Caravaggio for his use of shadows and light; Lucien Freud for his ability to paint the form as so brutally mortal; Eric Fischl because, as a modern painter, he is closest to what I do in terms of subject matter; and John Singer Sargent for his super-sure handling of paint."

Tracy is quoted in her biography as saying, "As an artist, I am impassioned by painting portraits of the human figure; as a person, I need to express

the primary emotions of the human existence we all feel." What is it about a person that attracts her to painting them? "It can be different things. Sometimes I know the person, and sometimes I don't. I think I project a lot of my own feelings onto the subjects. I have a painting on the table now that's a female nude; I haven't done a nude in a while. Sometimes I try to think of an emotion or a vibe and a way to express and conceptualize it, then build a photo shoot around that idea. This latest painting has her on a bed while clenching her fists with her head uplifted while screaming. To get an emotional context for this painting, try and imagine why she is screaming—there is nothing in the painting to suggest the reason—that's for the viewer to decide."

The subjects of her paintings have such a visible emotional intensity that it feels as though she is channeling those feelings from inside herself. "Sometimes I do, like in the three-part sisters painting series; I was telling my story through the images. With my current painting, I am trying to externalize what I think this woman is feeling: we all feel like throwing our heads back and screaming sometimes. The nudity adds the vulnerability to it as well."

Tracy and her husband Joey met through her work at Metal Blade. "Joey's band, Armored Saint, was newly re-signed to Metal Blade around the same time I started working there. Since Joey was the main contact in the band for both the recording and the art, we ended up spending a lot of time together. Though it certainly wasn't and isn't encouraged that an employee should date one of the artists, Joey and I knew we could handle the situation. Luckily, Brian Slagel had been friends with Joey since the label's beginning in 1982, and I think that, along with his confidence in my professionalism, left Brian taking a wait-and-see approach. Joey and I knew from the beginning that we were going to be together for the long haul. Maybe Brian recognized this as well."

On May 30, 1992, Tracy and her husband Joey were married. "After all these years, our love is still rooted in respect, and we actually still like each other! Even though we sometimes get bogged down in the day-to-day, we always try to make time to be together. We enjoy so many of the same things, and he always makes me laugh. We love to cook together and like to consider ourselves amateur chefs (who doesn't these days!)." One of the many things they have in common is their love of sci-fi and fantasy; the two can also be found regularly at the Renaissance Faire when it comes to town. They even have an homage to one of their favorite films on their wedding rings. "We are a bit obsessed with *The*

> **"With my current painting, I am trying to externalize what I think this woman is feeling: we all feel like throwing our heads back and screaming sometimes."**

Lord of the Rings. Our wedding rings say *one ring to bind us* in high Elvish!"

One of the most momentous events in Tracy's life was becoming a mother when she had daughter Kayleigh. After that, she looked at life through a different lens, providing a newfound perspective on happiness and her life's purpose. "Motherhood was a big awakening for me. Being responsible for another human being alive. It is both amazing and scary watching my daughter grow up and change. I am so proud of her as a person. I never knew I could love someone so much! When I look at her and see this beautiful human, I become overwhelmed with joy; to me, that is a measure of success. I am so grateful for everything in my life."

Tracy is an incredibly real, honest, and direct woman who takes that honesty into everything she does, especially her art. Her paintings take you on an expedition to the deepest caverns of the human heart and mind. She has been fearless not only professionally, but personally as well. Tracy explores all facets of herself and exercises the freedom to be who she wants: a lover of fantasy with a fascination for the harsh reality of the human condition, a focused executive by day and a wild head-banging concertgoer at night. The comedy/tragedy aspect of Tracy's quote from *The Godfather* to start her chapter is yet another example of her unconventional character and humor. Last December, she got her first tattoo, an elegantly drawn fine-lined scorpion nestled in beautiful flowers. It's a perfect reflection of how Tracy sees life and art: the beauty in darkness and the darkness in beauty.

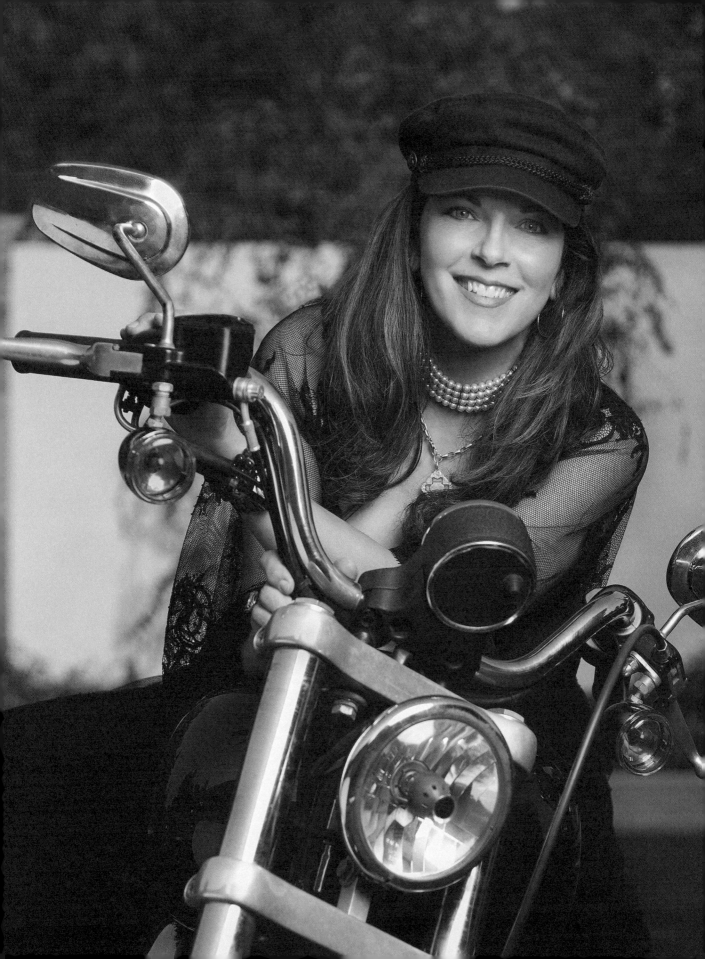

MAMA-BEAR BIKER
YVETTE NIPAR

AUTHOR | ACTRESS | ENTREPRENEUR

"NO ONE SAVES US BUT OURSELVES. NO ONE CAN AND NO ONE MAY.
WE OURSELVES MUST WALK THE PATH."

—BUDDHA

Yvette Nipar is a woman with strong convictions rooted in honesty and integrity; it's the foundation on which she has built her life. When those values came under scrutiny after the disappearance of her ex-husband and father of her child, it was polarizing. This tragedy turned into an international tabloid sensation that shadowed her for over a decade. Protecting her son from the relentless media hounds and lies called for Yvette to hold up a shield of armor so impenetrable it kept her from addressing her own pain. The layers of heartache came full circle from a childhood steeped in abandonment, abuse, and neglect. She eventually faced it all with the same strength and compassion she bestows on others, with a renewed state of self-love and awareness. Music, motorcycles, and a memoir were the tools to take her on the road to healing.

SHE STARTED HER LIFE IN SOUTHERN CALIFORNIA IN THE 1960S WITH TEENAGE PARENTS AND AN OLDER BROTHER. INEVITABLY, HER PARENTS BROKE UP WHEN SHE WAS TWO, AND SHE DIDN'T SEE HER FATHER AGAIN UNTIL SHE WAS THIRTEEN. LIFE WITH HER MOTHER INCLUDED MUSIC FESTIVALS AND LOVE-INS AMIDST A FREE-SPIRITED LIFESTYLE. IT WAS YVETTE'S FIRST EXPOSURE TO LIVE MUSIC, WHICH CONTINUED TO BE A SOURCE OF JOY THROUGHOUT HER LIFE. "EVERYONE WAS SO HAPPY AND FREE, AND I WAS ENAMORED WITH THAT VIBE AND THE FEELING OF THE MUSIC THUMPING IN MY CHEST."

When Yvette was five, her mother and boyfriend Ronnie were arrested for selling marijuana, and the kids were sent to live with their maternal grandmother in Florida. "She was incredibly strict; we had been living the life of flower children going to pop festivals where people were dancing and tripping on acid. The dichotomy of the two lifestyles was unsettling. Beatings with a belt were a regular occurrence, often for things we didn't do."

After a year at her grandmother's, Yvette's mother reappeared, having married Ronnie; the two had become devout Pentecostal Christians. A whirlwind of changes was about to come crashing down, ending any hopes for normalcy in her childhood. "After an awkward court appearance, we were given back to my mother, moved to Houston to be near my stepdad's family, and were enrolled in Catholic school. Shortly after, the fighting started between them, religion fell by the wayside, and my little sister was born. They divorced, my mother fell in love with a heroin addict, and then became one herself, leaving me to raise my baby sister when I was only nine. There was no time for fun, except for rare weekends at my stepdad's."

Being with her stepfather was the highlight of her childhood and the only time she could be a kid. Otherwise, she was called upon to be the only adult in the room. "I had very little recollection of my biological father, so to me, my stepdad was my dad, and I called him Dad. He always made me feel loved. He put me on

my first horse and my first Harley. I always knew I'd have my own motorcycle—it was love at first ride. Then he moved to Key West, Florida, and I was devastated. I don't think he knew how bad my mom's heroin use was, and I didn't want to say anything for fear the courts would break up my family again. I also wanted to protect my mom. This was the start of being her protector, fixer, and caretaker."

Yvette was exposed to unseemly horrors of an addict's life that no child should have to witness. "I suffered a great amount of psychological trauma from my mother's neglect, beatings, and violence between her and her boyfriend. There was also the disturbing riffraff of drug dealers coming and going. I had boatloads of shame and was sure that everyone knew my mom was a heroin addict, that we got evicted every six months, and were dirt-poor. I don't recall anyone else being on scholarship at school and getting little red tickets for free lunches."

Yvette's biological father reentered her life just as she became a teenager and expanded her love of music and California. "My brother and I went to LA for the summer to meet our biological father, having no idea what he looked like. He was a successful recording engineer, and I was thrilled to be his tag-along at concerts and go backstage afterward. I remember keeping my cool standing next to Bonnie Raitt one night, and hanging out with Jackson Browne in his dressing room at the LA Forum. When my father started working with Joe Walsh and Don Henley, it was surreal; their music had gotten me through many dark days in Texas. I'm blessed to call them all friends to this day. Spending that summer at the beach in Malibu and driving through the canyons made me certain I wanted to move back to where I was born."

She made it back to California at the end of her freshman year, when her grandmother sent her mother money to get there. "My grandma, who had since moved back to California, offered us her home in Huntington Beach, where we lived in a tension-filled household for a year. We finally got an apartment during my junior year, but by my senior year I was sleeping on a drug dealer's couch because we got evicted. Fortunately, a good friend invited me to live with her."

"I took an acting class, and I discovered I could make people laugh and feel."

During her last semester, an easy credit led to a lucrative career. "I took an acting class, and I discovered I could make people laugh and feel. I ended up doing a Don Henley music video at the height of MTV, and I was hooked. The day after I graduated high school, I moved in with

my biological father in LA and started teaching aerobics at Jane Fonda's Workout studio. Then, I was walking through a mall where Elite Models was doing a model search. I jumped in line for shits 'n' giggles and ended up signing with them, which took me to Japan for three months and got me a lot of work in magazines."

It wouldn't take long for her expressive and vibrant personality to land her a plethora of acting roles. After a year of modeling and doing commercials, a chance meeting would launch her acting career: "I met a woman in a clothing store who asked if I had a theatrical agent. A month later, I had a contract role on *General Hospital*—getting paid to learn for a year. When I consistently started getting episodic guest-starring roles on shows like *Matlock* and *Murder She Wrote*, I was able to get my own apartment. Playing Johnny Depp's girlfriend on *21 Jump Street* was definitely a highlight, because the character was feisty and smart." Her acting career would enable her to fulfill two dreams she had held onto since she was a child: owning her first home and motorcycle. She bought a Harley-Davidson that she rode for twenty-six years, until recently upgrading to a bigger and more powerful one.

Yvette finally had roots, self-respect, and financial security; but her peaceful sanctuary was about to be torn down brick by brick by a man disguised as love. She would learn how someone could be responsible for the greatest gift in your life and the most profound hurt.

"A few months after I bought my house, I met the father of my child, Patrick McDermott, and everything changed. By the time we were engaged, I knew in my gut that we would never last, but my codependency kept me from breaking it off. Then I got pregnant. I think I did what many women do when they get pregnant while in an unhealthy relationship: hope the baby will make everything better. Unfortunately, it only made things worse. Patrick was verbally abusive and had a serious anger management issue. I found myself shrinking, always walking on eggshells, and devastated that our son, Chance, was being exposed to such destructive energy. Because I'd made a promise to Chance on the day he was born that he'd never be subjected to the kind of craziness I grew up in, I felt like a complete failure. When he turned one, we were broke, so I went back to work and booked a job in Toronto a month later, playing the lead in the *RoboCop* series. It was a major blessing, because it enabled me to remove our son from such a toxic environment. It was so special for him to have that year of serenity. I had asked for a legal separation before I left for Toronto, then got the nerve to ask for a divorce shortly after we got back."

She then went through a decade of volatile and dysfunctional coparenting with her ex-husband that was emotionally and financially debilitating. "We had a very acrimonious relationship. He fought for full custody for years, forcing me to sell my house to keep up

"I FINALLY FOUND THE WHEREWITHAL TO LET GO AND ACCEPT THAT I HAD NO CONTROL OR RESPONSIBILITY OVER WHAT HAPPENED. THIS WAS WHEN I STARTED WRITING. IT LIFTED SUCH A WEIGHT OFF MY SHOULDERS, AND I GRADUALLY BEGAN TO FIND CLARITY."

with attorney fees. My beautiful house, my own little piece of this planet, was gone because he was hell-bent on getting custody. There wasn't a chance in hell I was going to let that happen. I'd heard him lose his patience too many times with our son and transfer his pain onto him with anger and harsh words. A parent's voice becomes a child's self-talk. That much I knew. I had lived it and fought very hard to kick that sort of negative self-talk to the curb. I know my mom did the best she could, but that doesn't cancel out the scars."

Her mother was not able to conquer her addiction, and sadly left this earth without restoring a relationship with her children. Yvette tried many times over the years, but it wasn't meant to be. Her mom had always loved inspirational quotes, and Yvette found they were another source of comfort for her. She figured out a way to share some of that positivity by putting quotes on T-shirts. That's when her company, Be So Do So, was born. *Laugh at yourself often, A smile costs nothing, Attitude is everything,* and *Let go of fear* were some of the sayings on the shirts.

A few years after Patrick and Yvette were divorced, he started dating Olivia Newton-John. They had an on-and-off relationship for nine years. Yvette was about to embark on the biggest challenge of her life, one that would unleash a torrent of emotions that had been locked up since her childhood. She would be abandoned once again, only this time, so would

her son. "Patrick went on an overnight fishing trip with twenty-two other passengers and five crewmembers on a charter boat. Everyone remembers seeing him on the five-hour evening trip out to drop anchor in the middle of the Pacific Ocean, but no one saw him the next day. Chance and I were at the Colorado River and came home because it was Patrick's turn to spend two weeks with his son—but he never showed up. The last time anyone saw him was around midnight, sitting in the galley on the boat."

Patrick's disappearance has been shrouded in controversy ever since. The media's fascination was solely due to his relationship with Olivia. It was everywhere and became the focus of numerous TV shows and tabloids: not for one year, or even two, but continuing to pop up to this day, fifteen years later. It sent Yvette down a rabbit hole of seclusion, pain, and loneliness, while she was doing everything to give her son a happy and healthy childhood.

"After the media got involved, we were prisoners in our own home. Journalists were at our door with cameras and microphones sporadically for the first year. Then, every time the news would announce a supposed sighting of Patrick, it would all come back— the emotions and the reporters. We were essentially collateral damage, and never had an opportunity to move on."

As if that wasn't enough, some of the press reports villainized Yvette and fabricated stories about her: "It would crush me to my core to read articles and listen to newscasters insinuating that I had anything to do with Patrick's disappearance. They were saying that I drove him away and that I threatened to put him in jail. This was someone I once loved, and the father of my child. I would never wish ill will on him. They inflated Patrick's late child support from the $8,000 he owed to $30,000. Not having a voice during that time was incredibly frustrating, but I had no desire to be a part of anyone's *story*, especially knowing how the media twists people's words. These were only headlines and top-of-the-news stories around the world because of Olivia's fame. They didn't care what we might have been going through. In every journal entry during that time, I wrote, *please help me*, over and over. It was a dark time—really dark."

The Coast Guard declared Patrick lost at sea, but finding closure would be an arduous task. "I never imagined my son would grow up without a father; that was a hard pill to swallow. Especially after so much time had passed, and Patrick didn't come back. Every supposed sighting was like a punch in the gut. I finally found the wherewithal to let go and accept that I had no control or responsibility over what happened. This was when I started writing. It lifted such a weight off my shoulders, and I gradually began to find clarity."

Writing and a sisterhood with Olivia were exactly what she needed to heal. "Olivia was the silver lining. The first time we talked, we instantly connected: the friendship was there from the get-go. It was as if I'd known her forever. We were the only ones who *got* what happened on a deep level, because we'd both once loved the same person. We each understood what the other was going through with the *not knowing* of it all. Then we started hiking and having conversations that only she and I could have. We cried on each other's shoulders, and we cried for what could've been for Chance. She encouraged me to keep writing, and she always had this uncanny intuition to call when I was in a funk and pull me out of it. She's been an incredible inspiration with all that she's been through; her positivity and light are contagious. In a sense, she became my mentor and taught me the notion of truly letting go and moving on, even though fifteen years of 'sightings' gave me a run for my money. Much of my healing and writing happened while housesitting for her over four years, tucked away in the remote Santa Barbara mountains."

> "One of my first shirts was *Be your own best friend*, which is the ultimate self-love and respect. When it comes down to it, it's me who needs to show up for me."

That much-needed time of tranquility and self-reflection at Olivia's allowed Yvette a space to continue writing her powerful memoir, *Alive & Well*, that will be released in 2023. Often writing through the pain, she found a particular saying from her T-shirt line that resonated with her: "One of my first shirts was *Be your own best friend*, which is the ultimate self-love and respect. When it comes down to it, it's me who needs to show up for me."

She shows up for herself and everyone else in her life, especially her son, the love of her life. "I'm so proud of the kind, respectful, young man he's become. When he was born, I had no idea I had the capacity to love another human that much— my life was complete. I have a sense of pride in myself now, instead of living in regret that I didn't

do it perfectly. I did a damn good job with what I had. I succeeded in breaking the cycle of crazy that's gone on in my family for generations. It's an honor to call Chance my son."

Yvette will always love fiercely, laugh loudly, empathize greatly, advocate strongly, and hurt deeply. She has learned how to balance her emotions, and she has become grounded through a life of simple pleasures. She dances off any frustrations from her day with everything she's got. "Dance is in my blood and my soul. It's the Puerto Rican in me; it's where I get my fire." Her other form of therapy? Riding her Harley! "It's the only time the committee between my ears is quiet and I'm free…with my knees in the breeze and the wind in my face. It's everything. I'll still be riding when I have no teeth."

HEART AND SOUL OF ROCK 'N' ROLL DEBBY HOLIDAY

SINGER | SONGWRITER

"DON'T DIE WITH YOUR MUSIC STILL IN YOU."

—WAYNE DYER

Debby Holiday is a powerhouse singer/songwriter with sixteen top-twenty Billboard hits. If she could, she would sing and perform every second of the day! She does her best to accomplish that, with a rigorous schedule of writing, performing, and recording music. She believes music saved her life, inspiring her to touch others in the same way by creating healing through music. She is fully committed to writing authentic songs that go inside one's emotional core to focus on relatable issues. This independent woman had a rough start in this world, and she learned at an early age how to make positive life decisions for herself—a trait she continued to use in her professional life when she boldly started her own record label, Mocha Music, after leaving Warner Bros. Records. She is a survivor with immense gratitude for her life and the people she loves.

IT'S NO MYSTERY WHERE DEBBY GOT HER MUSICAL GENES. HER FATHER, JIMMY HOLIDAY, WAS A SUCCESSFUL SONGWRITER. HE TOPPED THE CHARTS WITH SEVERAL ORIGINAL SINGLES BEFORE GOING ON TO COWRITE THE HITS "ALL I EVER NEED IS YOU" AND "UNDERSTANDING" WITH RAY CHARLES, AS WELL AS WRITING THE CLASSIC "PUT A LITTLE LOVE IN YOUR HEART" FOR JACKIE DESHANNON. SONNY AND CHER, KENNY ROGERS, AND DOTTIE WEST, ALL RECORDED "ALL I EVER NEED IS YOU," MAKING IT A HIT MANY TIMES OVER.

From the outside, it looked as though Debby had a charmed and privileged upbringing, but behind closed doors it was a very different story.

Debby's childhood was a turbulent ride that she skillfully maneuvered with her innate wisdom. She spent the first three years of her life in foster care until her father brought her home. Debby had been the result of an affair Jimmy had while married to his wife Betty. He turned a blind eye to his daughter's existence until his wife made him go and get her. Despite Betty's anger about the affair, she was able to see how wrong it was for Jimmy to abandon Debby. Unfortunately, Betty could never stop seeing Debby as a reminder of her husband's infidelity, which was grossly apparent in the way she treated her.

As an adult, Debby now looks at her stepmother's anger with an empathetic heart. "Betty was raised in an abusive household. She left her abusive father, only to find my abusive father. She was an addict and did the best she could with the limited tools she had. She was a sorrowful and broken woman." Something never felt right in her relationship with Betty, who Debby thought was her biological mother for almost her entire childhood. The pieces of the puzzle finally started to fall into place with a startling admission: "When I was sixteen, Betty told me that she was not my biological mother. I was so thankful to find this out because it explained why she was so angry and resentful toward me all the time. It taught me a lot about people's behavior, and that there's always something behind it."

Jimmy Holiday was an abusive and angry man, but he did provide an excellent education for Debby and was her first window into the magic of music. His success exposed her to some of the most iconic artists. "I grew up with legends like Etta James and Ray Charles (Uncle Ray), who were considered family. Music was all around me, incredible music filling my soul. I grew up in a very progressive house, and I was basically my own parent. I went to great schools, starting at a select academy for little folk with ten people in my sixth grade graduating class. Then I went to Harvard Westlake, another very well-to-do school, which I am super grateful for."

Debby may have grown up in an affluent area and received an advanced education, but it came with a price. "I've always felt different. I think it was because I grew up the only Black kid in my neighborhood of Beverlywood, California. With only two other Black kids in my entire school, it felt like I never belonged anywhere. I didn't belong to any of the cliques in my school either. Instead, I became friends with everybody. When I was very young, my father told me that being Black meant I had to be three times better than the white person next to me. I took that to heart and always maintained a 4.0 grade point average. I felt I had to be perfect in everything I did. It started from the time I sang my first note.

"When I was five, I hummed along to my father playing the piano. He pulled me over and said, 'Sing this note.' I sang it, and he told me I was flat. I tried it again, and he yelled, 'Sing it again, you're still flat!' I remember saying, 'But Dad, I'm five.' To that, he replied, 'I don't care how old you are. You don't walk around this house singing flat.' So, I learned how to sing from my father's insistence that I learn how to sing

> **"I've always felt different. I think it was because I grew up the only Black kid in my neighborhood of Beverlywood, California. With only two other Black kids in my entire school, it felt like I never belonged anywhere. I didn't belong to any of the cliques in my school either. Instead, I became friends with everybody. When I was very young, my father told me that being Black meant I had to be three times better than the white person next to me. I took that to heart and always maintained a 4.0 grade point average. I felt I had to be perfect in everything I did. It started from the time I sang my first note."**

"I AM MUCH MORE FORGIVING OF MYSELF AND OF OTHERS THAN I USED TO BE. I STILL PUT PRESSURE ON MYSELF, I'M STILL MY OWN WORST ENEMY, AND I'M STILL A PERFECTIONIST, BUT I AM MUCH MORE FORGIVING OF MY FAUX PAS. I HAVE ALSO LEARNED THAT IT'S HEALTHY NOT TO PUT YOURSELF IN A BOX. IT'S A BIG PET PEEVE OF MINE FOR ANYTHING IN LIFE: IF YOU'RE BLACK, YOU'RE SUPPOSED TO DO THIS. IF YOU'RE A WOMAN, YOU'RE SUPPOSED TO DO THAT. IF YOU'RE GAY, YOU'RE SUPPOSED TO BE THIS. ALL OF THOSE BOXES INTERSECT AND CROSS OVER."

correctly. I always had his words in my head when I sang along to everything from Barbra Streisand to Aerosmith. It sounds a bit harsh, but it helped me learn how to sing properly."

The downside of her father's messaging has been a lifelong battle with perfectionism. She has now learned how to be kinder to herself while still maintaining a high bar personally and professionally. "I am much more forgiving of myself and of others than I used to be. I still put pressure on myself, I'm still my own worst enemy, and I'm still a perfectionist, but I am much more forgiving of my faux pas. I have also learned that it's healthy not to put yourself in a box. It's a big pet peeve of mine for anything in life: if you're Black, you're supposed to do this. If you're a woman, you're supposed to do that. If you're gay, you're supposed to be this. All of those boxes intersect and cross over."

During Debby's first year as a teenager, her life as she knew it would be turned upside down. "When I was thirteen, my father was diagnosed with a mental health issue and taken to a hospital back to his hometown in Iowa. In those days, when you were admitted, they froze all your assets. In a three-week period, we went from being bloody rich to bloody poor. Betty got a job working for Motown with Barry and Gwen Gordy. It only took six months for Betty to meet a cowboy, and she was off to Santa Maria, California. I had no choice but to go with her, only I had just started my sophomore year in high school and wanted to finish that year all the way through. I was fortunate

enough to be able to do that by staying with my friend Robin Gordon. Robin's mother is Florence LaRue of the Fifth Dimension.

"I finished tenth grade and then made the move to Santa Maria with Betty. I took a test at my new school, and they skipped me two grades. I was now a senior in high school at fifteen. I couldn't stand the school. It was very segregated, and I only made it four months before I took the GED. After that, I started going to Hancock College and received a scholarship to the Alvin Ailey Dance Company in New York. I had always dreamed of being a dancer, but since I didn't know anyone in NY, I decided to go back to LA where I had friends. This was also when I picked up a guitar for the first time, and I was hooked! When I got there, I worked in a boiler room selling office products, and I got ripped off by the company and didn't get paid."

Debby had hit bottom: homeless and penniless. Her fairy godmother appeared in the form of the actor and football player Rosie Greer. "I was still friends with Rosie, who was one of my dad's best friends. I called him and asked for help. He paid for a month's rent on an apartment, but gave me specific conditions: 'You've got thirty days to get your act together. I'm not paying for another month—this is it. You're going to have to go out and get a real job and support yourself.' Sure enough, that's what happened. I was so grateful for his help, and I did end up finding a great job."

Now this gutsy and determined woman was ready to realize her dreams. Debby had never wanted to be like her father, but there was one trait she didn't mind inheriting. "Jimmy was completely fearless, and I am definitely my father's daughter in that regard. The perfect example was how he got his start in the music business. He was a struggling songwriter who loved Ray Charles. So, he went to Ray Charles's office on a Monday morning and announced to the receptionist, 'I've got some reel-to-reel tapes I think Ray Charles would love, and I want him to hear them.' He sat there from 9:00 a.m. to 5:00 p.m., and when five o'clock came, he said, 'I'll see you tomorrow.' He came back the next day, and Ray still wouldn't see him. He was there the entire week, from 9:00 a.m. to 5:00 p.m. with his reel-to-reel tapes on his lap. When the office was about to close on Friday, he said, 'I'll see you Monday.' The receptionist had finally had enough and buzzed Ray. 'Mr. Charles, this man is starting to scare me!' Noticeably annoyed, Ray replied, 'Send that Negro in!' My father played his songs, and three of them ended up on Ray's next record!"

> "After all these years, I still have people come up and ask, 'How did you learn rock 'n' roll?' There are so many people who don't really know where rock 'n' roll came from. It came from the blues and Black folks, y'all! Excuse me, Big Mama Thornton—this is where you got everything from! She's the woman who wrote 'Hound Dog.' Very few people know that song started out as an anthem of Black female power."

It was Debby's turn to break into the music scene with that same drive and fearlessness. "I started a band called Stiletto that ended up winning a KNAC award. This was a big deal for me since KNAC was a hard rock station and, for some reason, my being Black and female made it surprising to people that I could even play rock 'n' roll! After all these years, I still have people come up and ask, 'How did you learn rock 'n' roll?' There are so many people who don't really know where rock 'n' roll came from. It came from the blues and Black folks, y'all! Excuse me, Big Mama Thornton—this is where you got everything from! She's the woman who wrote 'Hound Dog.' Very few people know that song started out as an anthem of Black female power."

It would be another ten years before Debby was signed by music industry giant Irving Azoff and Warner Bros. Records. "Warner Bros. had no idea what to do with me, so they just kept trying to change me. I wanted to play rock 'n' roll, and I wanted my guitars. Don't you touch my Les Paul!

One of the people at the top of the label said to me, 'Look at the Billboard rock charts. Do you see any Black women there? No, you don't, and you won't!' At that time, and let's face it, still to this day, you don't see many Black women playing rock 'n' roll.

"I had a lot of great experiences at Warner Bros. I was on tour with Rod Stewart and opened for Joe Walsh. When I finally did get dropped, I was fortunate enough to have a great attorney, Eric Greenspan, and he made sure I had a play-or-pay clause, which means either put my record out or drop me and give me a big fat check. I got the big fat check and started my own record label after my friend and manager, Andrew Breskin, sent my song 'Dive' to a record producer named Chris Cox. He loved it, and the next thing I knew, I was starting my own record label, Nebula 9 (now Mocha Music), with that first song hitting #5 on the Billboard dance charts!"

Debby is the first to admit dance music wasn't the direction she saw her career going in all those years ago as a young rock singer. She has learned some valuable life lessons since then about always staying open to the prospects around you. "I am so grateful that the world of dance music found me. Sometimes you need to let go of a particular dream and embrace the opportunities right in front of you, realizing that perhaps it's exactly where you're supposed to be. There's a famous Wayne Dyer quote, 'When you change the way you look at things, the things you look at change.'

Life is ever-changing, and thankfully it inspired me to write in a completely different genre of music."

These wise words were the doctrine that would get her through her toughest challenge yet: breast cancer. She found a lump on her breast during a self-exam in the shower. Her gynecologist assured her it was nothing. Two years passed, and Debby knew something wasn't right in her body. She demanded a mammogram, and even though the doctor could clearly see a dot on the images, he said it was fine. Once again, Debby was in a situation where she had to advocate for herself: "I was literally about to go to my doctor's office and scream, 'I WANT A BIOPSY!' I had read about needle biopsies, and I wanted one immediately. They finally did it, and it was cancer. I had a lumpectomy, and they removed my sentinel node. They shot up my breast with blue dye to find my sentinel node, because it is the guard that stands at the gate. That was super attractive for nine months. It looked like my breast auditioned for the Blue Man Group. Usually, if the cancer is not in the sentinel node, it's most likely not in the rest of your lymph nodes. Fortunately, it had not spread to my lymph nodes.

"About a year and a half later, it was back. It was never properly taken out the first time. I changed doctors because the first doctor missed it in spite of the growth being less than an eighth of an inch from the one he removed. I ended up going to Cedars-Sinai in LA and got a fantastic doctor. I did radiation and was able to avoid chemotherapy. Thirteen lymph nodes were taken in total, and I

have been cancer-free for fourteen years. I am truly blessed. I get tested every six months and do blood work every three to six months. I do self-checks constantly, and I try to get rid of as many negative people as possible in my life. I have since learned how to give myself time to stop, whether it's five minutes or five hours. I also have a yoga and meditation practice that keeps me grounded in gratitude and the present moment."

Inspiration for this sensitive spirit comes from many different directions. "I cry about happiness and the beauty of love. It inspires me to live a better life. I'd like to make as much money as possible to help as many people as I can while on this planet. Over the years, I've been so lucky to have had the most wonderful friends. I have twenty- and thirty-year friendships I wouldn't trade for the moon."

She only saw her father a few times as an adult, and the last time was when she went back to Iowa for his funeral. "My father passed away from a brain aneurysm in 1987; he was fifty-three. I went to his funeral and met many relatives I'd never seen before. He had an open casket, and it was the

> "I cry about happiness and the beauty of love. It inspires me to live a better life. I'd like to make as much money as possible to help as many people as I can while on this planet. Over the years, I've been so lucky to have had the most wonderful friends. I have twenty- and thirty-year friendships I wouldn't trade for the moon."

happiest I had ever seen him. The anger had finally stopped, and he was at peace. I was glad I was able to see that."

The quest for peace amidst the anger also mirrors the state of our country right now. Debby reflects on some of her emotions during this tumultuous time in our history: "I have spent the majority of my life trying to understand others and find our commonalities. I write songs about learning, growing, standing up for others, and knowing that most people are basically good. I could not possibly count the hours I've spent watching documentaries on other countries, reading literature from international authors, and works from many of our known American heroes, poets, and scholars. Yet, perhaps, I have not wanted to spend a great deal of time seeing what's really going on. I do, after all, live in a musical bubble. When you sing and play music, no one cares much about your race; they just want to be entertained. So, I've stepped back in light of recent events and spent time revisiting a part of my heritage. In that pursuit of knowledge, one of the documentaries I found is *13th* on Netflix. If you are wondering

what the layers of systemic racism might include, this film is a powerful analysis that's impossible to disagree with—it's simply facts! It's our history. We should know it. All of it."

Debby has devoted much of her time and fundraising efforts to charities like St. Jude Children's Hospital, the NAACP Legal Defense Fund, and the Innocence Project, as well as organizations for LGBTQ+ rights, women's rights, and animal rights. She is a proponent for the rights of all people, equally as one.

There is nothing this accomplished musical artist can't sing: rock, pop, dance, soul, and even country—they all perfectly suit her sultry and symphonic vocals. Her recordings have also been featured in film and television, most recently having her music placed in the Amazon show *Making the Cut*, starring Heidi Klum and Tim Gunn. Her latest double album, *Free2B*, is a collection of both rock 'n' roll and dance music.

When Debby was a young girl, her first concert was Alice Cooper and the second was Bette Midler, setting the tone for her diverse love of all styles of music. But one artist stands alone as her favorite of all time: David Bowie. Just like Bowie, Debby pulls you into her performances both musically and visually. She becomes one with the melody, and you get lost on an exhilarating and euphoric ride. For Debby, music is the language of her spirit, which she uses to unite the world with the love in her heart.

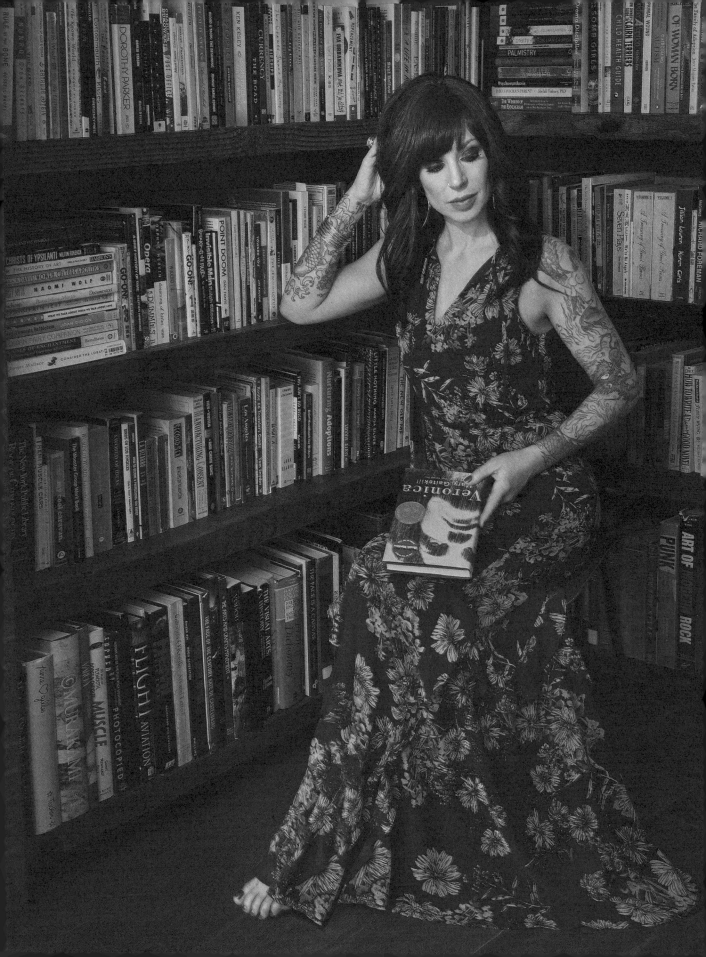

TRUTH TO TELL
JILLIAN LAUREN

AUTHOR

"EVERYONE HAS A CREATIVE IMPULSE, AND HAS THE RIGHT TO CREATE,
AND SHOULD."

—PATTI SMITH

*N*ew York Times bestselling author Jillian Lauren moves through life with an unrelenting commitment to her creative calling—wherever that may take her. Her hometown of Livingston, New Jersey, quickly became a stifling environment for this free spirit. Theater, dance, books, music, and writing were the outlets for her creativity and vivid imagination. These talents are fully expressed in her home today, which she shares with husband Scott Shriner, bass player for the band Weezer, and two sons, Tariku Moon and Jovi Starshine.

HER ADVENTUROUS AND CURIOUS NATURE INSPIRITED HER TO LEAVE HIGH SCHOOL AT SIXTEEN TO STUDY THEATER AT NYU, BUT THAT WOULD PROVE TO BE SHORT-LIVED: "AT THAT TIME, I THOUGHT I ALREADY KNEW EVERYTHING I NEEDED TO KNOW IN LIFE. IF I COULD GO BACK TO COLLEGE NOW, I WOULD LOVE THE OPPORTUNITY TO SIT AROUND AND STUDY ALL DAY. BACK THEN, MY ENGINE WAS GOING FAST, AND I WAS ALWAYS SO EAGER TO BE AT THE NEXT PLACE. WHAT HAPPENED WAS THAT MY AGE ACADEMICALLY AND MY AGE EMOTIONALLY WERE TWO DIFFERENT THINGS— PROFOUNDLY DIFFERENT."

"I got the test scores that let me go to college at sixteen, but I didn't have the grit to get through the hard stuff of life. That came much later."

After leaving NYU, Jillian continued working with theater groups. As a teenager living in New York with few options to support herself, she turned to stripping. This eventually opened the door to working as an escort. At eighteen, she went to an audition for "pretty girls to decorate parties" thrown by a rich man in Singapore for two weeks and $20,000. She romanticized the job as an exotic, international adventure. In reality, she became a member of the harem for Prince Jefri Bolkiah, the youngest brother of the Sultan of Brunei. Those two weeks ended up becoming eighteen months of extreme decadence, misogyny, and isolation. This surreal time in her life would serve as the backdrop to her first memoir, *Some Girls: My Life in a Harem*, a *New York Times* bestseller.

Not long after returning home from Brunei, Jillian got lost in a life of drugs, heartache, and excess. She wrote in *Some Girls* about her emotional state when she left Brunei: "I wound up being a well-paid piece of property—only a rental property, but still, I had severed the connection between my soul and my body so profoundly that I could barely feel my own skin anymore."

It was not an easy road back to finding herself, but she did, with a lot of support, a spiritual program, and her passion for writing. She made the decision to go back to college to finish her bachelor's degree and then her master's degree in creative writing. Jillian has a

genuine gift of communicating with people through her art. *Some Girls* is filled with universal themes women can relate to and the transparency of a life story that all can learn from.

Jillian shared how she found the courage to stand in her truth while writing *Some Girls*. "It was my first memoir, and I was terrified of the reaction from my family, the world around me, my friends, and even the families at my kids' school. But when I published it, even though I did get some backlash, I found that I received much more love and support. It was a relief because I had compartmentalized my life up until that point. I wasn't particularly ashamed of my past, but I also didn't talk about it a lot. What the book did for me was really integrate my life, and it forced me to have an honest conversation with my parents that might never have happened without it. There were some events I included and some I did not. I think there is this misconception that a memoir is just vomiting up your whole life on a page or transcribing your journals, and it's not. It's a crafted narrative, a story, but it's not every single event that happened in my life.

"My parents were super upset about the book, and they're still not thrilled. My mother and I can joke about it now, but at the time of publication, they were angry and hurt. It took a lot of years for us to reconcile and agree to disagree that writing a memoir is a perfectly valid thing to do with one's life. We were forced to confront some of the toxic undercurrents that remained in our relationship. Right now, we have a fantastic dynamic, and my kids get to be close to their grandparents. It doesn't feel like I'm pretending to be somebody; it feels like I have parents who love and accept me for who I am, even though we might differ on things."

Jillian talked about her path to parenthood with Scott that led them to adopting their two beautiful boys: "We weren't trying to get pregnant right away, but we weren't not trying either. After a couple years, right around when we got married, we decided to start trying more actively. It became clear pretty quickly that it wasn't happening. We tried infertility treatments but did not keep at it for very long, as it was apparent that it wasn't right for me. Early in the infertility process, I said, 'I can't do this anymore—I can't do it to my marriage, and I can't do it to my body.' My health was a mess at that time, and quality of life was one of the big reasons I stopped. Having been adopted myself, it was always in my plan somewhere along the line. So, it was not a hard decision for me."

Writing her first memoir was an incredible experience for Jillian, but it still comes in second to becoming a mother. The two events went hand in hand: "I walked around for years saying, 'I just want a baby and a book deal,' and I could not seem to get either for the longest time. Of course, be careful what you ask for, because I got them both at the same time! I wrote the first half of my book while we were waiting and getting ready to go to Africa once we were matched with Tariku by the adoption agency. Then I wrote the second half with a new infant. It was one of the hardest times of my life, as well as being one of the most rewarding. We did this attachment-heavy parenting therapy during the early

days, and we were so close that it was hard for me to be away from him. I started having a sitter come to the house for an hour a day while I was working. As summer started, I had a deadline in six months. I called everyone I could think of, 'Please come sit with him in the backyard while I finish!' It was wild. After turning that draft in, I looked at Tariku playing in the yard and couldn't believe I'd just done that! I made it happen, and I am still very proud. It also gave me a real experience of my own resilience. Now, when I am facing a project or a situation that seems impossible, I know I have already done the impossible."

Their first son, Tariku, literally called to them from across the globe with a spiritual pull to Ethiopia. In her second memoir, *Everything You Ever Wanted*, she writes about the stages her pursuit of parenthood took, from numerous infertility treatments to holding her first child. She explained how they came to the decision to adopt internationally: "It was really just an instinct. I always say we went to Ethiopia because that was where Tariku was. We just really had a strong feeling about it, and, at that time, it was a good program. Basically, we were at this seminar about the different routes of adoption, where parents and lawyers were speaking, and one parent showed us a photo album of her trip to Ethiopia to adopt her seven-year-old daughter. As I was taking in those pictures, I looked at Scott and said, 'I think that's where our kid is.' Normally I am more metaphysical than he is in that way, but he did not disagree with me. Then we started the process. It was certainly long and challenging, but going to Ethiopia was a remarkable experience. Once you are out the other side of it, it's hard to even remember how difficult it was during the process and the waiting. I imagine it's like forgetting the pain of childbirth once your child is in your arms, and that's your only reality. We met some of our closest friends while in Ethiopia, and we try to see them every year—eight other families who adopted at the same time. That's a really meaningful piece of our lives and our extended family."

Unfortunately, none of these families lived in Los Angeles near Jillian. She was left feeling isolated among her friends, who couldn't relate to having a child with specific needs. "The reason I started my blog was that the transition and the unique experience of being a new mom with an eleven-month-old did not feel consistent with any of the experiences of my friends in my immediate circle. I was going through a lot of stuff that they hadn't gone through, and their advice didn't feel all that relevant to me. My blog was an attempt to broaden that network and to start reaching out to other families in similar situations. I wanted to tell our story and experiences to look for connection and commonality in a broader way. My older son's many needs made those first few years with him challenging. After we got the proper help for him, and for us, I could look at the story as more of a story; that's when I decided to write my second book, *Everything You Ever Wanted: A Memoir*."

When it came time to expand the family, Scott and Jillian turned to a local agency, Five Acres, to adopt their second son, Jovi. He was three when he came to them, and he also had a history of trauma. In one of her poignantly written blogs, Jillian gives a summary

"I FEEL LIKE I'LL ALWAYS SPAN A LOT OF DIFFERENT GENRES AND MEDIUMS BECAUSE I HAVE A VERY FLUID IDEA OF CREATIVITY AND STORYTELLING. WHAT I LOVE IS TELLING STORIES. I ALSO DO THEATER, AND I'M CONSTANTLY FASCINATED WITH THE DIFFERENT AVENUES THAT STORYTELLING TAKES IN OUR CULTURE. TELLING STORIES IS HOW HUMAN BEINGS CREATE MEANING OUT OF THE CHAOS OF OUR LIVES. THAT'S REALLY MY WHOLE PASSION AND DRIVE IN LIFE, SO I THINK I WILL CONTINUE TO EXPLORE AS MANY DIFFERENT AVENUES AS I CAN."

of what a history of trauma looks like through the eyes of her children. "My kids each have different diagnoses, but if I were to boil it down, I'd describe them in layman's terms as having a cluster of profound sensitivities to the world around them that can make sensory input, strong emotions, even affection painful. Everything is too loud, too fast, too abrasive. Even joy. Especially joy. They may appear tough (Scott likes to say Jovi is equal parts Mike Tyson and RuPaul), but that's just the armor they wear because their nerve endings are so close to the skin."

I was fortunate enough to meet and spend time with her and her boys. They were each spectacular and talented in their own way. I saw Jillian in Jovi, and Scott in Tariku—no different than a family joined by genetics. Her face lights up when she talks about them: "Yeah, they're boys! They are completely obsessed with each other and they fight nonstop, which is always challenging with siblings. They are so delicious, fun, funny, resilient, wild, and creative. They are both totally musical, which you couldn't have planned any better! They jam with Scott almost every night. They are perfect…we are perfect together. Jovi came to us a year and a half ago. We adopted him out of the foster care system. That was a decision we made knowing what we know now, having been in the adoptive community for so many years. We were looking to grow our family and were very aware of the crisis level of need for families to foster and FostAdopt, particularly amongst kids who are a little older. We knew the second we looked into Jovi's big brown eyes that he was our son."

Jillian has written openly over the years about her lifelong bouts of depression. "I do believe depression is a universal thing, but I think you find it quite common amongst those in the arts. These are people who tend to think critically and ask questions, which can cause them to face challenges. Depression is something that I think still carries a lot of stigma and shame. I have felt completely incapacitated by it at times, but mostly when I was a lot younger and couldn't recognize it for what it was. At this point, it really annoys me when the clouds hang over my head and there's nothing logically I can do to combat it. I understand what it is now, and I can look it in the eye and keep doing the things that create good chemicals in my body. I take care of myself, eat right, exercise, take my medication, which I have for many years; you will have to pry it out of my cold, dead hands! That's not a cure-all, and that doesn't mean I don't still deal with this, but now I don't feel powerless about it. I have a sense of surrender, and I also know that it will change; it's not forever. Having that perspective, I see it as inconvenient, really hard and sad, but no longer devastating. I just say, 'Hello, thank you very much, I know you. Well, I'll hang out with you for as long as you need to be here.' Doing everything I can to keep myself healthy is the best I can do right

> **"For me, it has never been an option to not make art. It's not just something I do: it's who I am."**

now. Every one of us has limitations; we just have them in different degrees. We find tools so that we can function with them. My kids will never not have trauma. They will always have trauma-related thoughts and behaviors. My hope is that I can give them tools to cope with those issues and behaviors. You don't have to be this perfect person in order to have a happy and successful life."

I was excited to hear about what was in the future for this versatile and emotive artist. "Right now, I'm writing for all different kinds of media: film, television, and another book. I feel like I'll always span a lot of different genres and mediums because I have a very fluid idea of creativity and storytelling. What I love is telling stories. I also do theater, and I'm constantly fascinated with the different avenues that storytelling takes in our culture. Telling stories is how human beings create meaning out of the chaos of our lives. That's really my whole passion and drive in life, so I think I will continue to explore as many different avenues as I can."

Her latest literary achievement has been the completion of the book *Behold the Monster: Confronting America's Most Prolific Serial Killer and Uncovering the Women Society Forgot*, available April 2023. Jillian opened a Pandora's Box of horrors while corresponding with serial killer Samuel Little, who at seventy-nine was serving multiple life sentences for the murders of three women, though he had confessed to killing ninety-three. Jillian became obsessed with what had been revealed to her and managed to get face-to-face meetings with Little that produced hundreds of hours of interviews in

which he confessed to dozens of murders for the first time. After this descent into darkness, she was driven to honor the women whose lives were lost at the hands of this gruesome monster. Joe Berlinger directed a five-part docuseries, *Confronting a Serial Killer,* documenting Jillian's chilling interactions with Little and the devastation left behind. The series was released on April 18, 2021, on the STARZ network. Jillian continued to communicate with Little until his death in 2020, hoping to solve more murders and bring closure to the families of his victims.

Jillian leads wholeheartedly with instinct, silencing fear and hesitation in the process. She has been able to block out criticism and judgment to move forward with conviction in her life. "For me, it has never been an option to not make art. It's not just something I do: it's who I am. It's how I relate to the world and how I relate to my kids. It's a Venn diagram. My creative work feeds my family life. Not just through my happiness, but in multifaceted ways." Jump in, bounce around, and embrace the beautiful chaos, then revel in the tranquility of actualization—this is Jillian Lauren.

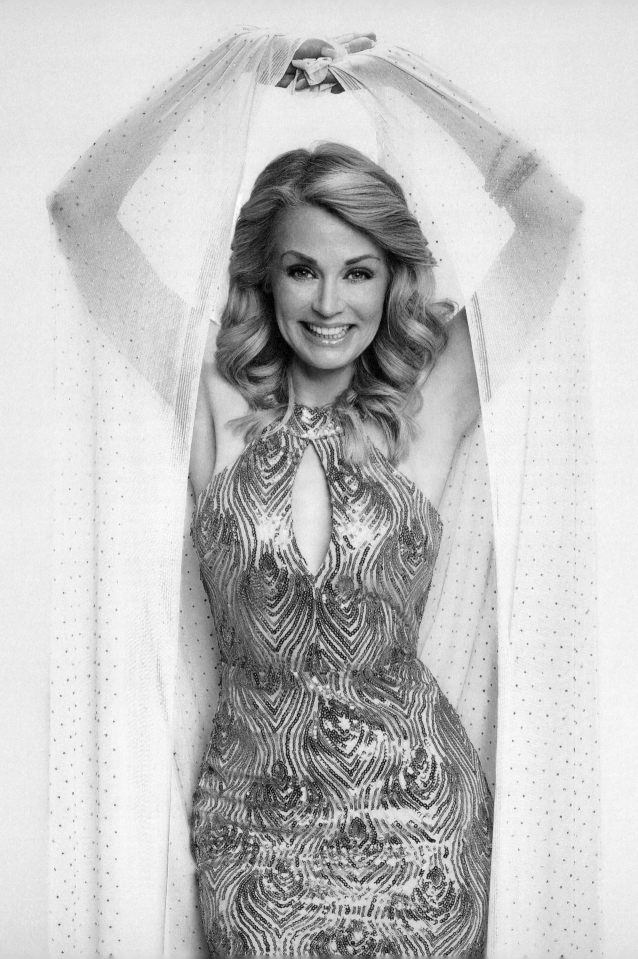

AGE IS BEAUTY
KATHY JACOBS

ACTRESS | MODEL | ENTREPRENEUR

"IT TAKES A LOT OF MONEY TO LOOK THIS CHEAP!"

—DOLLY PARTON

Who decides they want to be in the *Sports Illustrated Swimsuit Issue* at fifty-five? Kathy Jacobs did! In the last few years, Kathy has become a women's ageism activist, tirelessly working to change the narrative on women and aging. She was featured in the 2020 *Sports Illustrated Swimsuit Issue,* as one of the six finalists for the SI Rookie of the Year for a full layout in 2021. She won, and was fifty-seven when the issue hit newsstands! Kathy's motivation for taking on this latest challenge was personal: "I am doing this to be part of a change in how the world views women over fifty, not only by society but by ourselves. It is a boomerang effect, and we need to stand together and realize how amazing, relevant, beautiful, and sexy we all are. It's time women of all ages unite and claim our power! Ageism impacts all of us, and women of all ages coming together to stop it now helps prevent future generations from ever experiencing it!"

THIS UNYIELDING DRIVE IS HOW KATHY HAS APPROACHED EVERYTHING IN HER LIFE, ESPECIALLY WHEN THE ODDS ARE AGAINST HER. SHE STARTED HER CAREER AS AN ACTRESS/PETITE MODEL WITH ROLES IN FILMS SUCH AS *HOFFA*, *REVENGE OF THE NERDS IV*, AND *THEY CAME FROM OUTER SPACE*. THEN, AFTER HAVING HER DAUGHTER, ABIGAIL, KATHY PURSUED A CAREER UTILIZING HER OBSESSION WITH CRAFTING AND BAKING. SHE STARTED *KATHY'S CAKE & COOKIE CONSTRUCTION CO.*, WHERE SHE MADE DECORATIVE AND DELICIOUS TREATS.

One of her inventions, the "Snow Globe Cookie Kit," landed her on the TV show *American Inventor* as well as in a segment on the Food Network show *Unwrapped*. The kit made the most adorable edible snow globe scenes out of shortbread cookies, icing, candy canes, candy dots, and, of course, edible glitter! Kathy handmade every tiny edible accessory that went into the kit, including a snowman made of white gumdrops. When assembled, it was a charming snowy scene of a gingerbread house, Christmas trees, and wreaths—everything that says, "It's Christmastime!" The only thing not edible was the plastic dome top.

She can create beauty out of anything and everything. Kathy proved this when she put together an entire wedding at the 99 Cents Only store using only the items sold on their shelves. She even made a wedding dress out of napkins and doilies modeled after an elaborate Chanel bridal gown. It was gorgeous! The wedding was held in an aisle of the Hollywood 99 Cent Store and televised on a local morning show in Los Angeles. After this event, she was given the title "Dollar Store Diva." The publicity from this event brought about numerous television appearances, such as making gingerbread houses on *Good Morning America*, Easter crafts on *Home & Family*, and showing how to do homemade Halloween costumes for kids on the *Rachael Ray Show*.

Kathy has self-diagnosed herself with OCCCD: "I have some kind of crazy disorder that has to do with baking and crafting. I call it OCCCD,

Obsessive Cake Cookie & Crafting Disorder. It's like I have an addiction to making things; I'm looking around my bedroom right now for something to make! My husband Rob is constantly annoyed with me since the house is always filled with craft supplies, or the kitchen has bakers' racks with hundreds of decorated cookies. He wishes I would be a receptionist or something, anything that isn't this."

After the exposure she received on so many television shows, Kathy was very close to getting a show of her own. Unfortunately, the deal fell through. She was always the runner-up in these competitions, but in the end, she never won the big prize. She jokingly says, "I am failing my way to the top." Kathy is known for her jovial, self-deprecating humor. She will occasionally perform at stand-up comedy clubs—she's hysterical! Kathy was also a Dolly Parton impersonator many years ago. When Dolly Parton was a guest on *The Tonight Show,* they had Kathy done up like Dolly holding the cue cards as a playful prank. "I was so excited to meet Dolly. She said to me, 'Oh, you make me look good. I like you.' I did a bunch of shows as Dolly Parton, including *Burke's Law.* The day after the show aired, I went on an audition and told the casting director about my part. She looked at me and said, 'I saw that show, and that wasn't you.' I said, 'Yes, yes it was.' She replied, 'Honey, that wasn't you, that was Dolly Parton. You are lying to me.' I guess that meant I did a good job!"

"I am failing my way to the top."

Kathy talked about how she handles criticism, rejection, and judgment, even if it comes from her own family. "Years ago, my husband Rob looked me right in the eye and said, 'Kathy, I just can't watch you fail anymore. You have to stop.' I was shocked; this was something that didn't compute in my brain. Stop? Why would I ever want to do that? I listened at first, because of some residual effects from my childhood and feeling like I didn't deserve to follow what I truly wanted to do. I used to think about everybody else first and allow them to dictate what I should or shouldn't do. I caved in for a while and got a job I hated. I ended up quitting because I was so miserable. So, in the end, it's counterproductive for everyone, since the people around you are miserable because you're miserable. I decided I would never do that again. Whenever you have a passion to do something, you've got to put your big girl pants on and believe in yourself. When it comes right down to it, you're the only person you have, especially if the people around you aren't giving you confidence or support. So what if the odds of it working out are low? You just have to do it no matter what noise is around you, even if the noise is from your own family. Do whatever the fuck you want and put on your tunnel vision to see only your dreams in front of you."

She doesn't like to talk about her childhood; it consisted mostly of sadness and trauma. Kathy grew up with two older brothers, Shane and Andy.

"IT SEEMS RIDICULOUS TO ME THAT IT'S AN ISSUE TO SEE A PERSON AT MY AGE IN A BATHING SUIT OR WHATEVER ELSE THEY WANT TO WEAR. ARE YOU SAYING WE CAN'T DO THAT ANYMORE? NO ONE IS TELLING MUSICIANS LIKE KEITH RICHARDS THEY'RE TOO OLD AND CAN'T GO PLAY ON TOUR, OR THAT THEY ARE NOT RELEVANT BECAUSE OF THEIR AGE. WHY SHOULD IT STOP WOMEN? IT SEEMS MEN CAN KEEP DOING WHATEVER THEY WANT UNTIL THEIR LAST BREATH. EVERYBODY DESERVES THE RIGHT TO SHINE."

Shane had muscular dystrophy, and the heartache from this will forever haunt her. "From the time I was born, every single day of my life, I watched Shane suffer. He died when he was twenty-one, a few days before Christmas. Christmas was his favorite time of the year. It still makes all of us very sad." She has worked closely with the Muscular Dystrophy Association for years, doing the MDA Lockup fundraisers and MDA summer camps, but it takes an emotional toll on her. "I'm very good with anybody with special needs, no matter what type of disability it is. I innately know how to act in that situation, and that's why my daughter and husband always tell me it's what I should be doing with my life. It just breaks my heart when I see those kids. I feel so helpless, and it brings up so much pain for me. I went through years of going to therapy and learning meditation techniques to help me release a multitude of childhood traumas, so this is something I could never do full-time."

Along with entering the *Sports Illustrated* swimsuit competition came a lot of support, but also a lot of vicious rhetoric from people on the internet. Kathy feels her childhood and life experiences have enabled her to tolerate it. "I feel that I would not be as resilient as I am if I'd had an easy childhood. If I had everything handed to me, and I didn't see someone suffer every day, I wouldn't have the same ability to brush things off and keep moving forward whenever I get knocked down. I know firsthand how much worse it could be, and I always have that underlying feeling of gratitude for my life. It doesn't matter to me what people say at this point. Mostly I get positive feedback,

but I also get some extremely toxic comments and messages. A few examples are: 'You're too old to be wearing a bathing suit,' or 'You look older than most women your age.' I have also gotten, 'I look so much better than you.' I had this one woman send me a direct message on Instagram telling me how ugly she thought I was. The sad thing is that the nastiest comments seem to come from other women."

Any negativity that comes Kathy's way is easy to overlook due to the number of supportive and positive messages she has received, letting her know the difference she's made in people's lives. "I get so many women my age, and younger, saying things like, 'Thank you for representing me. Thank you for cracking the code. Thank you for inspiring me not to give up.' I have had daughters email me saying, 'Thank you; my mom feels so much better about herself after following you on social media.'

"It seems ridiculous to me that it's an issue to see a person at my age in a bathing suit or whatever else they want to wear. Are you saying we can't do that anymore? No one is telling musicians like Keith Richards they're too old and can't go play on tour, or that they are not relevant because of their age. Why should it stop women? It seems men can keep doing whatever they want until their last breath. Everybody deserves the right to shine. I can't imagine being anything but supportive to someone for who they want to be and doing what they want to do. The thought of deliberately trying to make a person feel bad or hurt is so foreign to

me. I read this excellent book, *This Chair Rocks—a Manifesto Against Ageism* by Ashton Applewhite. It has a ton of statistics in it. One of them is that, despite retailers and mass media rarely featuring women over fifty, we are the demographic with the most disposable income. It also said that in the next ten years, advertisers are going to realize this and start focusing their marketing on this age group."

A particular class helped Kathy regain her confidence and gave her a good dose of self-love at the perfect time. "For the last four years, I have been taking belly dancing classes at the Carousel Dance Studio in Canoga Park. I love the ladies and the instructor, Orna Gonzalez. It's a judgment-free zone, and everybody dances and feels sexy, no matter what stage in life they are in. We have a girl in the class who's seventeen and a lady who's seventy-two. It took me a year to take my T-shirt off and dance in my sports bra like everyone else. I regained such a healthy relationship with my body and my sexuality. I don't think I would have had the confidence to enter the *Sports Illustrated* competition if I hadn't taken this class, and I certainly wouldn't have been able to do the runway portion of the competition. I became so used to performing in front of people wearing the belly-dancing costumes that it made the *SI* stuff much easier for me. There is a lot more to belly dancing than people realize; it takes a good amount of brain cells, and it helps ladies get their sexy back!"

> "I think we must change the way we see other women our age and the way we all see each other. When we throw that positive energy out there, the world will give it right back to us, as long as we collectively stand up and say, 'Hey, we are still in the game.' Think about it, if you are fifty, you could potentially live another fifty years. Are you going to spend the next fifty years feeling less-than? I don't think so."

Kathy met her husband, Rob, through a mutual friend. Rob said he knew right away he never wanted to be with anyone else. They have been married twenty-five years, and a few years into the marriage, their daughter Abigail was born. Kathy's pregnancy did not go smoothly. She went into premature labor at only three months, and to save the pregnancy, the doctor had to sew her cervix closed. The procedure is called a cerclage, and you must remain flat in bed for the entire pregnancy. "I never experienced being pregnant in public or even getting pregnancy clothes; I just wore pajamas the entire time. I couldn't walk around, and I could only shower once a day for five

minutes. Rob made me trays of food, and I just lay there eating sandwiches and potato chips every day, while sewing."

She sewed everything by hand for Abigail's nursery during this time: bedding, curtains, pillows, and stuffed toys. She never once complained. "What was there to complain about? It wasn't that big a sacrifice because at the end of it, look what I got. Again, it goes back to my childhood. I saw my brother suffering and unable to walk. Lying flat for six months was nothing."

Kathy's daughter is now twenty-four, and she describes how motherhood has changed for her over the years. "To me, being a mother means you have a responsibility to always be there for your child, whether they are three or thirty. When she was little, it was more about giving her enough attention and guidance to become a functioning adult. Now it's just being there and being supportive. Motherhood is always evolving. Right now, I'm in the role of more of a friend and confidant for Abigail. She's way more intelligent and mature than I am! When she was a little girl, I would drop her off at school and say, 'Use your powers for good.'" Those words must have resonated because Abigail is about to start medical school at NYU.

Kathy's determined to do away with the stereotype of women and aging. She has recently been doing national commercials again, modeling, and stand-up comedy, and she was featured in the latest music video for the band Green Day as a

sexy seductress. "I think we must change the way we see other women our age and the way we all see each other. When we throw that positive energy out there, the world will give it right back to us, as long as we collectively stand up and say, 'Hey, we are still in the game.' Think about it, if you are fifty, you could potentially live another fifty years. Are you going to spend the next fifty years feeling less-than? I don't think so." She lives by her two mottos, "Wear your age like a crown," and "Old is gold." She sums up her current mindset in her uniquely Kathy way: "I could either be eating off the senior menu at Denny's or posing in a bikini for *Sports Illustrated*. I choose to pose in a bikini for *Sports Illustrated*."

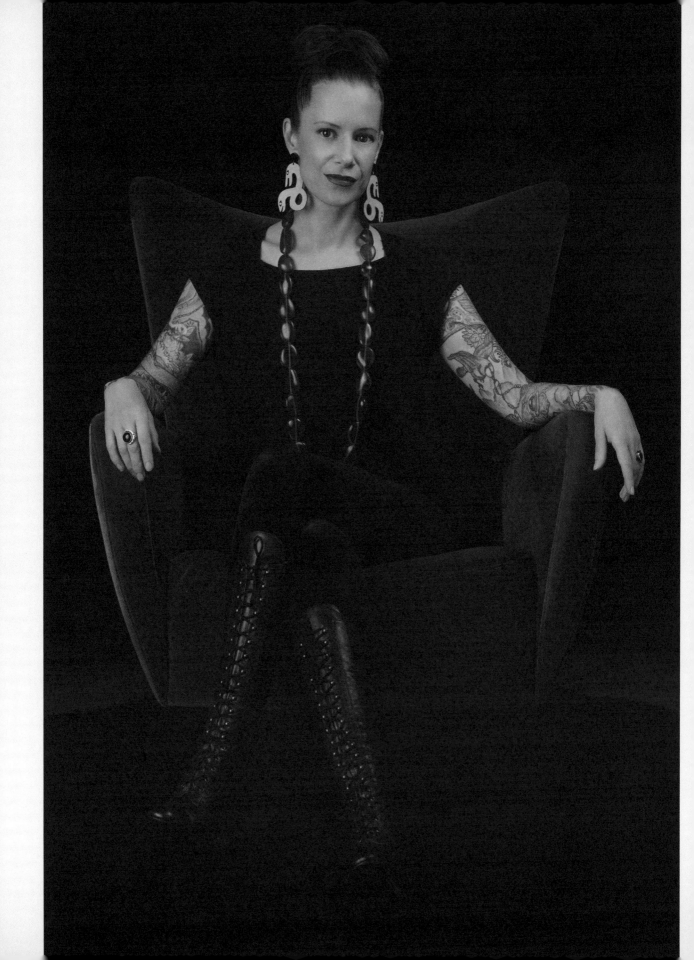

INFINITE INK
SARA BOWYER

TATTOO ARTIST

"TIME IS FLYING BY AND NO VAMPIRE IN SIGHT TO GIVE US ETERNAL LIFE."

—PATRICIA MORRISON

Sara Bowyer approaches life in a no-frills, pragmatic way. She strives to keep things uncomplicated, focusing only on what's important. She adheres to a strong code of ethics that is a combination of traditional and modern. These attributes were instilled early on while growing up in a suburban, middle-class neighborhood in Melbourne, Australia. Her parents raised Sara and her younger sister with a hands-on approach. It was a house where women made things when they needed them: sewing, knitting, calligraphy, painting—no crafty undertaking was too big a challenge. This environment taught the girls to be self-sufficient, resourceful, and confident women who approach problem-solving in their lives with independence and strength.

SARA STARTED DRAWING AS SOON AS SHE COULD HOLD A PENCIL AND HASN'T STOPPED SINCE.

She is vehement about the necessity of the arts in schools: "All the kids did art in my school—drawing, painting, making things with clay—it all started in kindergarten. Creative thinking for children is vitally important. We know that teaching children how to look at art from an objective point of view results in them not only making art, but looking at it with an understanding that there is art and design going on all around them 24/7. They start to think about the work that goes into making the shoes they are wearing and the phone they are holding; there is design effort in everything. There is learning how to communicate and engage with art, to look at a piece of art and discuss what you think is going on in it and whether it stirs up any thoughts or feelings. Art teaches you to look at the world in a completely different way. The arts in education feeds the psyche of your culture. I firmly believe any art practice or art theory opens up a part of the brain that's not exercised enough. Learning to critically study art allows you to think critically about a problem and see both sides of it. In math there is only one answer, but in art there could be multiple answers."

Music has been an integral part of Sara's life and inspiration. The love of music began with her father's diverse record collection: "My father always had music on in our house: Elvis, Billy Joel, Linda Ronstadt, Neil Diamond, and Bette Midler, to name a few. In the late 1970s, Abba was massive in Australia; my sister and I would argue over who would sing which line, and we tried to mimic all the harmonies. When I was twelve, I bought my first piece of music with my own pocket money: a Culture Club picture-disc single of *Karma Chameleon*. As a teenager, I got into Duran Duran in a big way! Coming from a commonwealth country where UK culture was still dominant, we were all about the British New Wave movement: the look, the sound, and the sexy moodiness were so cool. As I got older, that naturally evolved into the British late 1980s scene with bands like the Cure and the Smiths. I especially loved goth music that was more guitar- and bass-driven. I remember watching *The Young Ones* with my friends when Motorhead was on. We watched their episode over and over; I loved everything about them! Lemmy's persona pulled me in, his all-black semi-goth clothing and attitude, along with the heavy bass—that's what opened the door to metal for me."

After graduating high school, Sara spent a year working in an architecture firm and then earned a bachelor of arts degree in archaeology and art history in 1993. Her passion for goth and metal music led to her interest in the tattooing wave sweeping the youth culture at that time. Music's connection to body art would be the gateway to discovering her life's work. She obtained an apprenticeship with a local tattoo artist who

shared her vision of making the industry more welcoming to female clients.

Her outlook on the art of tattooing and the industry came firmly out of years of training in the street shop system in Melbourne during the mid-1990s: "I first started in 1994 during the eruption of the body art movement, with more women getting tattooed. During my apprenticeship, and the years following, I had to learn multiple tattoo styles while working with different flash designs. We did a lot of walk-ins, and your job was to make that tattoo happen, even if it meant quick customizations to please the client. Learning in that environment taught you to be patient and flexible. I've always felt that having a diverse range of clients and tattoo styles to draw upon kept me on my toes, and no day was ever dull! It could be quite a lucrative career if you focused and were good to your clients. As an Australian on the other side of the world, the idea of being 'tattoo famous' was so far off my radar. Back then, we could keep up with what American, British, and European tattoo artists were doing through the tattoo magazines; those publications were a source of inspiration to us. Watching how much tattooing evolved globally over the 1990s and 2000s was exhilarating. Not until the internet, social media, and tattoo TV shows exploded was it conceivable that you could become world-famous at this. Now the business of tattooing is quite mainstream and somewhat of a fashion statement for a good percentage of people, instead of being overtly rebellious in nature.

"Tattooing is a unique folk art, a craft, but also a commercial art. It involves problem-solving, using materials and machinery, and translating what the client wants and making it come to fruition on the body."

"Now here we are, after the internet revolution, and we lost most of the magazines but have the massive world of social media as a tool to reach a new audience and connect with other artists. We have all had to evolve in this industry. Personally, I am not comfortable with putting my personality on social media. I am a grumpy old '90s chick who doesn't like the selfie and the *too much information* vibes! I prefer to keep my social media about my work, with just a hint of who I am. I don't think you can get to know someone through two and a half square inches of screen; it's through sitting down for an hour or two during a tattoo session that you can get a glimpse into someone's life and who they really are. Social media can also be a huge distraction and keep you from being productive, as it's designed to do. I get online every couple of days and like a few things, then get off. The more you're on it, the more you start having anxiety. It feels like you're in high school again; it's a really toxic environment."

"IT UNIVERSALIZES LIFE AND OUR HUMAN EXPERIENCES, WHETHER GOOD OR BAD—YOU JUST HAVE TO KEEP GOING. WE ARE ALL IN THE SAME BOAT IN ONE WAY OR ANOTHER, AND PAIN IS PART OF THE JOURNEY. TATTOOING CAN BE A VERY THERAPEUTIC AND CATHARTIC PROCESS FOR SOME PEOPLE. IT'S A RITUALISTIC AND SACRED EXPERIENCE. NO MATTER HOW PEOPLE COME TO THEIR APPOINTMENT, THE ACT OF PERMANENTLY MARKING SOMEONE'S BODY IS PRETTY PRIMAL AND REMINDS THEM THEY ARE HUMAN."

Sara has a clear and succinct view of how she sees herself as an artist: "Tattooing is a unique folk art, a craft, but also a commercial art. It involves problem-solving, using materials and machinery, and translating what the client wants and making it come to fruition on the body. I see tattooing as a combination of being an illustrator and a tradesperson. For example, a fine artist is completely engrossed in their own vision, whereas I'm largely dealing with other people's visions. My job is to work out the technical possibilities and to be aware of the technical impossibilities because there are limitations: we are dealing with the skin, which is a living organ."

During the 2000s, Sara's travels brought her to the United States many times. In early 2011, Sara succeeded in obtaining permanent residency in the US and has been living in Los Angeles ever since. She shares her new home with the love of her life, husband Rohan Ocean. Emigrating to the US during the recession involved a lot of starting over in her career, as well as establishing herself in the US credit system. It took five years of hard work to build up a steady clientele and to be voted one of the top female tattoo artists in LA by *Citizine* magazine in 2016 and by *Los Angeles* magazine in 2018. Her strong work ethic and ability to not give into negativity has been her saving grace: "I just keep going with a stiff upper lip and move forward. I try not to have meltdowns, and I always go to work forging ahead, no matter what personal issues I may be experiencing. I am so intimately connected to people while tattooing them that when they share their stories,

I am reminded that we are all going through the same stuff.

"In twenty-five years, I have tattooed people who have lost children, loved ones, and partners. A lot of my work involves grief, death, trauma, illness, divorce, and remarriage. It universalizes life and our human experiences, whether good or bad—you just have to keep going. We are all in the same boat in one way or another, and pain is part of the journey. Tattooing can be a very therapeutic and cathartic process for some people. It's a ritualistic and sacred experience. No matter how people come to their appointment, the act of permanently marking someone's body is pretty primal and reminds them they are human. Even though our contemporary practice has evolved to be just as much about business licenses, marketing, staff meetings, and paperwork, I still think there is room for the mystics in us to come through. I think because I tattoo in LA, and so many people I tattoo have come from other places to be here, their tattoos are often like ancient nomadic markers on their skin. This definitely feeds my work, and I really want to channel that for them."

In 2015, after four years of tattooing in Hollywood, Sara moved to a new studio, Incognito Tattoo, in Los Feliz. The last few years have involved further adaptation to newer clientele and local culture, focusing a lot of her tattoo work on themes of nature and having each tattoo help to maintain symbolic reminders of our connection to the earth. Her highly developed artistry is astonishingly realistic as well as

including fantastical elements and splashes of whimsy. Her use of color, shading, and design make every tattoo a striking work of art.

Sara has a multitude of social issues she is passionate about: "I grew up during an era in Australia with a succession of federal governments that supported accessible education for most families. At the time, affordable college education was considered integral to Australia's future as a nation. The support of humanities and cultural departments was also a vital part of the universal well-being and modernizing of the country. I will be forever grateful for having that opportunity. I do believe in an education system that serves the whole community, not an education system that rewards the rich or financially burdens families. I feel the same about healthcare; we need access to a system that's not going to bankrupt you because of a horrible accident or a genetic mistake.

"Part of what also fuels me is trying to honor the idea that our environment, and all of the non-human species that we share this space with, are not just a background for our pleasures, entertainment, and bottomless pits of resources. I'm really interested in the concept of multispecies ethnography (anthropology of life) that explores ideas of how all living species enable humans to live and our culture to exist at all— how knocking out the balance of that connection with non-human species has gotten us on a troublesome path."

"Part of addressing our health issues could also involve making fresh produce not only more available to all neighborhoods, but more enticing to people. Yes, I'm another vegan. I have fluctuated from vegan to pescatarian since I was thirteen. I studied the history of food domestication in ancient societies while at college, and you can see where we haven't adjusted to twenty-first century life. We are eating diets that agricultural people were eating and burned off daily while working on the farms. We not only haven't adjusted our diets to sitting at our computers all day, but also added a lot of processed foods. This is perpetuated by the many corporate interests that want to keep it that way. These are the same corporations who have gotten into the vegan fast-food industry because it's having a moment. I just don't want people to be tricked into thinking that replacing a standard meat

burger and fries with a vegan burger and fries will create a good outcome for your health."

Sara is also an avid reader of anthropological research and studies. She is immersed in the issues surrounding the environment and human-animal relations. "Part of what also fuels me is trying to honor the idea that our environment, and all of the non-human species that we share this space with, are not just a background for our pleasures, entertainment, and bottomless pits of resources. I'm really interested in the concept of multispecies ethnography (anthropology of life) that explores ideas of how all living species enable humans to live and our culture to exist at all—how knocking out the balance of that connection with non-human species has gotten us on a troublesome

path. I've had an inkling of this connectedness ever since I was a kid, so it's interesting to see this philosophy being explored worldwide while we are deep in the COVID crisis."

This Aussie girl is now grounded in her Los Angeles home. Sara has procured a strong connection to her community. She starts her mornings with a walk to the river, visiting the local horses and dogs along the way. She humbly sets forth on her day, enjoying a cup of coffee and the hopes of catching a glimpse of a red-tailed hawk or a flock of wild parrots. Her desire for a peaceful and unified existence on this earth has come with a meaningful purpose: touching people's lives by giving immortality to their hopes, dreams, memories, and pain with her striking tattoos.

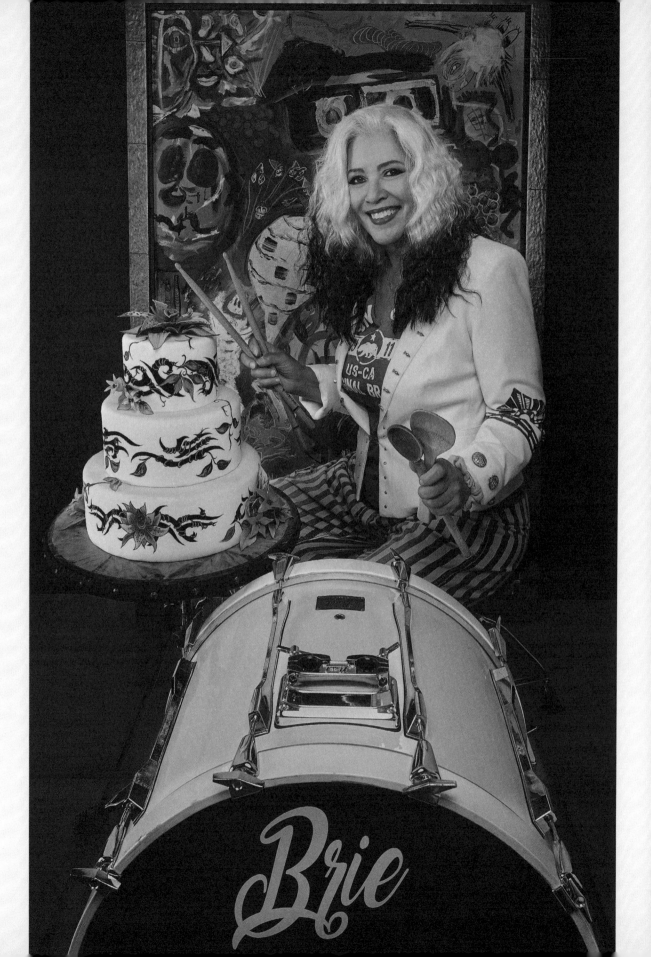

CHAPTER 23

AND THE BEAT GOES ON
BRIE DARLING

MUSICIAN | ARTIST | CAKE QUEEN

"STOP WORRYING SO MUCH ABOUT WHAT OTHERS THINK, AND START BEING WHO YOU'RE SUPPOSED TO BE. IT'S TIME TO DO SOME EPIC SHIT."

—JONNY B. TRUANT

This creative mastermind jumps back and forth between music, design, art, and high-end cake creations. Brie's passion for music propelled her into becoming a trailblazer for female musicians everywhere. She was one of the first female drummers to record rock music, in 1965, with the Kee-Notes. In 1966, she joined a band that would become Fanny, the first all-girl band to have a song on the rock charts and the first female band signed by a major record label, Reprise Records, in 1970. Fanny paved the way for other female artists, but they didn't get the recognition they should have at the time. Cherie Currie of the Runaways has been quoted as saying, "Fanny started all of it. They cracked that door and made it possible for us to believe that we could do it too."

FIFTY-ONE YEARS LATER, THE WOMEN OF FANNY WOULD REUNITE AND FEEL THE LOVE FROM SOME OF THE WOMEN THEY SET THE STAGE FOR, SUCH AS CHERIE, KATHY VALENTINE (THE GO-GO'S), SUSANNA HOFFS, VICKI PEARSON, AND DEBBI PETERSON (THE BANGLES), WHEN THEY ALL DID GUEST APPEARANCES ON THE *FANNY WALKS THE EARTH* ALBUM, RELEASED IN 2018.

Award-winning documentary filmmaker Bobbi Joe Hart shot an intimate film documenting the two-and-a-half-year process of making this reunion album. After the Fanny album came another powerful collaboration for Brie with Cherie Currie. *The Motivator* is the first release of a four-album deal for the duo.

Brie spent her childhood in a combination of small towns and rural nature. Though she looks back at it as a wonderful way to grow up, it was much too laid-back for this blooming artist and musician, who preferred the stimulation of a more urban environment: "My parents met in the Philippines when my father was stationed there in the army. They were married and had my older brother before returning to California, where my father is from. We lived in a little house in a small town outside Sacramento, called Folsom, until the army transferred him to a military base in Anchorage, Alaska. By that time, it was my older and younger brothers and me; my little sister was born there. We lived in Alaska until I was eight before returning to Folsom. I had a wonderful time growing up with the wilderness and small-town life, but it left me hungry for the city—for something else. That turned out to be Los Angeles. As soon as I moved here at eighteen, I knew this was home for me."

The lack of diversity in Folsom led Brie to question her identity. "My mother is Filipino, a mix of Spanish and Chinese, and my father is German, Scottish, and Irish. It was so strange because I looked like my mom, but inside I felt like my dad." The kids' comments at school would further heighten the critical voices in her head: "There were about 5,000 people in Folsom, and it was all white. We were the only minority family there. Being different made it difficult. Kids can be cruel, especially in high school. One of my good friends, who was a beautiful blonde, blue-eyed girl, said to me one day, 'You know, you'd be pretty if your nose wasn't so wide.' She meant it as a compliment, but it devastated me. I knew I was different; my skin was a little darker than everyone else's, and I had Asian features. I remember one little girl asked me, 'Did you grow up in an igloo?

Are you an Eskimo?' I think she was genuinely curious and didn't realize it was hurtful. I felt those words, and I think I just barreled through them to cope, but they affected me deeply."

Luckily, her home life gave her the balance she needed to cultivate her talents and to keep the negativity from destroying her confidence. "I think that my parents' goal was to have a loving family, and they did an amazing job at that. I couldn't ask for better parents. They inspired us, they encouraged us, and they were just great."

There was an abundance of artistic talents for her parents to embolden in Brie: "I've been drawing ever since I was a kid. I remember drawing every day, making comic books and pictures. Reading was also a big deal for me. I have always found a lot of inspiration from books. It introduces me to so much more of the world. You find things you relate to or that you want to do. It introduces you to more lives, whether real or fictional." She continued to develop her drawing skills over the years, later designing album covers, posters, and illustrated children's books. She also has over a decade of acting credits to her name.

> "I've been drawing ever since I was a kid. I remember drawing every day, making comic books and pictures. Reading was also a big deal for me. I have always found a lot of inspiration from books. It introduces me to so much more of the world. You find things you relate to or that you want to do. It introduces you to more lives, whether real or fictional."

As much as she loved art, music electrified her soul: "I started playing drums because my mom wanted us all to learn an instrument, and we were told to choose one. My older brother picked the guitar, and my younger brother the drums. I was a girl, so we thought the piano would be good, which was fine. One of the beautiful things that my parents taught us was to share, so my brothers and I would trade instruments. My older brother had an audition at our house with a band to be their drummer. The drums were set up in our living room for the manager and the bandleader to come hear him play. They walked in when I was sitting at the drum set, and the manager thought it might be useful to have a girl drummer and hired me for the band. My older brother gave up his audition, and my younger brother gave up his drums for me. They said, 'Go Brie, go!' My brothers were, and still are, the most supportive people in my life; so is my sister. They're there for everything I do, and there's no jealousy, no animosity, just unconditional love, pride, and

support. On the *Motivator* album that I did with Cherie, I was able to have both my brothers and sister play on it, which meant so much to me. I only wish that my parents were alive to have seen that. That was a huge bucket-list item of mine."

All those years of feeling different soon came to an end when Brie met June and Jean Millington. She auditioned for the all-girl band the Svelts after her first band broke up. June played guitar and Jean bass, and they had just started looking for a drummer. The sisters had moved to Sacramento from the Philippines and, like Brie, had a father in the military and a Filipina mother. These three strong-minded and independent women were about to embark on a connection that would last a lifetime. "I auditioned for the Svelts and got the gig. I was sixteen and, because we had no tour manager, we drove ourselves, rented U-Hauls, were our own roadies, got our own gigs—we did everything. We toured all over, and even played a gig at the Fillmore with the Doors!"

Brie shared a story illustrating a pivotal point of inspiration that established how she wanted to approach her musical performances. "In the late 1960s, a girlfriend and I went to a concert at Freeborn Hall in Davis, California. We were sitting on the floor because it was in those hippie days, talking and laughing during the opening act. This woman walks up to us and says, 'Hey! Have some respect for the band that's playing.' At the time, I sort of rolled my eyes, but she was right. We should have respect for somebody who was up there laying out their heart. Well, that same

woman walked out on stage, and it was Janis Joplin. I had already been a fan of hers; that's why I was there, and she blew my fucking mind. I read that she sang every note as if it were her last. She was so immersed, and she wasn't doing it for the audience—she was just doing it. That made the biggest impression on me. I was a big fan of soul music, and she was doing a different kind of soul all her own. I wanted to feel like I believed she felt—that's when it hit me; sing it from my soul as if it was killing me. It's been a big problem all my life because I can't hold back when I perform, and I just trash myself. I'm entirely in the moment, and I don't care. I'm not thinking about having a voice for the next song—fuck that! This is the song! This is the moment! This is the story right now, and tell it with your entire being."

Brie left the Svelts when she married her boyfriend and moved to San Jose. "June and Jean eventually followed me down there. Their drummer left, and we started playing together again until I got pregnant, and then the other drummer came back, Alice de Buhr, who was with them for a long time. When they all left the Bay Area and moved to LA to get a record deal, I ended up following them down there. Only this time, I was a single mother with my one-year-old daughter, Brandi. When I got pregnant in 1968, I had just turned eighteen. I was a child in a rock 'n' roll band. I was just starting to live my life, and she followed me along in it. I have regret left over from that time; I wish things could have been different for my daughter. I don't know how I could have changed the way I was, since I was a kid myself. When I look at my

" I WANTED TO FEEL LIKE I BELIEVED
SHE FELT—THAT'S WHEN IT HIT
ME; SING IT FROM MY SOUL AS IF IT
WAS KILLING ME. IT'S BEEN A BIG
PROBLEM ALL MY LIFE BECAUSE I
CAN'T HOLD BACK WHEN I PERFORM,
AND I JUST TRASH MYSELF. I'M
ENTIRELY IN THE MOMENT, AND
I DON'T CARE. I'M NOT THINKING
ABOUT HAVING A VOICE FOR THE
NEXT SONG—FUCK THAT! THIS IS THE
SONG! THIS IS THE MOMENT! THIS IS
THE STORY RIGHT NOW, AND TELL IT
WITH YOUR ENTIRE BEING."

grandkids now, they're over eighteen, and I can't imagine them being parents! There were some disasters—there were some unfortunate times, and I feel like it was rough on my daughter. I think that if I had to make one big blanket statement, it would be that I was so focused on me that I didn't focus enough on her."

There were many special ways that Brie expressed her love for Brandi: "We did share a lot of great times and creative times. We made all kinds of stuff together. I remember every morning I'd make her a bag lunch for school, and it wasn't just a bag; it was a piece of art that she could take with her. Another thing I loved doing was to hide treasure hunt messages all over her school. She would get the first clue in the morning, and during the day, she would go through the school hunting for these little notes, each one giving her clues to the next one. We had a lot of fun experiences, and she's a very creative, smart, and talented person. I love her more than any person on the planet."

Brie was ready to start her new life in LA, and it didn't matter that she wasn't a Fanny member when she moved in with June and Jean—these ladies were family. "They had this fantastic place above the Chateau Marmont, this wonderful old Spanish house that was once Hedy Lamarr's, on the end of Marmont Lane overlooking Sunset Boulevard. They were signed to a label, now as Fanny, and their producer asked if I could join the band as a singer. I think he felt that they could use a strong lead vocal, after he happened to see us at a jam session one night at a club."

The collective energy among these talented young women was on fire! "We were this tribe of creative, energetic, enthusiastic women who loved playing. We loved performing, individually and together. Doing something creative is like giving birth to a child, and when it becomes a tangible reality, it's a lifelong connection. We have so many funny stories from when we lived in that house. We called it 'Fanny Hill.' There was a basement, a first floor, and a top floor. We would have bands over to jam in the basement: Little Feat, the Band, Bonnie Raitt, Joe Cocker—so many incredibly talented musicians. It was the place to be. One time we jammed at Frank Zappa's with Kris Kristofferson and Rita Coolidge—it was a magical time and a magical place."

Another magical presence around the band was one of the most iconic musicians of our time, David Bowie. He was a huge fan of their music and had a close relationship with Jean Millington. About twenty-five years after the band broke up, he did a surprising shout-out to them in a 1999 *Rolling Stone* interview where he said, "*One of the most important female bands in American rock has been buried without a trace. And that is Fanny. They were one of the finest fucking rock bands of their time, in about 1973. They were extraordinary. They wrote everything, they played like motherfuckers, they were just colossal and wonderful, and nobody's ever mentioned them. They're as important as anybody else who's ever been, ever; it just wasn't their time. Revivify Fanny. And I will feel that my work is done.*"

Brie remembers one night when he came to a Fanny show and gave the girls some professional advice: "David used to come to our shows, and he was so awesome and supportive. There's this one story about him that I love. We were doing a show in a theater somewhere, and while we were on stage performing, he slowly walked down the center aisle with his entourage, and of course, all the spotlights turned to Bowie, wearing this fantastic wild blue suit, until he took his seat. After our show, he comes backstage and said, 'Girls, always remember how to make an entrance.' "

Her time with Fanny would come to an end—again. "The producer and the manager decided they wanted to do a fab-four Beatles thing, so they let me go. It was devastating. We still lived in the same house together, and we were all still friends. I watched the band, my friends, go out and tour to support the record that they finished without me. I was a single mom with a baby and, at the time, I remember being sad, but I must have been frightened, too. I was twenty in LA, with no idea what I would do next. In the end, everything fell into place. I found bands, went out and played, and continued to become better at what I was doing. When I did the last album in '74 for Fanny, the producer liked my vocals so much that he started using me with all the other artists he was producing, like Ringo Starr, ELO, Melissa Manchester, Roger Daltrey, and Keith Moon. I got to do some fantastic records and tours. I toured with Carole King for five years doing vocals and percussion, and with Jimmy Buffett and Robert Palmer for multiple tours.

"Had I stayed in Fanny, who knows, maybe when it was done, I would have been done. It was upsetting at the time, but maybe I have that to thank for bringing me a whole life experience of recording and touring with all these incredible artists. In the end, I think I'm the only one out of that group who had a long-standing musical career."

Brie would continue to spread her wings musically and collaboratively for her entire career. She also had a deal with MCA Records, writing songs with Glen Ballard and Davey Faragher. They wrote over sixty songs, as well as starting a band together called Neola. "One of the songs we wrote back then, 'Nightline,' was supposed to be the lead track for Michael Jackson's *Thriller* album. Michael liked that song so much that they scratched the entire album they had already recorded and rerecorded it with songs based around the style and approach of Nightline. Two other artists, Randy Crawford and the Pointer Sisters, covered the song, so Quincy Jones, who was producing *Thriller*, pulled it since it wouldn't be an original release anymore. We could have had a title song on what we thought would be a four and a half million-seller—little did we know *Thriller* would sell thirty million! It was upsetting, but I must tell you what surprises me is that I don't feel bitter. I don't feel shorted. I mean, yeah, it's unfortunate, but you know, my life wouldn't be what it is right now. It's something that happened, and it's in the past. Instead, I want to be open to more things to come. I don't feel like I don't have

enough. If this is what I have for my time on this planet, I'm a lucky motherfucker."

She would also become lucky in love when she met her husband, Dave Darling, while working with producer Giorgio Moroder. They called in Brie about a band they were putting together. The project wasn't quite right for her, but they exchanged information for future endeavors. A year later, she heard from Dave when he sent her some songs for his band, Boxing Gandhis. She loved the songs, loved the band, and would soon fall in love with him. "Dave and I have been together twenty-seven years, and we work on many projects with one another. There was definitely some magic surrounding Boxing Gandhis. It was one of my favorite experiences. There has been so much love around creating this beautiful baby together: we love what it is, and what it has become twenty-five years later." The Boxing Gandhis song "If You Love Me (Why Am I Dyin'?)" hit #5 on the Billboard Adult Alternative chart in 1993 and won the Billboard "Video of the Year" award that same year. In 2011, the song was also featured in an episode of *True Blood* on HBO.

Brie would find a new place for her artistic expression to run wild: cake creations. The inception of Brie Darling Cakes came after she watched a cake-decorating show on television and thought, *I can do that!* She could, and would, in a big way. It only took a few cake-decorating classes, and she was off! It also turned out to be a wonderful creative outlet she would occasionally share with her daughter Brandi and granddaughter Storm. There is nothing she can't make, no request too extreme: guitars, pianos, poodles, harmonicas, jellyfish, and the most magnificent flowers, skulls, and butterflies you could ever imagine. Brie didn't stop at just making the outside of the cakes beautiful; she also figured out a way to make the inside just as fabulous. She makes a patented signature leopard-print cake unlike anything ever seen before. Their slogan describes them perfectly: "Not so normal cakes for not so normal people."

> "Say yes, then assess. I have always said yes to everything, and if it isn't right, then I move on. You never know what you might be passing up."

She recently had a diagnosis that would connect the dots to understanding herself in a whole new light: "Not that long ago, I found out that I had ADHD. It woke me up to a lot of my behaviors. It gave me a sense of renewal and a newfound acceptance about myself. My therapist gave me this list of pros and cons about ADHD—it's awesome. There are so many good sides to it that I love, and the downsides I've already dealt with over the years."

A few other philosophies she has lived by have proved to benefit her professionally as well as provide personal empowerment: "Say yes, then assess. I have always said yes to everything, and if it isn't right, then I move on. You never know what you might be passing up. When I was in a band called American Girls, the producer told me, 'If you're comfortable, then it's time to do something else, because when you're uncomfortable, that means you're growing.' So, whenever I feel uncomfortable, scared, or worried, I remind myself that I am growing, and it's an excellent place to be."

Brie has never stopped breaking new ground and stepping out of her comfort zone. Whether it's writing new music, designing absolutely anything, or the next elaborate cake creation, she will throw herself into it 1,000 percent. Even at seventy-two, with a resume the size of a novel, she feels as though there is something greater ahead. "I still feel like there's something I haven't done yet that's bubbling to the surface in its own time. I don't feel like I'm done. I still have plans, I still have ideas, and I have no intention of letting anything stop me—now or ever!"

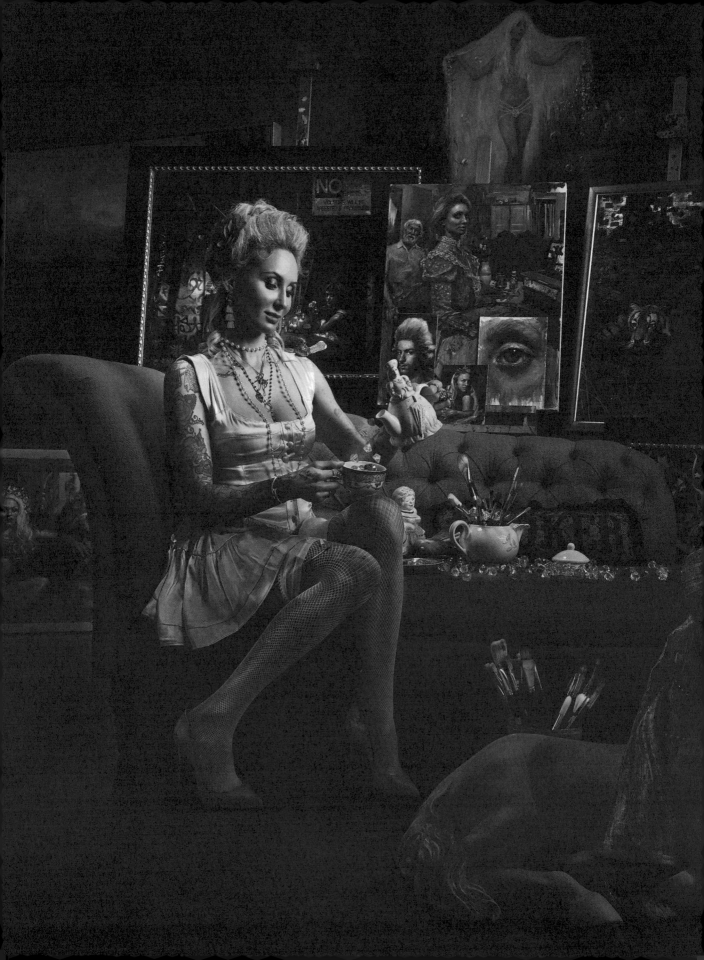

PAINTER'S PARADISE
NATALIA FABIA

CONTEMPORARY PAINTER | INSTRUCTOR

"THE HARDEST THING TO DO IS START, AND THEN SOMETIMES WHEN YOU START, YOU JUST CAN'T STOP."

—NATALIA FABIA
(INSPIRED BY STEVE HUSTON)

Natalia Fabia, a graduate of the Art Center College of Design, is a world-renowned artist whose figurative paintings are a visual celebration for the mind. Her paintbrush is like a magic wand—every stroke wielding the use of light and color in a remarkable combination of fantasy and artful realism. You become mesmerized by her paintings and are completely transported into her vision. Natalia has an uncompromising drive and passion for painting that has enabled

her to have a career as an artist from the instant she graduated from college. "I had no plan B. I sometimes think when you have a plan B, you subconsciously keep that tucked away in your head, and the minute you get nervous, you fall back on it." Painting was like oxygen for her, and she felt there weren't enough hours in the day for it—even finding sleep an unwanted distraction. What did prove to be a worthy distraction was motherhood. The boundless love she felt for her child would unleash a new level of inspiration, one that was locked inside her heart since the loss of her mother as a young girl.

NATALIA WAS RAISED IN THE SAN FERNANDO VALLEY IN SOUTHERN CALIFORNIA BY PARENTS WHO HAD EMIGRATED FROM POLAND IN THE 1970S. THEY WERE BOTH ARCHITECTS.

Her paternal Polish grandmother and her sister, Natalia's great-aunt, lived with them as well. "I guess it's a traditional Polish thing because now my dad lives with us, which I love. They were two super religious Catholic Polish ladies who walked to church every single day. They didn't speak English, so in my early childhood, I was constantly switching back and forth from English to Polish."

Her father, also a woodcarver and watercolor artist, would be one of her earliest artistic influences: "I asked him to draw me things, and I was fascinated by everything he painted. I remember being engrossed by the books we had on Leonardo da Vinci, Raphael, Michelangelo, and art encyclopedias; I loved the art. Fortunately, all of the schools I went to had art as a

big part of their program. I had some great teachers who, early on, noticed my abilities and encouraged my talent. It was my favorite subject, and kids started asking me to do their art homework! I started drawing and painting a lot from life by the sixth grade. That's the best way to learn and the hardest thing to do. First, I started drawing the girls I loved from fashion magazines. Then I started drawing my friends at lunch and breaks between classes. They always wanted me to draw them because I made them look older, like the models in the magazines."

Natalia's family unit would soon be tragically broken apart. When she was only eleven, and her younger brother Albert was nine, they lost their mother to breast cancer. She was only fifty-two. Not long after, this loss would be compounded by the passing of her grandmother and her grandaunt. Natalia lost three women in her life by the time she was thirteen; she was now the woman of the house and took care of everything, including her brother, creating an inseparable bond between the two.

While Natalia was the strength for everyone else, who was taking care of her? Where did she find refuge from her pain? "My friends were so important to me, and my middle school life was everything. My friends'

moms were there for me as well, which I am extremely grateful for. I blocked out a lot of my feelings back then. Once I had my daughter, I started thinking about my mother a lot." After losing her mother, she found healing through art. "Painting and doing anything creative is meditative—you can get lost in it. I'm sure as a child, it must have helped me release a lot of the sorrowful energy I had bottled up. I'm fortunate to have had art in my life; I can't imagine a world without it."

By the time she was in high school, she knew her future was in the art world: "I think my teacher at Notre Dame High School was the first to tell me about Art Center College of Design in Pasadena. She also told me about the Ryman program at USC, which did college-level art education for youth on the weekends. It was amazing, and I felt so lucky to have gotten in. It was the first time I did figure drawing, and the first time I saw a naked man! When it came time to apply to college, Art Center was the only place I applied!" Art Center is one of the most respected colleges in the country, also known to be one of the most grueling when it comes to its workload. "It was like boot camp for artists. It was gnarly! You leave there with a crazy portfolio. I started there in 2002, but I feel like it's not as tough anymore. I'm sure it's still a great school, but

for people looking to seriously study fine art, I tell them to go to an atelier-style school."

Even while still in school, she was laying the groundwork for a successful art career. "I had been waitressing since I was in high school at Mel's Drive-In on Ventura. I was always painting, painting, painting, and I was so excited about it. I don't know what drove me, but I wanted it so badly. I made a little book of my work. Back then, there weren't digital cameras, so I used my disposable camera for the photos in these books. I would show them to my customers at Mel's Drive-In, and sometimes people would buy my work. Looking back, I think, 'How annoying was I?' But at the time, luckily, I was naive, and hopefully they thought my enthusiasm was charming. Not long after I started at Art Center, I had to stop working because it got so intense. I wasn't even sleeping at one point."

Her determination to succeed in the world of art continued, and there was no stopping her. "My friends at Art Center and I would put together art shows downtown with bands that we knew. The shows drew a lot of attention and then attracted some galleries like Cannibal Flower, and I started being asked to be a part of other group shows. It was all about shoving my work into lots of people's faces! That's how Corey

> "Painting and doing anything creative is meditative—you can get lost in it. I'm sure as a child, it must have helped me release a lot of the sorrowful energy I had bottled up. I'm fortunate to have had art in my life; I can't imagine a world without it."

"MY VERSION OF *HOOKER* IS NOT LITERAL IN ITS MEANING, BUT MORE IN LINE WITH A PLAYFUL AND PROVOCATIVE INTERPRETATION OF THE WORD. IT'S REPRESENTATIVE OF STRONG, INDEPENDENT, TALENTED, AND SENSUAL WOMEN FULLY EXPRESSED IN THEIR SEXUALITY. I LOVE SEXINESS. ... I'VE BEEN LUCKY TO BE AROUND SO MANY BADASS WOMEN WHO ARE ALL RAD, TATTOOED CREATIVES—I WANTED TO CELEBRATE THAT."

Helford Gallery found me while I was still in college. The owners came to my grad show at Art Center, and I signed with them. I left them recently after ten years, but we're still good friends."

Her nonstop career has had many highs, and it all started with her own shows: "When I was at the Corey Helford Gallery, I would have a solo show every year—that's my favorite thing to do! Getting ready for opening night was exhilarating: my outfit, the performance, absolutely everything about it! I would have girls walking around in specifically designed clothes; it was all tied into the installation theme." She has had her work in numerous other museums and gallery exhibits. "I was in the Bristol Museum of Art, the MXW Masterworks group exhibition at Long Beach Museum of Art, and Lancaster Museum of Art—such a major career highlight! Another huge honor was when *Juxtapoz* magazine did an eleven-page spread on me. I had always been such a fan of the magazine that it was wild to be in it." She was also featured in another magazine, one that would find the little girl who drew models from fashion magazines jumping for joy...*Vogue Italia*!

One of her most treasured highs has been connecting with artists she has admired over the years. "It's such a surreal experience when artists who you love and are inspired by become your friends and consider you a peer; it's mind-blowing. I did an artist talk with renowned figurative artist Jon Swihart. I looked out into the front row and saw Mark Ryden and Olivia De Berardinis and my incredible instructor, F. Scott Hess, from Art Center, who is an amazing artist. Even my junior high school art teacher and my first collector

from Mel's Drive-In were there. When I looked out at the audience and saw everyone, I yelled out, 'This is fucking crazy!' Three years later, I still can't believe it!"

Natalia was always fascinated by the beauty of the female form. Pinup art and burlesque were some of her earliest influences. "When I was younger, I loved Bettie Page and all the different pinup artists like Gil Elvgren and Olivia De Berardinis. I've always been obsessed with Toulouse-Lautrec, which is probably where I got the whole hooker theme with my paintings back in the day. My version of *hooker* is not literal in its meaning, but more in line with a playful and provocative interpretation of the word. It's representative of strong, independent, talented, and sensual women fully expressed in their sexuality. I love sexiness. I have always painted my friends, who are mostly women. I've been lucky to be around so many badass women who are all rad, tattooed creatives—I wanted to celebrate that. I've always been interested in fashion and the cult aspect of women and their friendships. That's why my work has evolved into larger scenes featuring group dynamics of women."

Everything seemed to come to Natalia early, even her husband Jay Bentley, a founding member of the punk band Bad Religion. They met seventeen years ago, while she was still in college, and waited until 2016 to get married, after their daughter Peribeau was born. Motherhood is the only thing that has risen to the level of her passion for painting. It swept her off her feet: "I feel as though I have another brain; there's a part of it that will forever be just for her. A part of me will always be subconsciously thinking about her nonstop. Being a mother is the deepest love, but also the deepest

hurt, because you are so in love with them. It's just the best thing in the world! Becoming a mother has brought up a multitude of emotions about the loss of my mother and the realization of how much that has affected me over the years." She used this quote by Rajneesh as a statement for the stunning painting she did of herself and Peribeau, titled "Mother and Child," that exemplifies her feelings on motherhood: "The moment a child was born, the mother is also born. She never existed before. The woman existed, but the mother, never. A mother is something absolutely new."

Not long after motherhood opened her heart, she would have it broken in a way she had never felt before with the sudden death of her brother Albert from a subdural hematoma. On the sixth anniversary of his passing, she posted a beautifully written tribute to him. Here is an excerpt: "I can't believe it's been six years. I lost a giant piece of my heart, part of myself, and my future when Albert made his transition from this world. Most days, I still don't believe it is real. It has made me look at life differently. It is so delicate and unexpected, unexplained. Dumb shit doesn't matter, only family and human life—real and spiritual connections."

She would process his death in a completely different way than she did with her mother's. Years of studying the philosophies of yoga and meditation helped her

> **"It has made me look at life differently. It is so delicate and unexpected, unexplained. Dumb shit doesn't matter, only family and human life—real and spiritual connections."**

heal through this dark time. She started practicing when she was only nineteen and is a dedicated yogi who maintains an advanced practice. "When my mom died, I shut everything off—fuck you—fuck everything—life isn't fair. With Albert, I was seeking help, answers, and spirituality. I went on a retreat with one of my yogi friends, and I got to see this famous swamy and talk to him about my brother. I did the exact opposite of blocking it out; I wanted understanding, healing, and acceptance."

Natalia continued to process her emotions through her art. "My last solo show explored how we live in seven-year life cycles, from the innocence of birth to death. In my paintings, I expressed this connection to ourselves and the universe through cosmic stardust: I communicate this with rainbow sparkles, splatters, and expressive marks. I've had so much death in my life, and when you lose somebody like your sibling, a part of you dies. When I was going through the whole innocence part of life, it was perfectly reflected in my daughter. She goes to a Waldorf school, where they're focused on spirit and believe children need a connection to their environments and how important it is to play. Deep play and nature are so important; it's meditative, and especially crucial for the formative years in children, preparing their brains for the future. One thing I have learned is that boredom is important

for kids. Shoving an iPad in front of a kid's face because they're bored is counterproductive because, guess what? They should be bored, because they're going to be bored a lot in life and should be learning how to manage that instead of constantly needing a sensory thing to keep their minds occupied. That's why the arts are so necessary."

About five years ago, Natalia started teaching, which began an entirely new chapter in her career. "I always wanted to teach, but I never had time for it, and I was a little nervous about doing it. I finally decided to because I had been alone in my own gallery world for so long and felt like I'd started developing some bad habits. I wanted to get back to academic painting, and teaching gets you back to proper techniques. You also get to be around the excited energy powers of students!" Natalia's approach to teaching is a direct one: "I'm very honest and let them know there are no shortcuts in art; you just have to do it and put in the time. Teaching made me go backward, and I had to retrain myself on many techniques and practices. That's one thing with painting: it's forever. You always expand and get better, but you can never master it. For me, the second I get better and go to a whole new level, all I look toward is the next one!"

She doesn't fall into any category, other than her own. "I'm too risqué to be in one of the more serious galleries; some places are very conservative. Many of them want work based on pure realism and don't like a bold and colorful interpretation, or tattoos and nudes. I know there will be a place for me someday. If not, I will make my own."

Natalia's art studio resides in an industrial park with linear rows of repetitive white structures. Her two-thousand-square-foot space is hidden amongst the framework of these generic buildings like a secret garden. The only rule is to check your inhibitions at the door and let your imagination run wild. Upon entering, I had the same visceral reaction as when I walked into Disneyland for the first time as a child. Paths of glitter lead you to seemingly endless amounts of artwork, each one as captivating as the other. The line between fantasy and reality disappears, and you begin to believe unicorns do exist, rainbows can happen anywhere, and confetti does rain from the sky. The soundtrack that runs through your mind is somewhere between Tchaikovsky and the Sex Pistols, conjuring up images of tattooed sugar-plum fairies dancing in the moonlight.

The strong message that women are free to express themselves and their sexuality whenever, and however, is empowered in her work. She is a cutting-edge contemporary artist of her generation who is in a class all her own. Her paintings open viewers' eyes to a new way of seeing the world. Once you climb aboard Natalia's wild ride, you will never want to get off!

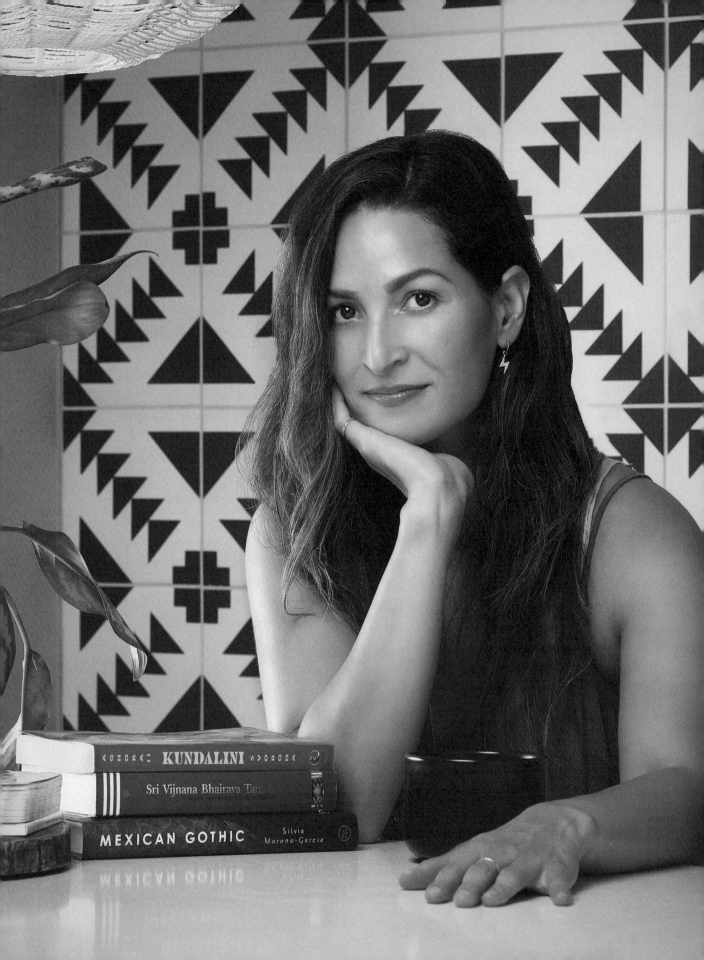

RADICAL LOVE
ROSIE ACOSTA

INSPIRATIONAL SPEAKER | YOGA & MEDITATION TEACHER | AUTHOR

"NO PODEMOS ARRANCAR UNA PÁGINA DEL LIBRO DE NUESTRA VIDA, PERO PODEMOS TIRAR TODO EL LIBRO EN EL FUEGO."

—MARIA FELIX

TRANSLATION: "WE CAN'T TEAR A SINGLE PAGE OUT OF OUR LIFE STORY, BUT WE CAN THROW THE ENTIRE BOOK INTO THE FLAMES."

"I believe that we are waves in the vast ocean of the Universe or of God. We are here to make waves and announce what our dharma is, our duty, and to do whatever it takes to see it through. It's extraordinary to think of how many other little waves you've affected during the process of being alive." This quote by Rosie Acosta, a world-renowned yoga and meditation teacher, trainer, author, and holistic health coach, illustrates her expanded awareness of our existence here on earth. Though it wasn't always that way. She was once a troubled teen from East LA. Rosie is a child of immigrant parents who came here to make a better life. However, she fell prey to the harsh realities of her environment and, just months before her fifteenth birthday, was arrested for attempted grand theft auto—*of a cop car*. Wanting to look like a badass in front of friends, she jumped into the driver's seat of a running patrol car while the officer was chasing a suspect on foot. Her hasty plan backfired, and seven police officers surrounded her with guns drawn. The arrest was the first step toward breaking a destructive cycle. Shortly after that day, she made a conscious decision to commit

to her future after hearing Cuban actor Tony Plana speak at her school. He demonstrated that it is possible to overcome adversity and achieve success no matter where you are from. He signed her notebook with the words *Dream On*, and from that day forward, she did.

ROSIE WOULD FIND THE OUTLET TO ACTUALIZE HER POTENTIAL WHEN SHE DISCOVERED YOGA AND MEDITATION. WHEN HER PURPOSE BECAME CLEAR, SHE CREATED RADICALLY LOVED: A LIFESTYLE BRAND CENTERED AROUND THE MODALITIES OF YOGA, MEDITATION, AND MINDFULNESS—TOOLS THAT GUIDE PEOPLE TO CONNECT WITH THEIR LIVES BY EMBRACING PASSION, PURPOSE, AND JOY.

She serves others, not only by planting seeds of hope, but by empowering them to grow the entire tree— nurturing every branch of their lives. She does this through her yoga and meditation classes, the award-winning *Radically Loved* podcast, worldwide retreats, speaking engagements, international teacher training/coaching, and as a proud ambassador to *Yoga Journal*. Rosie has taught people ranging from at-risk youth to elite Olympic athletes, NFL champions, NBA All-Stars, her local community, and Afghanistan veterans.

Walking up to Rosie's house, tranquility washes over you while butterflies flutter along the vibrant flowered hedges. I couldn't help but think about the stark contrast to the turbulent backdrop of her youth. Rosie's curious and inquisitive nature were all inherent characteristics that enabled her to see a different future for herself. She says, "Hope is useless without action," and she has clearly enacted this philosophy to get where she is today.

She describes her early years as seen through the eyes of a child who adapted to her surroundings. "Growing up in East LA during the LA riots was extremely intense. I think it's an interesting reflection because, when you grow up in a chaotic environment, you don't know you're in one—it's a normal part of your life. But it's not normal to experience that much violence and destruction. My neighborhood had a lot of immigrant families that came from underdeveloped countries plagued by war or famine. Comparatively, for them, the United States might as well be Disneyland. My parents are from Mexico, and I would hear these horrible stories about where they grew up. We had some friends who talked about what it was like living in

El Salvador during a civil war; their stories didn't seem abnormal to me at the time. I think growing up in this way affects your childhood in many ways.

"I never felt like I lacked anything. I certainly always felt loved. What I never felt was safe, and I considered it my duty to protect everyone. One time I was at the supermarket with my grandmother, and there was an armed robbery; all I could think of was that I needed to protect her from harm—yet I was a child. In terms of the fight-or-flight responses to stress, mine was to fight for my family's safety. It strongly affected me in my teenage years, manifesting in the forms of PTSD, as well as insomnia, depression, anxiety, and overeating. It presented physically as an autoimmune condition and anemia. I was raw, in an ultra-sensitive state of mind. This was no fault of my parents. They came from extremely oppressive environments. My father is from Mexico, and my mother immigrated to Mexico from Spain. They immigrated here together and did the best they could with what they had."

"There will always be destruction before transformation. There's a lot of intensity that happens with just being a teenage woman. We start to bleed, and we start to inquire about our own identity. Who are we? What do I want in my life? ...When a butterfly comes out of its caterpillar shell, it wasn't told to be anything; it evolved how it evolved. It wasn't told it needs to have a larger wing gap, or that its colors should be different. It was allowed to be who and what it was meant to be."

Rosie was a discerning child filled with questions, an early glimpse into the future of this insightful mind: "As kids, we were taught to believe with this blind faith and expected to listen to whatever anyone said without questioning it. I was too inquisitive for that, and I always wanted to know how things worked. I wanted to understand why there was injustice.

Ultimately, it led me to realizing that everybody has a choice. I had this innate belief that we had more power than was being shown to us. This whole process of inquiry brought me to where I am now: asking questions and being able to make different choices. We may not know all the answers, but at least the journey's process is being able to ask the questions to create a different life. What it translated to for me was, 'Can I possibly move out of this paradigm and create something new?'"

As a child, Rosie's father would say to her, "There is no peace without war." Her arrest would mark the beginning of her war, the battle for her future. It was time for Rosie to start directing some of those questions and solutions toward herself. She had a

two-year probation, along with one hundred hours of community service, therapy, and keeping her grade point average at 2.0 or above. "There will always be destruction before transformation. There's a lot of intensity that happens with just being a teenage woman. We start to bleed, and we start to inquire about our own identity. Who are we? What do I want in my life? All the things we go through as teenagers allow us to identify who and what we truly are. When a butterfly comes out of its caterpillar shell, it wasn't told to be anything; it evolved how it evolved. It wasn't told it needs to have a larger wing gap, or that its colors should be different. It was allowed to be who and what it was meant to be."

The programs she was required to complete did help her, but she feels some critical changes to them could make a stronger impact on kids in this situation. "If we could change the motivation from *kids getting into trouble because they are bad* to a different narrative, it would help the recovery rate with these programs. I think it's wonderful to have community service include cleaning up our freeways and beaches, but what about including an education on global warming and the environment, to illustrate the value in what they are doing as giving back to the earth and not just a punishment? When you frame it as *punishment* and not *reeducation,* they retreat into anger and resentment, which only fuels the initial problem. I was so fortunate to have my community service be at the public library. I loved books and reading, so this encouraged and nurtured that spark in me. More of that kind of community service would benefit kids in a much more positive way by turning things around instead of continuing down the same destructive path."

Rosie's mother first introduced her to yoga and meditation after a work colleague recommended it to her for stress management. She brought pamphlets home about the program, which was at the Self-Realization Fellowship temple in Hollywood, founded by Paramahansa Yogananda. Rosie didn't take to it right away, and she even dismissed it as a cult after her first visit to the temple. Despite this, some ideas that were introduced started to resonate once she had time to absorb them. One of the beliefs discussed was about being responsible for creating the life you want—awakening her to the fact that she was the only one who could change her self-destructive behavior.

Today Rosie says, "Our background and circumstances may have influenced who we are, but we are responsible for who we become." By the time she was twenty-two, she had started an intensive yoga training, taking the first steps to becoming an accomplished yogi. She would later attend Yoga Works's 200-hour teacher training and, in 2011, started studying with Rod Stryker, founder of ParaYoga. "No matter what stage it is in our lives, we get to the point when it's the right time; that's when it will happen. You can't lament over time because it's the experience."

Early on, Rosie was drawn to the positive effects of being part of a community of strong women, something she has carried on to this day by featuring top wellness experts on her *Radically Loved* podcast, and guests such as Elizabeth Gilbert and Tererai Trent on her *W.I.S.E.* (Women Inspiring Success and Empowerment) podcast. "I was always much more drawn to being around older women like my

"I WANTED TO UNDERSTAND WHY THERE WAS INJUSTICE. ULTIMATELY, IT LED ME TO REALIZING THAT EVERYBODY HAS A CHOICE. I HAD THIS INNATE BELIEF THAT WE HAD MORE POWER THAN WAS BEING SHOWN TO US. THIS WHOLE PROCESS OF INQUIRY BROUGHT ME TO WHERE I AM NOW: ASKING QUESTIONS AND BEING ABLE TO MAKE DIFFERENT CHOICES. WE MAY NOT KNOW ALL THE ANSWERS, BUT AT LEAST THE JOURNEY'S PROCESS IS BEING ABLE TO ASK THE QUESTIONS TO CREATE A DIFFERENT LIFE."

grandmother and her neighborhood friends. My grandmother would have prayer vigils every week to pray for their families. Many of these moms, grandmothers, and sisters would all come together to pray for their children who were directly affected by violence: Some were in jail, and others had recently passed away. There was a deep level of connection and comfort for me. When we were in these situations, we were with family and friends close to us. I never felt like I was alone."

Her hard work and positive message are clearly reaching people. She is headlining festivals, and her *Radically Loved* podcast won the Verywell Best Wellness Podcast Award with over 120,000 worldwide listeners, and she was recently the cover story for *Yoga Journal*. She also just released her first book, *You Are Radically Loved: A Healing Journey to Self-Love*. These are all exciting accomplishments for Rosie, but not what she values most in her career: "The biggest highlights are just seeing the lives of my students changed. So many of them have accomplished incredible things, and some have been inspired to become activists. Though I am extremely excited, honored, and grateful to have written this book, even that will come and go. Certain things in our

lives are transient, and at the end of the day, what are you left with? For me, my practice, my community, and my ability to be still and happy in my body are the biggest highlights I could ever ask for, and they consistently bring me the most joy."

One of the most significant breakthroughs in Rosie's life has been learning to process emotions. "I spent the first half of my life suppressing what I felt and being performative. I appeared to have it together on the outside, but I never actually dealt with the hurt, trauma, and pain inside; I was numb. The process of getting to a place where I can express my feelings, cry, and have an experience of what a fully processed emotion looks like was probably one of the biggest accomplishments of my life. I was never a crier, but I am now!

> "I spent the first half of my life suppressing what I felt and being performative. I appeared to have it together on the outside, but I never actually dealt with the hurt, trauma, and pain inside; I was numb. The process of getting to a place where I can express my feelings, cry, and have an experience of what a fully processed emotion looks like was probably one of the biggest accomplishments of my life."

Bessel van der Kolk's book *The Body Keeps the Score* discusses how our issues are in our tissues, and our body is a storehouse of energy. Releasing that energy is essential to our emotional and physical health. Now, I can look outside and be moved to tears by the beauty of the waterfront."

During those early years of emotional expansion, she also found love with upscale accessories-designer Torry Pendergrass. Their love story caught fire eighteen years ago at a Motorhead concert when an extra ticket from a friend found the two on an impromptu date. They have been together ever since. She explained what she attributes the longevity of their relationship to: "There are always ups and downs, but I think the most important thing for us has been forgiveness—to be able to forgive each other for our mistakes and grow from them. I believe the key to our relationship has been a deep commitment to honoring each other, our individuality, and the relationship as its own entity."

For the past few years, the couple has been working on starting a family, resulting in Rosie experiencing deep-seated emotional pain. "It's been hard for a while now because I've gone through several miscarriages. I was pregnant most of the year in 2018, and some of 2019, until I finally got to a place where I realized my body couldn't handle it anymore. My body would reject the pregnancy. I was still traveling, teaching, and doing speaking engagements through all of this. It was hard to have to perform in the midst of this terrible thing happening in the background. So, at the end of last year, I decided that my body and heart needed a hiatus. I was energetically depleted. I still worked, but stopped traveling.

"The interesting thing was that by allowing myself this space, the other baby that wanted to be born started to come to fruition, which was my book. In a sense, it showed me that something did want to come to life in me, and that is where my attention needed to be.

When that shift happened, I started to feel so much better about everything. I still want to have my own children, and I am open to receiving a child however it comes. I finally came to the conclusion that I'm going to be a mom—I know I am. My child is going to come to me, and it's going to be perfect."

When Rosie shares the gifts of her knowledge with others, it is done from a place of compassion and connection. She says, "Your mind is a scary place, and you shall not travel alone." Which you will never be with Rosie by your side. "I've worked with some great clients for years who have fully transformed their lives and are doing incredible things; all I did was listen and ask questions. They've created their own success and their own feelings of transformation. It's important to always know that everything we need is already present. Everything we need is right here, right now, in the present moment. We need to recognize that we, and we alone, have the power within to discern what will serve our heart, our health, and our happiness. Moving through life's journey knowing that we have the capacity to do this is everything." She humbly guides us to the understanding of our own power, unearthing the warrior who lives inside us all.

FINAL THOUGHTS

"BEAUTY BEGINS THE MOMENT YOU DECIDE
TO BE YOURSELF."

—COCO CHANEL

In today's social-media-fueled world, it's harder than ever not to compare ourselves to others physically, professionally, personally, and artistically. I watched my daughter struggle with this when she was a teenager searching for her own identity amongst her peers. Seeing others attempting to pressure her into doubting the pursuit of a career in the arts drove me even harder to create this book. I had gotten the same discouraging message at her age and was shocked that artistic fields were still looked upon as a risky and unattainable road to take. I wasn't going to sit back and watch her question an undeniable talent and passion because of the societal stigma of "the starving artist." I saw the importance of shining the spotlight on women who have found success in a multitude of creative careers.

Creativity is the expression of our innermost desires and can manifest itself anywhere in our lives, from works of art to designing a detailed filing system for your office. It's an essential outlet for mental wellness—it's meditation, creation, infinite freedom, and self-love. It can be a savior during our darkest hours and a friend when we are feeling alone. We are all *wildly* creative in our own unique way. It's never too late to open the door to a world free from limitations. Here I am becoming a published author at fifty-seven!

Until you have a clear vision of what you want to see in your life, you can't paint the picture. The journey begins when you allow yourself to be led by your heart and soul. Clarity starts when you peel away the layers of who and what others want or expect you to be. Since you can't please everyone, why not focus on pleasing the one person you can: yourself. Self-love is honoring all aspects of ourselves—the lows, the highs, successes, and failures. Look to the harmony in nature's chaos: when the storm hits, the rain is our tears, the wind our resistance, the destruction our pain. Once it passes, there is the opportunity for new growth: the air is cleansed, the soil is nourished, and the brightness of the sun restored.

The women in this book all seized these moments to plant even bigger trees and brighter flowers. May these stories enliven your enthusiasm to celebrate what makes you exceptional and incomparable to anyone else. Join this coalition of creatives and be a rebel from the norm. Become liberated from outer influences and identify exactly what you want. Please pass along the symbiotic wisdom from these magnificent women with whomever you feel will benefit from it, strengthening the invisible thread that unites us all.

I would love to hear your stories of creative empowerment and how it has enriched your life. You can email me at angelalomenzo.com. Let's keep this conversation going!

With much love and gratitude,

Angela LoMenzo

ACKNOWLEDGMENTS

I look at art in all forms as a collaboration. Whether you walk alone in your craft or are in concert with others, the inspiration, influence, and support of the people who have touched our lives, either directly or indirectly, all have had a hand in the creation of a body of work. Here, I would like to thank the many beautiful people who made this book possible.

The soul, spirit, and heart of *Wisdom of Wildly Creative Women* are the extraordinary women whose stories are featured in its pages. Thank you for trusting me to share your empowering experiences with the world. I hold this honor sacred. You have all infinitely touched my heart and will always be a source of inspiration to me.

There are two kindred spirits who saw the significance of this project from the beginning and have been its greatest advocates in turning my dream into a reality:

My editor Brenda Knight, who instantly shared my vision for this book. Your uncanny ability to read my mind is astonishing! I am so grateful that you decided to take a chance on this first- time author, enabling me to bring this book to life. My superhero literary agent, Tina Wainscott—my right hand and editor-in-chief in everything, thank you for believing in me and for your unwavering commitment and patience. You've been my mentor, confidante, and most of all, friend, every step of the way.

The Seymour Agency, and Nicole Resciniti, thank you for your representation and guidance.

Big thanks to Chris McKenney, Robin, Vero, Meloni, Lisa, Megan, Nehemie, Krishna, Minerve, Shelby, and the entire Mango team for all your hard work and expertise.

A huge acknowledgment goes to my husband, James, my creative partner, and the love of my life. I am in awe of your immense talents and masterful photography. Thank you for filling my life with unconditional love and mind-blowing music. Most importantly, thank you for keeping me laughing throughout this magical journey we are on together.

I am extremely blessed to have been surrounded by an abundance of love and creativity throughout my life, which all starts with my family. Thank you to my incredibly talented daughter and muse, Zoe Rose, for your beautiful art and for listening to countless hours of book talk, and to her boyfriend, Tyler, for his help and kind words. To my loving parents: my mother, my ray of sunshine, thank

you for always being my biggest cheerleader, friend, and my first read-through.

My father, my hero and #1 fan, we not only share a birthday but a father/daughter bond I cherish with all my heart. Thank you for being my rock, a role model for truth and integrity, for your virtuoso violin performances that serenaded my childhood, and for allowing me to have a revolving door of animal rescues. You were my daily voice of love and adoration, and your excitement for this book was a constant boost in motivation for me. My love for you is eternal Dad, and though you can't be here physically anymore, I will always feel you in my heart, hear you in my mind, and see you in my thoughts.

Papa Earl, your unconditional love always gave me strength and hope even during the most trying of times. Aunt Teri, throughout my life you have inspired me with your beautiful paintings and passion for art. Allen, your resilience and enduring lust for life has shown me what never giving up looks like. Thank you to my mother-in-law, Gloria, for the love, prayers, and devotion you give to your family. Ellie, your love and friendship I will treasure always. Lita Belle, my fur-baby bestie, you were the perfect cozy copilot throughout the writing of this book.

I am fortunate to have two rock star attorneys who are also dear friends, Mark Abbatista and Keith Cooper. Thank you for your exceptional counsel and invaluable legal prowess.

Danica Lynch, your wise words opened my eyes to the possibilities for my unique vision. Fortune, your sage advice enabled me to find the rainbow after the storm. Stefanie Michaels, thank you for jumping right in and giving this project its first rocket launch! Esther Margolis, your words of encouragement added greatly to my confidence. Nancy Cleary, your love of this project was an integral part of its evolution. Daniella, your shining example of turning dreams into reality has always kept me believing.

To Karla and Lori, the angels who live in my heart, the beauty you both brought to this world will forever light my path.

In closing, I want to profess my heartfelt gratitude to all the authors, artists, designers, musicians, filmmakers, and performers who have inspired and enriched my life with their work. The sublime power of art is never-ending and ever-changing—unifying us all in its splendor.

CREDITS

PHOTOGRAPHY

Principal photography by James LoMenzo

Except for:

Alison Wright photographed by Alison Wright

Drea de Matteo photographed by Robby Staebler

Elissa Kravetz photographed by Alena Kartushina

Creative Director: Angela LoMenzo

MAKEUP | HAIR

Makeup by Angela LoMenzo for:

Chloe Trujillo, Pearl Aday, Bianca Sapetto, Christine Devine, Tracy Vera

Makeup for Kathy Rose: Pircilla Pae | Hair: Kiara Bailey

Makeup for Kathy Jacobs: Suzanna Melendez

Hair and makeup for Natalia Fabia: Dan Nguyen

Makeup for Stefanie Michaels: Steve Oraha

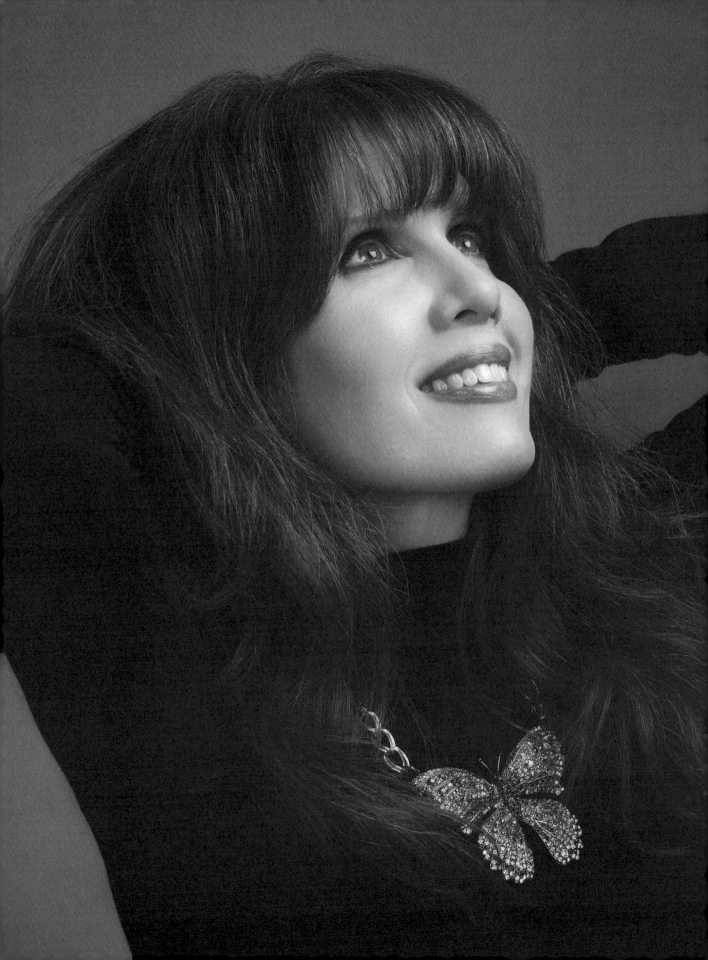

ABOUT THE AUTHOR

Angela LoMenzo grew up in an interfaith and multicultural environment, surrounded by a family of artists and musicians, including an Academy Award-winning grandfather. In one house, she had her father, the son of a Hungarian Greek Catholic priest, an attorney, and a classical violinist who cofounded the Los Angeles Pops Orchestra. In the other house, she lived with her bohemian artist mother and Jewish Moroccan stepfather, a bassist whose band toured with the Doors.

This diverse exposure as a child helped to develop her core values of unity, equality, and the belief that we are all interconnected as one. She is fiercely passionate about women's issues and human rights, as well as advocating for animals and the environment. Writing, art, and photography have been her outlets for self-expression for as long as she can remember.

Angela has been a makeup artist for over thirty years, working in television, music videos, print, and photography. In 1993, she married her soul mate, veteran bassist James LoMenzo. Spending her entire life in a community of uniquely talented artists has kept her firmly rooted in a creative lifestyle. She lives in her native Los Angeles with James and rescue pup Lita. The two have a daughter, Zoe Rose, who is a graphic artist and illustrator. When Angela is not writing, she is the creative director and makeup artist at Monster House Productions, the video/music production company she started with James in 2012. She recently became certified as a Chopra Meditation Instructor to help people to learn the healing benefits of meditation both physically and mentally.

Mango Publishing, established in 2014, publishes an eclectic list of books by diverse authors—both new and established voices—on topics ranging from business, personal growth, women's empowerment, LGBTQ+ studies, health, and spirituality to history, popular culture, time management, decluttering, lifestyle, mental wellness, aging, and sustainable living. We were recently named 2019 *and* 2020's #1 fastest-growing independent publisher by *Publishers Weekly.* Our success is driven by our main goal, which is to publish high-quality books that will entertain readers as well as make a positive difference in their lives.

Our readers are our most important resource; we value your input, suggestions, and ideas. We'd love to hear from you—after all, we are publishing books for you!

Please stay in touch with us and follow us at:

Facebook: Mango Publishing
Twitter: @MangoPublishing
Instagram: @MangoPublishing
LinkedIn: Mango Publishing
Pinterest: Mango Publishing
Newsletter: mangopublishinggroup.com/newsletter

Join us on Mango's journey to reinvent publishing, one book at a time.